Adobe® Photoshop® Forensics

Sleuths, Truths, and Fauxtography

D1441658

Cynthia Baron

THOMSON

★

COURSE TECHNOLOGY

Professional ■ Technical ■ Reference

ISBN-10: 1-59863-405-4

ISBN-13: 978-1-59863-405-1

Library of Congress Catalog Card Number: 2007923930

Printed in the United States of America

08 09 10 11 12 BU 10 9 8 7 6 5 4 3 2 1

Publisher and General Manager, Thomson Course Technology PTR:
Stacy L. Hiquet

Associate Director of Marketing:
Sarah O'Donnell

Manager of Editorial Services:
Heather Talbot

Marketing Manager:
Jordan Casey

Project Editor and Copy Editor:
Dan Foster, Scribe Tribe

Acquisitions Editor:
Megan Belanger

Technical Reviewer:
Mark Abdelnour

PTR Editorial Services Coordinator:
Erin Johnson

Interior Layout Tech:
Jill Flores

Cover Designer:
Mike Tanamachi

Indexer:
Larry Sweazy

Proofreader:
Gene Redding

THOMSON

COURSE TECHNOLOGY
Professional ■ Technical ■ Reference

Thomson Course Technology PTR, a division of Thomson Learning Inc.
25 Thomson Place ■ Boston, MA 02210 ■ www.courseptr.com

To my husband, Shai, who never complained and was always supportive.

ACKNOWLEDGMENTS

I OWE AN ENORMOUS and permanent debt of gratitude to all the investigators whose work is cited in these pages. Each spent significant time providing me with examples, answering my sometimes ill-formed questions, and brightening my e-mail with good humor and collegiality.

In particular, I send my thanks to Hany Farid for sharing his work and time and to Neal Krawetz for his boundless enthusiasm, insights, and generosity. I learned much from our conversations and hope to continue them.

In addition to the investigators, several others gave of their time and intellectual property. A big thank you to photographer and camera collector Regis Boissier, to banknote maven Mike Jowett, and to peripatetic photographer John Pettitt for their kind release of artwork.

Thanks also to Katie Ullmann for her modeling services and to Karen and Dennis Vaccaro for their warm friendship, their electron microscope slides, and the use of their Maine retreat when my spirits flagged.

Thanks to Sarah Nelson, Pacific Alaska Region Archivist for NARA, and to Joe McCary of Photo Response, who added a personal touch to navigating the Library of Congress.

I appreciate the support of several people at Northeastern University. In particular, thanks to Bruce Hamilton for his aid on our photo shoots, to Jay Laird for strategic help at a critical moment, and to Dean Mary Churchill for providing me the time and space to finish this project.

Thanks to the Course Technology PTR team: Publisher Stacy Hiquet, Editor Dan Foster of Scribe Tribe, and Technical Reviewer Mark Abdelnour. It was a pleasure to work with you.

My assistant, Mitch Weiss, deserves a special note. Many of the original photographs in this book (in particular the case studies in the last chapter) are his. He translated my requests and direction perfectly and was a joy as a collaborator.

And last but not least, thank you to my agent Neil Salkind, who brainstormed this idea with me and helped make this book possible.

ABOUT THE AUTHOR

CYNTHIA BARON is Associate Director of the graduate program in Digital Media and the undergraduate program in Multimedia Studies at Northeastern University in Boston, MA. Formerly she was the Technical Director for the Department of Visual Arts, and she has been teaching courses that integrate digital tools with design and creative imaging for 20 years.

Cynthia is a designer and photo imaging artist who has been the executive vice president of a Boston-based graphic design and typography studio for more than a decade. She also holds an MBA with a concentration in Marketing from Northeastern University.

Cynthia was editor of Rockport Publishers' *Design Whys* book series and a contributing editor for *Critique: the Magazine of Graphic Design Thinking* and for *Computer Graphics World*. She has edited, authored, or co-authored more than a dozen books, most notably *Designing a Digital Portfolio* and *The Digital Photography Field Guide* for Pearson Education.

CONTENTS

PART II
PROFESSIONAL MISCONDUCT

PART III
BODY OF EVIDENCE

PART IV
OUTER LIMITS

INTRODUCTION

EVERYBODY LOVES a good crime story. We identify with its clever and dogged investigators while trying to outguess them. The most satisfying stories dole out clues in small doses, sending us down into dead ends and surprising us with unlikely perpetrators.

Some of our favorite moments are the puzzle-solving ones. When an investigator in one of the *CSI* episodes sees the significance of a fragment of glass or an unlikely scratch on a wall, we're glued in place. Soon the almost magical forensic technology will build a cage around the killer. Not surprisingly, enrollments in criminal justice programs around the country have exploded. This is one cool job.

Not all of us can contemplate joining a forensics team, no matter how many episodes of crime procedurals we devour. Navigating the forest of spectrometers and pipettes, let alone weighing a brain in an autopsy, is a little beyond our reach. But not all crimes are murder, and not all tools require a doctoral degree. In fact, chances are high that if you are reading this introduction, you already have a powerful forensic device in your home or office: Adobe Photoshop.

Of course, this device cuts both ways—it's also a weapon. Although we are now more visually literate and skeptical about "photographic evidence" than our parents or grandparents, we can still be taken in by a good fake, especially if it's a fake we want to believe. Perpetrators take advantage of that all-too-human weakness and wreak much damage before their trick is discovered.

But if you know what to look for and how a fake is created, you can see through these damaging or expensive frauds. And just as a criminologist studies evidence and learns to see significance in things a layperson will miss, so can you. All it requires is an educated visual eye, an occasionally skeptical mind, and a full understanding of your tools' remarkable range.

This book's goal is to help you understand how Photoshop can be—and has been— used to modify, lead, and mislead. Even if you've never considered editing an image, you can read through the stories for the fun of exploring photographic fakery. You can use this book as a way to train your eye, educating yourself on the telltale signs that point to the conclusion that an image has been altered.

In addition, in each chapter a case study constructs a pathway through a fraud or fake. In some instances the study shows you the telltale signs of fakery. In others, you'll watch as an image or combination of images becomes something that looks convincing but is utterly untrue. Either way, the case study demystifies some fascinating Photoshop tools and explains how they can be used most effectively, whether you are a potential perp (heaven forbid!) or a future forensic star.

PART I

COUNTERFEITING AND THE LAW

Now if you have a taste for this experience

And you're flushed with your very first success

Then you must try a twosome or a threesome

And you'll find your conscience bothers you much less

…

Because it's murder by numbers, one, two, three

It's as easy to learn as your ABC

—"Murder by Numbers" by Sting & Andy Summers

CHAPTER 1

SHOW ME THE MONEY

IMAGE EDITING SOFTWARE is fast becoming as common a computer tool as the Office suite. We optimize, improve, or integrate photographic imagery as part of the many tasks we do at work. When we're done, the image gets incorporated in some larger project for our company. Our company uses this project in some gainful way and in appreciation pays us, while offering the government its legal share.

But isn't that process terribly inefficient? We could just cut out the middleman and save a lot of effort every April. This train of reasoning explains why all official documents—particularly financial ones—are vulnerable to counterfeiting and "creative" alteration. They represent a tempting combination of low entry threshold to crime with a very high rate of return.

LEAD US NOT INTO TEMPTATION

No matter what type of official material is altered—from currency to IDs to licenses—our society loses. The issuing body's authority is compromised. In time, this leads to more successful forgeries, as people lose their trust in the organization and its ability to create genuine forms. In the worst case, the economy ruptures, and governments collapse.

With so much at stake, our society has a clear interest in preventing all forms of counterfeiting. Each time a new threat becomes apparent, governments and corporations try to find and close the counterfeiter's opportunities. That's why our over-the-counter pills come in tamper-proof bottles, our credit cards and money include holography, and increasingly more packaging contains identifying nano-sized chips.

Unfortunately, all the laws, rules, and regulations don't translate into foolproof security from fakes. The major reasons are three: opportunity, knowledge, and greed.

Opportunity

We are much better at plugging the holes of forgery after they've appeared than we are at anticipating where the holes might be. Although there are some security consultants who make their living by asking "what if" to close gaps before they're exploited, their numbers are dwarfed by the volume of people on the other side. If there is any rule about criminal intent, it's that if an unanticipated avenue of attack exists, someone will use it.

Knowledge

Fakes often succeed because we either aren't familiar with the real thing or have never looked closely at it. Consider for a moment: Could you distinguish a counterfeit $100 bill from a real one? Or, assuming you're a U.S. citizen, could you tell if a Euro was counterfeit? If you don't think so, you're not alone. Many bad bills are passed in the international market, where people aren't as familiar with foreign currency.

Even badly executed document fakery can pass muster if it simply "looks official." Many targets of fraud don't realize how easy it is to edit a real document or create a fake one from scratch. Sadly, even when a fake is exposed, there's no guarantee that similar fakes will no longer appear. Once whatever publicity surrounding the scam dies down, new people can be targeted. If the scam involves a printed document, the scam artist can move to a new locale or adopt a new identity. If the scam involves the Internet, a new domain with a new owner name and address can be manufactured almost instantaneously.

Greed

The major reason that forgeries develop a stubborn life is because people ignore the golden rule of fakery: If it looks too good to be true, it is. The thrill of a bargain, of getting something wonderful on the cheap, is alive in all of us. There's a fleet of trucks around the globe whose back doors open at every pothole, spewing Gucci bags.

HARDER CURRENCY: COUNTERFEITING FOR CASH

Of all the forms of Photoshop-related fakery, counterfeiting currency is one of the most serious and tempting.

It seems amazing today, but until the late nineteenth century many countries did not print their own currency. In the U.S., money was printed by banks and the individual states until the Civil War. There was no consistent look to cash. Every note was designed differently, making it extremely easy to create and pass your own paper (Figure 1-1).

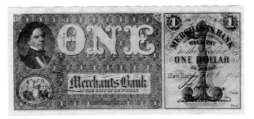
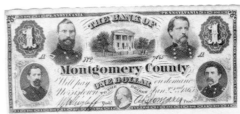
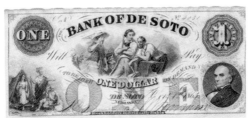
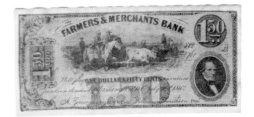
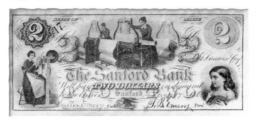
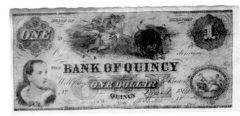

Figure 1-1 Each of these bills was legal tender in the United States before 1862. Note that none of the bills are green.

By the end of the war it was obvious that something needed to be done. The government, desperate to take control of its finances, established the Secret Service to counteract rampant counterfeiting. From then until the dawn of the computer age, the bar to entry into fake money making was relatively high. Printing presses are noisy, bulky hunks of metal. To create or alter a printing plate, you needed an engraver—a highly trained craftsman with artistic skill, patience, and an eye for detail. The combination allowed government investigators to narrow the list of players to organized crime and an occasional independent printing gang.

In contrast, the last few decades have been fruitful for the enterprising counterfeiter. With the advent of the color copier, scanner, and image editing software, anyone with a little money to invest, some patience, and a larcenous bent could make a mint.

The U.S. has always been very protective of its special paper and has been fairly successful at getting people to recognize good bills by concentrating on this unique feature. U.S. currency includes embedded color threads and has a distinctive hand-feel that most regular paper can't match. Unfortunately, one of the counterfeiting world's current tricks has been to bleach the ink from a low currency bill like a $1 or $5, then print a counterfeit version of a scanned $50 or $100 onto it. The paper looks and feels real, because it is.

The Treasury Strikes Back

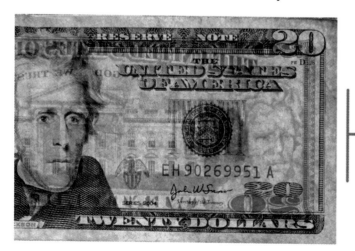

Figure 1-2 *Andrew Jackson's portrait is duplicated with a watermark next to the seal as indicated by the red marker. Watermarks are part of the paper, so they're particularly difficult to counterfeit.*

The government has responded to the threat in stages. Beginning with the $20 bill in 2003 and continuing with the $10 and $50, U.S. currency has been redesigned to hamper digital deceit. The $100 bill, a favorite of counterfeiters, is next. Following the European lead, they're adding features difficult to duplicate with computer tools. Patterned color backgrounds are specific to different denominations, and many details are micro-printed at a size too small for a desktop printer's resolution to duplicate. Inks on large numerals color-shift when you tilt the bill, and watermarks appear when you hold a bill up to the light (Figure 1-2). Both of these technologies are difficult to add to counterfeit currency and are easy to verify.

Corporate Response

Companies like Adobe whose products can be used for counterfeiting have responded to requests from the government. They've incorporating changes in their software to defeat the most obvious schemes. Some color copiers have detection algorithms that watermark copies of an image identified as having characteristics of a banknote. Others will shut down if you attempt to copy money and require service to function again. The service technician is required to report the attempt, which is logged in the copier's memory.

Detection systems are also embedded in some imaging software. If you scan or photograph a banknote and open the file in Adobe Photoshop CS or later, you'll get a dialog box that warns you that your image is currency and links you to a site with every major country's currency rules. (This feature is not exclusive to Photoshop. Competing image editing software, like Paint Shop Pro, includes similar blocks.) Exactly what happens within the software isn't consistent and varies according to which generation of CS you have (Figures 1-3 and 1-4).

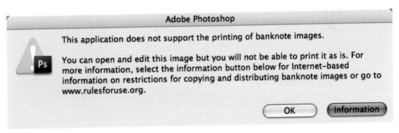

Figure 1-3 You'll get some variation of this message if you are working in Photoshop CS2 or later.

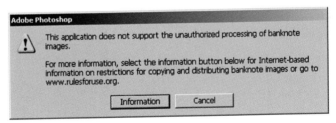

Figure 1-4 You'll get this message if you try to open the same file in Photoshop CS.

Educators, designers, and artists have used images of banknotes for a variety of reasons, ranging from school projects on the history of money to advertising campaigns and fine art projects. To try to meet those needs, the U.S. Treasury Department provides downloadable currency images (http://www.moneyfactory.gov/newmoney/).

Although these images can be edited and printed, they work best as teaching tools for people who need to recognize the new currency elements (Figure 1-5).

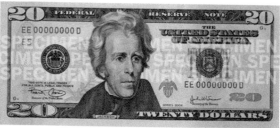

Figure 1-5 *The PDFs of the front (left) and back (right) of the redesigned bills are overprinted by the word "specimen," lack some of the details of a real bill, and are not to scale.*

Strike and Response

It would seem that the government has the currency problem in hand. Alas, these preventive measures barely slow down a reasonably savvy Photoshop user, let alone a dedicated counterfeiter. The Photoshop CS and CS2 blocks have a pathetically simple workaround. Open the file in ImageReady and then in Photoshop select Edit from the File menu (Figure 1-6). Photoshop docilely opens and lets you edit and save the file. Once you've done the save, Photoshop will open and print the file for you in the future without complaint (Figure 1-7).

By CS3, the program is no longer as trusting. If you want, you can open a currency file in Adobe Fireworks (starting with CS3, ImageReady is a dead issue) and print it. But if you try to print the file after you've saved it as a .psd in Fireworks, Photoshop will still recognize the banknote. Still, Photoshop CS3 will open and print a currency file that was previously saved in the CS or CS2 version of ImageReady.

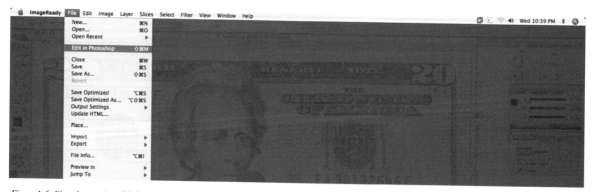

Figure 1-6 *Photoshop versions CS through CS3 don't examine content from ImageReady to see if it is currency.*

Figure 1-7 The scanned front of a $20 bill being printed from Photoshop CS3 (top) and the finished page printed on a color inkjet printer (bottom).

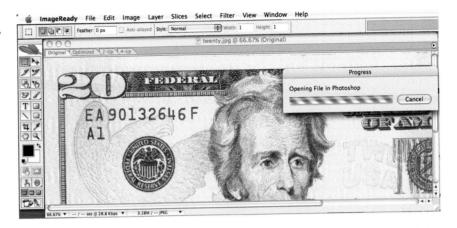

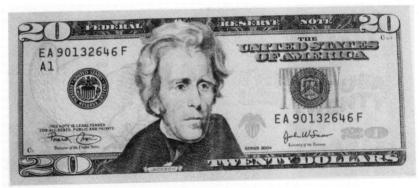

Small-time counterfeiters have moved to inkjet printers, both because of the blocking software and for the cheaper, more anonymous, and flexible output. Color copiers work on thermal technology, which limits the size, type, and characteristics of paper that can be fed through. Many inkjet printers optimized for graphic design can accept non-standard paper sizes and tolerate a wide range of paper types without jamming. The quality may not be good enough to pass muster at a bank, but it can be adequate to fool a high-school student on a part-time job or a cab driver from a foreign country.

Of course, for large runs of currency, there's still no substitute for a good printing press and a dedicated criminal mind. As recently as 2005, a British printing gang was caught with millions of dollars worth of counterfeit £10 and $100 bills. The quality of the banknotes was so high that they could easily have passed muster on the open market, complete with special inks and holograms.

The counterfeiters were caught only because they were having problems distributing such a large amount of currency. To do so, they had to find partners in Great Britain and the States. While looking for possible distributors, they talked to too many people. At the end of the line, they were infiltrated by undercover police and were also the target of a newspaper investigative team, which used a hidden digital camcorder to videotape a tour of the operations.

The Best Money Counterfeiter

Dealt a life full of bad cards, Alves dos Reis traded them in for a counterfeit life. Reis was the son of an undertaker whose bankruptcy prevented his son from entering a university. Penniless, Reis dropped out of engineering school at 20 to marry and fled to Angola to avoid being sent to the World War I trenches. Eight years later he came tantalizingly close to owning the Bank of Portugal.

Reis started his forgery career by granting himself a degree in engineering from an invented university. Relocated in the Portuguese colony of Angola, he landed a government job and began his research. He was looking for a loophole he could exploit to catapult himself into his wife's social level. He found a brilliant and devious solution by taking advantage of the lag between writing a check and covering it. As a result, he ended up the major stockholder of Transafrican Railways.

Rich and bold, Reis returned to Lisbon and tried to use a similar strategy to take control of another company. This time, he was thrown into jail for embezzling. Free on a technicality only two months later, he used the down time to plan the ultimate currency takedown.

In those days, Portugal didn't print its own money. It jobbed out the work to London. It created Angolan money, which was worth 10 percent less, by taking its banknotes and stamping the word "Angola" on them. Reis forged documents granting him authority to negotiate for banknote printing in London. Since he didn't have unique serial numbers, he just duplicated existing Portuguese sequences, explaining that the money was destined for Angola, so the duplication wouldn't matter.

When the 100 million escudos of banknotes arrived, Reis and his partners lost no time getting them into circulation in Portugal (Figure 1-8). Once again rich, he forged documents to get a license to open a new bank so he could more easily circulate his fakes. But even when officials became suspicious and examined his notes, they could find nothing wrong. After all, these were not just counterfeits...they were counterfeits made with the same plates used to print Portugal's real currency.

It took a year for authorities to realize that the banknotes did not have unique serial numbers and put an end to the scam and to Reis's living on the edge. When arrested, he was all of 28 years old.

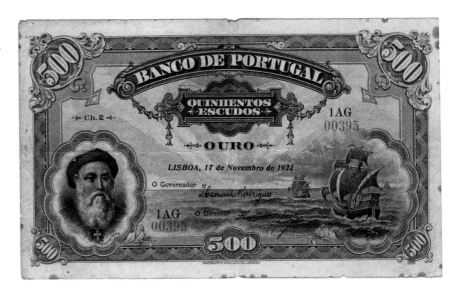

Figure 1-8 *One of the infamous 500 escudos forged banknotes. (Note provided by Mike Jowett, banknote collector, africanbanknotes.com.)*

"OF COURSE I'M 21. SEE MY CARD?"

Just as counterfeiting goes back to the first coin of the realm, so does the creation of a false identity. Throughout history, felons and freedom fighters alike have forged documents to avoid capture. Now that most countries need to know the true identify of their citizens and visitors, everyone is expected to carry something that verifies who they are, where they live, their age, their rights, and in many cases, their skills and affiliations.

To meet that need, many countries have a national ID card. The U.S. does not. Because many Americans believe that having a standard card could give the government too much power over individuals, it's never been developed.

For good or ill, this lack of a universally accepted card engenders a collection of plastic proofs. Drivers' licenses are *de facto* legal IDs, but there are 50 different types—one issued by each state. But not everyone drives, and there is some information that the government wants that a driver's license doesn't require. To cover different situations, there are visas, green cards, and Social Security cards, all essential for proving residency, tax status, and one's right to vote. Then there are IDs for special affiliations, like corporate IDs to enter company buildings. Student IDs get you into special events, give you access to on-campus discounts, and function as library cards.

All in all, the variety of needs offers unparalleled opportunity for forgers, from the 19-year-old student looking to buy beer to the street-corner criminal with a word-of-mouth clientele among illegal workers. Add to that mix the online fake ID companies, and you have quite an underground industry.

Although fake IDs are illegal to make and to use, it's surprisingly easy to find sources for one. A simple Google search brings dozens of sites (Figure 1-9) that promise fake

Figure 1-9 *Google is a helpful resource if you want to create a new identity document.*

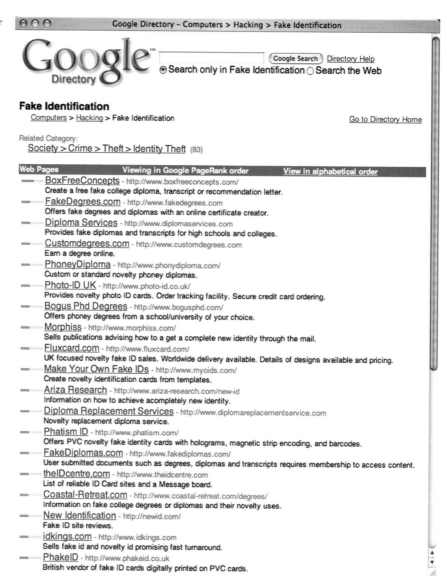

Figure 1-10 A list of fake ID sites.

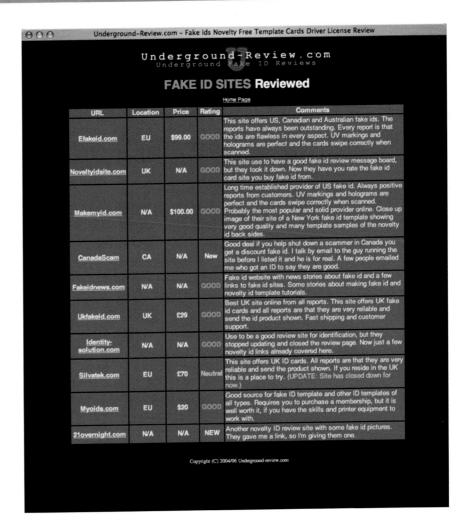

diplomas, replica drivers' licenses, and even a step-by-step process for reinventing yourself as someone new. To save you from getting taken if you need a new ID, there's a footnoted link from Wikipedia that takes you to a list of suggested sites (Figure 1-10). Most of these ID sites have a legal address outside the U.S., just in case someone official decides to pay a call.

A Novelty Idea

Yes, creating fake IDs is illegal in the U.S., but there is a loophole. Anyone can create artwork from scratch based on a real document, even an ID card. They can then advertise the cards as novelty IDs, with a disclaimer that warns customers of the penalties they'll face should they use these "toy" cards as real identity documents. These proliferating fakes are often very good and are one of the standard ways that underage drinkers get into bars.

But there are also many fake ID sites that are scams. Send them money, and they don't deliver, or they deliver something not quite good enough. That opens an opportunity for a more local source. On every college campus, there is at least one student, and often several, who has stepped in to close the gap for himself and his friends. By running a search on a peer-to-peer network, they can often find very good starter template files in .psd format (Figure 1-11). Then they need a good quality inkjet printer and a card laminator, both of which can be bought on the Internet or at any Staples store for less than $400. Add a basic digital camera and a blank wall for shooting ID snapshots, and you're in business.

Figure 1-11 A downloaded .psd template is the starting point for a Maine driver's license. This is a template for an outdated version of the license.

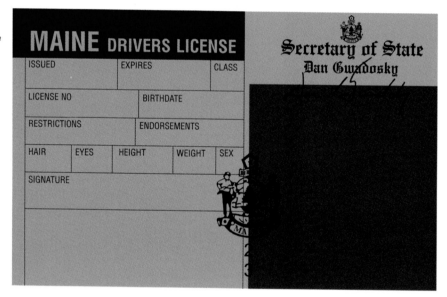

Worried about holograms? Even some of those can be faked with a stencil, light-sensitive paper, and a little interference silver or gold paint. All of these supplies are readily available at art supply stores.

Unlike currency, which is extremely complex and carries frighteningly serious penalties if discovered, fake IDs are often treated like a joke in the college community. If one doesn't pass muster at a club, the worst outcome is that the bouncer at the door confiscates the card and adds it to the growing collection. The student just finds a new source and tries again.

The Best of the Worst: Fake ID

Imposters have a special place in American folklore. Until the recent advent of mass ID fraud through computer files and the Internet, ID fraudsters were often seen as loveable outlaws, inheritors of Robin Hood's mantel. Even today, ID fraud is probably one of the most common illegal acts and a rite of passage for underage U.S. citizens.

The most famous identity faker of our age is probably Frank Abagnale, the inspiration for the hit Leonard DiCaprio movie Catch Me If You Can, *based on Abagnale's book of the same name. Before he was caught and turned over a new leaf as a security specialist, he held jobs and passed bad checks under dozens of false names.*

But the best and certainly most admirable fraudster of the old school was Frederick Emerson Peters. Born in 1885, he operated in a time when people tended to trust in the honesty of a smiling stranger. This particular stranger was charming and professorial. He criss-crossed the country for most of his life, impersonating a series of celebrities and passing bad checks in their names.

Peters' first arrest for forging bad checks came when he was barely 17, a shock to all since he was by all accounts a brilliant student from a good family. By 1924, already a veteran of the court system, he was sent to McNeil Island, a comparatively gentle penitentiary also known for housing the Bird Man of Alcatraz. While there, he took charge of the 15,000-volume library (Figure 1-12) and embarked on a full-time course of self-education. After his release in 1931, he parlayed this wealth of knowledge into a series of false identities— among others, an antiques expert, a book buyer for universities, a diplomat, a naval officer, and a government official.

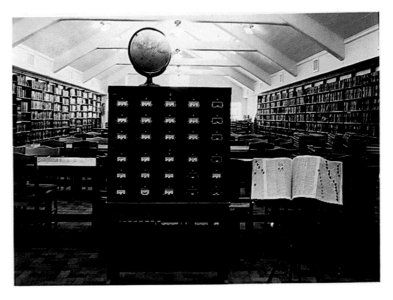

Figure 1-12 The library at McNeil Island Penitentiary, where Frederick Emerson Peters "home-schooled" while serving time.

Peters wrote thousands of forged checks, few of them larger than $100, and many of them made to antiquarian bookstores in the name of a famous author. Because each fraud was so comparatively small, some businesses would sometimes remember him fondly and frame his checks as souvenirs.

OFFICIAL BUT ANONYMOUS

Money and IDs are the most common forms of official documents with which citizens come in contact. But governments, companies, and other official, international agencies generate oceans of additional legal papers. There are diplomas, licenses, birth and death certificates, mortgage papers, wills, and writs. Any of these are possible targets for creative reproduction.

But the nicest potential forgeries are official documents on the Internet. No need to print them out and hand them to people who might recognize a fake—just make a copy of a real file and make some changes. The Internet is so large and so difficult to police that the fake almost never has repercussions. Goods are routinely shipped from post office box addresses, and money is transferred with the click of a mouse. Sometimes a very slick-looking Web space is a front for fraud. With a trusty stolen copy of Photoshop, a successful scam is only a tweak away.

HOODIA WANT?

You've tried the name-brand diet companies, and it's always the same—you're hungry and the weight comes back. Angie at work says that there's a pill: "A little pricey, but Oprah swears it works," and you can buy it online instead of being embarrassed at the drugstore. Now what was it called?

Food supplements can be an ideal Internet racket. They are mostly unregulated, unlike food and medicine. Their efficacy is almost completely anecdotal, so miraculous claims abound. Even with a useless product, the income stream can last for years without fear of prosecution.

One hot new supplement comes from a cactus called *hoodia gordonii* (Figure 1-13), long used by South Africa's San bushmen tribe to kill hunger pangs during times of famine. If it can do that so successfully for hungry children, imagine what a successful anti-obesity drug it might become! With some studies claiming that more than 50% of Americans over 20 are overweight, sales of a magic appetite suppressant would probably surpass those of erectile dysfunction drugs.

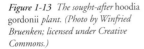

Figure 1-13 *The sought-after* hoodia gordonii *plant. (Photo by Winfried Bruenken; licensed under Creative Commons.)*

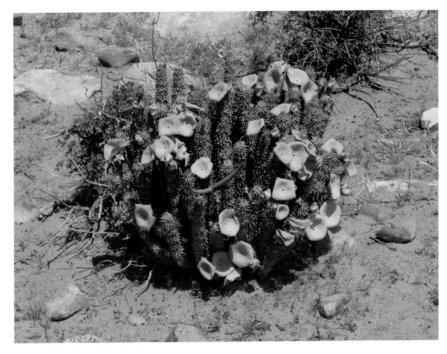

Unilever, owner since 2000 of the Slim-Fast line of diet products, bought the rights to develop the *hoodia* extract in 2004 and plans to build vast *hoodia* farms should the plant's promise play out in trials. In the meantime, *hoodia gordonii* is sufficiently rare that a permit from the Convention on International Trade in Endangered Species of Wild Fauna and Flora (CITES) is required to export it.

Usually, when an item is both sought after and rare, it's hard to find and very expensive. Yet a quick tour through Google turns up hundreds of devotees singing hoodia's praise in blogs and offering testimonials on diet and health Web sites. How are all these people getting their hands on this prickly cactus?

Well, most of them aren't. Their capsules are filled with a bad cook's leftovers, ranging from *hoodia*-but-not-*gordonii* (any non-poisonous cactus from the general vicinity) to an assortment of organic fillers. Unless someone bothers to spend hundreds of dollars checking the capsules' contents and then track the scam companies to their lair, the scam continues.

As someone without lab training, let alone a doctorate in chemistry, how can you tell the real from the fake? You certainly can't do it from the Web site. Some of the most nefarious sites have official-looking seals, sophisticated animations and videos, and quotes from reputable media. But the seals are faked, the quotes that lend credibility were lifted from other sources, and anyone can buy the services of a decent animator.

The one thing that separates the devils from the angels is a CITES export document to prove that the *hoodia gordonii* plant was legally imported. It must be signed, stamped, and prominently displayed, or the *hoodia* has to be fake. Sites without the CITES document are pure scam. But the majority of sites seem to have a link to this document somewhere. Are they all real?

It's time for the forensics team to step in. And this time, you're included.

The Case File: The CITES Document

How can you tell you have a fake? If we can find a real document, that's a good place to start. Two logical clues can help. First, is there something about the document that would be difficult to duplicate in a fake? Second, has the company gone to any lengths to prevent the document's reuse?

A genuine CITES document should display the name of the importer, the permit's export expiration date, the exporter, and the weight of the exported product. Since selling *hoodia* is a cutthroat business, some legitimate sellers choose to keep their exporting source confidential.

The company whose CITES document appears in Figure 1-14 has legal text that bleeds through from back to front. The bleed-through is a detail that confirms that this file was scanned directly from an original, two-sided permit. The certification in Figure 1-14 is overprinted with the name of the importer (in the upper left box). They've made an attempt to protect their certificate from appropriation.

As is clear from the edits done by the importer to protect the export information, when you edit a file with bleed-though, the edit is obvious. A sloppy scammer may copy any file, but one that hopes to bilk the public for a few months or longer may prefer to use Photoshop to adapt one of these good legal documents instead. That way, an investigator would have to trace the goods back to another country, spending money and time. Even the most dedicated do-gooders would hesitate. So to adapt this document, a scam artist would need to eliminate the text bleed-through. Photoshop offers a simple and effective way of doing that on a black-and-white document through the Levels tool (Figure 1-15).

The example in Figure 1-14 would be only a little more difficult, because it's an RGB file with a color overlay. The Levels trick wouldn't work here. However, there are plug-ins for Photoshop that can eliminate unwanted elements from an image if they are a consistent color. (In Chapter 2, you'll see how this trait can be used for police forensics.)

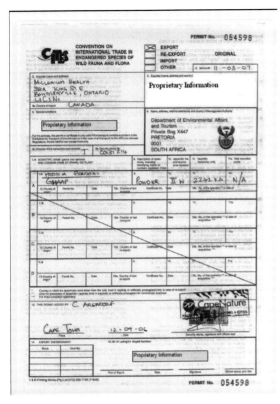

Figure 1-14 These CITES forms from South Africa appear to be scans from original documents.

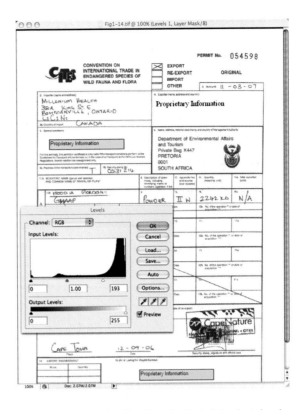

Figure 1-15 By moving the white point to the right in the Levels window, the document brightens, and the shades of grey (including all the bleed-through text) disappear. Note that you also thin and lighten the lines of the form.

Once there's a usable file on tap, it's anyone's game. The majority of *hoodia* documents on the Web show signs of multiple edits.

Besides possibly being tampered with before scanning, the file depicted in Figure 1-16 shows signs of multiple stages of editing:

1. The top segment, which often has identifying box counts and exporter information, has been cut out. Because it's the cleanest part of the file, this is probably the most recent alteration.

2. All logos and artwork are filled in. This happens most frequently with repeated resampling and resizing of the file.

3. The identifying importer and exporter names have been thoroughly deleted.

4. The lines on the form around the edges have been redrawn to try to fill in lost information.

5. The file has been saved so many times as a JPG that even the solid color areas are developing artifacts. The areas around the type are particularly bad.

Figure 1-16 *This file shows signs of multiple stages of editing.*

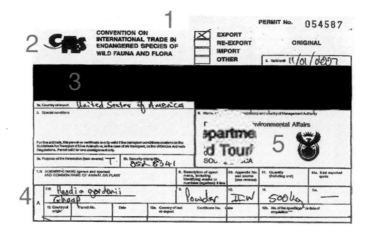

As each new scammer picks up a JPG file from another's site, he has to adapt it to fit his layout. Resaving at a lower resolution is one standard strategy. Others change the files to GIF, which is a good way to hold on to type and handwritten text but is pretty hard on screened graphics and stamps. Soon enough, someone else changes the file back to JPG for his site. Problem is, JPG files are lossy. That means that each time a JPG file is edited and resaved as a JPG, it loses more details. Later generations of the saved file will be smaller and will begin to pick up distortions called artifacts.

The CITES documents shown in Figure 1-17 all started from the same source file. Once compromised, the file has been copied and used numerous times. Each generation is worse than the previous one, and in each the file size is smaller as well.

Figure 1-17 *CITES documents from the same source. The figure on the left is closer to the original.*

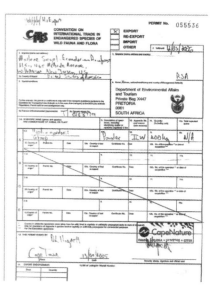

The version in Figure 1-18 is even further away from the original than the documents in Figure 1-17. Note that in this version the contrast has been increased to try to deal with the degraded quality of the file. This file has been edited for content as well. In this case, a numeral "1" has been added to make the quantity imported look larger.

The most insidious changes are done by the original owners of the CITES documents. *Hoodia* is expensive, but all you need is one import document from one real *hoodia* purchase, and you're in business. Almost no one looks at the date, although it's one of the most important pieces of information. A posted CITES document should show a date within six months of the current date. Anything older implies that the company is no longer importing real *hoodia*.

Dates on a CITES document from South Africa (Figure 1-19) are written in the European fashion, with the first number being the day, the second being the month.

Last, but definitely not least, mistrust a file that is too small to read. If you think that perhaps they're hiding something, you're probably right. The form shown in Figure 1-20 could belong to anything or anyone.

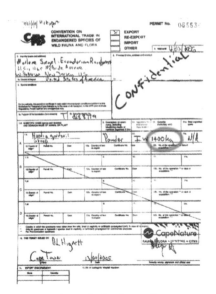

Figure 1-18 Contrast has been increased in an attempt to overcome the file degradation.

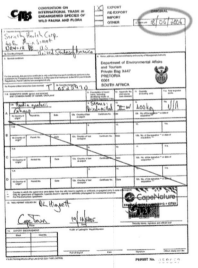

Figure 1-19 This document indicates that the certificate was valid only until June 18, 2006.

Figure 1-20 This file is the usual size of a thumbnail but is the only CITES document on the site.

The Best Official Document Forger

The saying goes, "History is written by the winners." It's also true that a cleverly written history can create the winners, although not necessarily exactly as planned.

The early ninth century was not exactly a heyday for the separation of church and state. But unlike the modern era in Europe when constitutions limit organized religion, the problem tilted in the other direction. Popes treated celibacy as an inconvenient fiction, investing their children in lucrative positions and keeping a rotating stable of mistresses.

In this ugly atmosphere, a group of learned theologians created a fictitious master theologian, Isidore Mercator. In his name as collector and editor, they secretly forged an impressive body of letters credited to revered popes from centuries before (Figure 1-21). The motive was to make it more difficult for the secular powers behind the Popes to arbitrarily replace or exile archbishops who tried to adhere to canonical law.

Figure 1-21 *Ninth-century illuminated manuscript.*

Because the letters wove scores of real material into the invented work, they were readily accepted when "discovered" over time. In an example of unintended consequences, the papers were used in the twelfth century to bolster the power of the papacy and create the strong executive Pope who presides over the modern Catholic Church.

It wasn't until hundreds of years later that researchers realized that the letters, now known collectively as the Pseudo-Isidorian Decretals, referred to texts that didn't yet exist when they were supposedly written. The fraud was finally exposed, but so long after its commission that it was unquestionably the most authoritative and successful fake document ever created.

FAKE DRUG PACKAGING: MURDER BY MOUSE

Hoodia fakers and other food supplement cheats may be ripping off their clientele, but they can claim that their deceit does little more than relieve the gullible of excess cash. But this reasoning can't justify the lowest form of counterfeiting: fake drugs and fake packaging (see Figure 1-22).

Figure 1-22 This comparison comes from the FDA. The bottom package bears all the warning signs of a fake. The typefaces and logo are different. The colors don't match, probably because the real package ink is a mixed color. The packaging is bent, and the plastic wrapping is damaged.

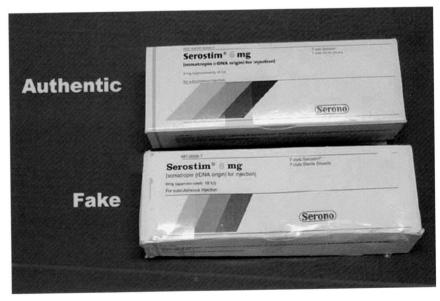

Fake medicine can kill. In the spring of 2007, the *New York Times* followed the trail of the substitution of glycerin—a neutral, sweet syrup added to cough medicines— for a poison called diethylene glycol, known best in the United States as antifreeze. Untold patients in third-world countries were killed or permanently damaged by this substitution.

But fake packaging can kill as well. Altered lot numbers or expiration dates on packaging can result in failure to deliver the active ingredients for cures or treatments or delivery of the wrong dosages. Fakes can be used to repackage one type of drug as something completely different.

Ten Ways to Recognize a Fake Drug Package

Anyone can buy the equipment needed to make a pill or capsule or contract with a company in the U.S. or abroad to do the manufacturing for them. Packaging is even easier. The forgers don't even need the real packaging if someone sends them the basic dimensions and a JPG to use as a template. But makers of fake packaging often cut corners to keep costs down. You can use your powers of observation to recognize the telltale signs of a forgery.

The following hints should help. To take the most advantage of them, save the packaging and at least one dose of a drug you are certain is real for future comparison before you buy online.

1. Don't buy from companies that promise an amazingly cheap price, particularly for an in-demand drug like Viagra or Lipitor.

2. Don't buy from companies that send you unsolicited e-mail.

3. Check the new packaging before you use the drug. Is the package sealed? Is the seal broken?

4. Compare old and new packaging. Is the new packaging the same size and shape? Is the design the same, and is the printing in the same typeface and the same color? Logos, in particular, should be identical (refer to Figure 1-22).

5. Be wary if the new packaging is printed on cardboard or paper that is thinner or less substantial than the old material.

6. If the old packaging has raised or indented lettering or color-shifting ink, so should the new.

7. Are there holograms on your old drug, either on the package or on a blister pack? If so, don't trust even the most professional-looking packaging that comes to you without them.

8. Check for the expiration date. All drug packaging has one. Has a label been placed over the original? Many counterfeiters buy real but old drugs and resell them as new.

9. If your drug comes in a sealed bottle, check for stickiness on the container. Labels can be switched, but the process may leave a residue on the bottle.

10. Compare the pills or capsules themselves. Are they the same as the old ones? Unless you have changed from name-brand to a generic, they should be identical in color, size, and shape.

Paying for What You Get

Both fake medicine and fake medical packaging are delivered through fake prescription Web sites, which far outnumber the legitimate ones. Few companies have been granted the National Association of Boards of Pharmacy (NABP) accredited label of Verified Internet Pharmacy Practice Site (VIPPS), which approves the sale of pharmaceutical drugs online. This approval indicates that the pharmacy is licensed and inspected and adheres to the same standards required of brick-and-mortar pharmacies. As of this writing, there are only seven companies that pass muster. Each has a VIPPS logo that links directly to the verification site, http://vips.nabp.net/verify.app (Figure 1-23).

Figure 1-23 If you click the VIPPS logo on this site, it links to the NABP verification page.

As for the sketchy sites, some of them simply ignore the logo issue, counting on buyer ignorance. Others just steal the logo from a legitimate site (like the previous CITES documents) and use a URL that looks like the correct one but links to nothing (Figure 1-24). If people click on the link, they get an error message. Most assume that there's a browser or connection problem, not that the error is deliberate.

Figure 1-24 This page's VIPPS logo is a fraud. The site is not authorized by NABP, and clicking on the link brings up a standard browser error message.

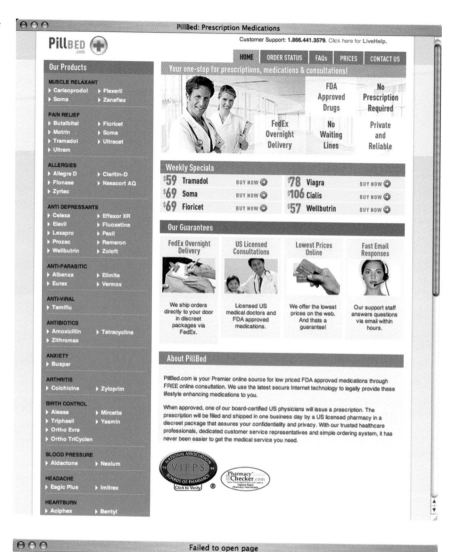

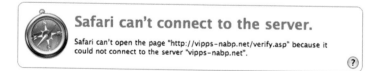

In short, Photoshop, particularly when combined with an online presence, can put document forgery, counterfeiting, and scamming within easy reach. No longer does a forger have to have remarkable talent, steely nerves, or the ability to keep eye contact while vacuuming your wallet. But this is only the beginning. With a little larcenous imagination, you can twist the legal system, too.

CHAPTER 2

ADMISSIBLE IN COURT

FORGERY HAS CHANGED with available technology, as have the tools to prevent and detect it. But all the detection is worthless unless you can convince a judge and jury that you've caught a criminal in the act. Therefore, the standards for admitting information as court evidence change fluidly with technology as well. Because the stakes can be so high, new technologies are not embraced overnight.

Polygraph (lie detector) results, for example, have been a source of disagreement since the technology's first use in the 1920s. Lately, the Supreme Court ruled that there was insufficient scientific consensus on the reliability of the polygraph. DNA testing is another technology that has had its day in court, although the consensus of its reliability has made enormous strides since it was questioned in the O.J. Simpson case in 1995. Unlike the polygraph, DNA testing is easy to connect to more traditional evidence tests, like fingerprint analysis or identification of blood types. All are tangible materials from the actual crime scene.

With all this new forensic technology, it's easy to forget that photography has only a slightly longer track record than these other technologies. Now that analog cameras are following the 8-track tape to landfills, digital photography and image enhancement are bringing new controversies to the courts.

PHOTOGRAPHY, PSYCHOLOGY, AND REALITY

Photography is usually treated as physical evidence, yet physical evidence can be examined and experienced objectively. Many photographs cannot. The dirty secret is that photographs are often more like testimony. They can tell the truth and lie at the same time.

We experience images as personal reality, which gives them enormous emotional credibility. We can feel the visual punch of a scene in a photo, on video, or on TV hundreds of miles and years away. People who experienced the collapse of the World Trade Center on television know how completely the event overwhelmed the physical space they were in as they watched.

Fair's the Objective

Understanding the psychological issues, many judges won't accept photographic evidence, even when it is relevant and unbiased, unless it is uniquely important to the case. By that definition, the information in the photographic evidence has to show or connect information that could not be conveyed any other way, and that is crucial to determining the outcome of the case.

For example, what if there are graphic autopsy pictures of a murder victim? Doesn't it make more sense to admit them as evidence rather than expecting a jury to read a description of the victim's injuries? A study done in 1997 suggests strongly that jurors who view such inflammatory evidence are more likely to convict, even if there is nothing in the pictures to connect the defendant to the murder. It's the ultimate guilt by association. Even worse, the mock jurors in the study genuinely believed that they were unaffected by the pictures and were still able to render a fair verdict.

Even if the scene and subject are not inflammatory, the photographer can have a potent effect. Variations in technique—like shooting angle, lens, and exposure—can subtly affect the viewer's opinion (see the "Group Psychology" sidebar). In fact, the worst crime photographer is an artistic one. A creative photographer can hardly help going for the best possible shot, rather than one that may be flat but accurate.

An experienced police evidence photographer should be able to ensure that crime scene shots are neutral and of good quality. Evidence photographers are aware of how easily important evidence can be erased, altered, or disturbed. They're trained to pay

attention to details and to document carefully. Unfortunately, very few people are professionally trained for this specialty. For example, there are only two licensed evidence photographers in the entire state of Massachusetts and fewer than 30 in California.

Group Psychology

The setting depicted here has been shot in a variety of different ways to illustrate why crime scene photography is both a skill and a narrative art.

Imagine that one man is accusing another of theft and assault. The second man, the defendant, says that the first not only started the fight, he hid on a fire escape and jumped him and then framed him for the robbery. The crime scene photo is important because one of the questions in the case is whether the fire escape actually provided a reasonable place to hide and launch an assault.

Figures 2-1 through 2-4 show photos of the alley where the alleged assault took place. You are the lawyer for the prosecution, and you have the opportunity to select an image to enter as evidence of the crime scene. Which of these images will you choose, and why? You can bet that the defense lawyer would select differently, given the same group of options.

Bear in mind that the different tones and impressions from these photos are purely the result of how they were photographed. None of these images have been altered in Photoshop…yet!

Figure 2-1 This artistic shot subtly emphasizes the narrowness of the alley and the sense of it as private and closed off.

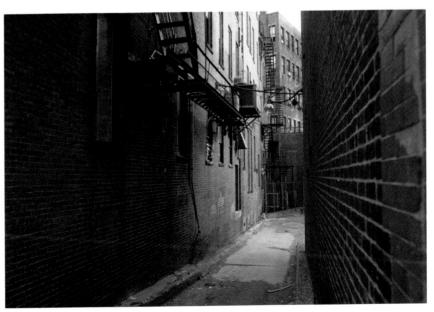

Figure 2-2 This shot is subtly off. Shot from a low angle, the fire escape seems to be very high. The alley itself seems wider and longer.

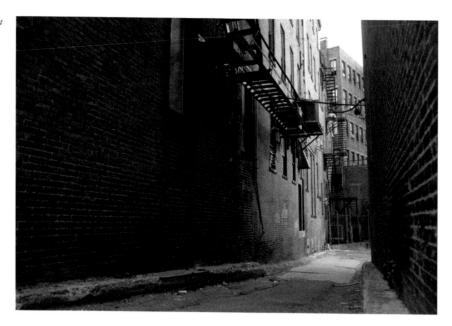

Figure 2-3 This is an inflammatory shot. It gives the impression of vertigo and a looming presence.

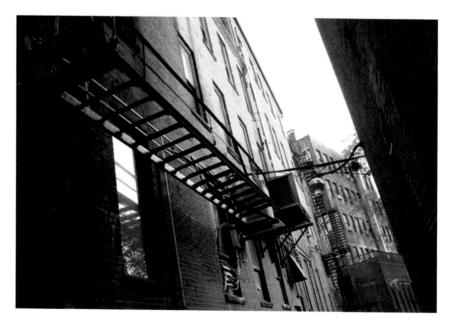

Figure 2-4 *Including a person in the shot helps establish a sense of scale. This shot compresses the length of the alley, giving the impression that it's open and safe to walk through.*

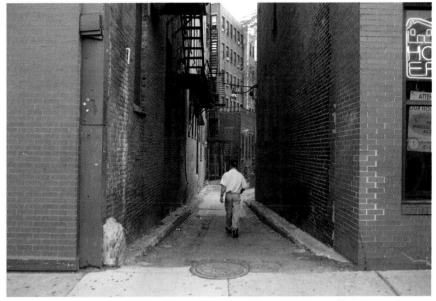

Figure 2-4 *Including a person in the shot helps establish a sense of scale. This shot compresses the length of the alley, giving the impression that it's open and safe to walk through.*

Is Image Editing Fair?

Being objective is only half the battle. Crime scenes are seldom set up for a good picture. Maybe you have to shoot toward an open window at noon. There may be fingerprints on walls or furniture that must be captured effectively and quickly, because the owners want their home cleaned, and fast.

If your assignment is a traffic accident at night, you'll be contending with headlights blazing past. Night shots in particular are difficult, yet night is the time when most crimes or suspicious fires take place (Figure 2-5). These are conditions when a flash is useless, and there may be no time or place to set up a tripod.

All of these less-than-ideal situations require image repair. You might need to increase the contrast or fix a color cast from fluorescent lights. In the days before digital photography, you needed special skills to even consider making changes. Today, you can fix many image adjustment problems in less than five minutes, as Figure 2-6 indicates.

Once you're editing, it's tempting to make a few more changes. There's a billboard about neighborhood policing at a gang shootout. People looking at the photo might see that detail and react unfairly to it. Should you crop it out? The wrong decision could lead to a miscarriage of justice and a retrial. With digital editing comes the need to know when an image has been created, how it was altered, and why.

Figure 2-5 *This is an unedited night shot at a suspicious fire.*

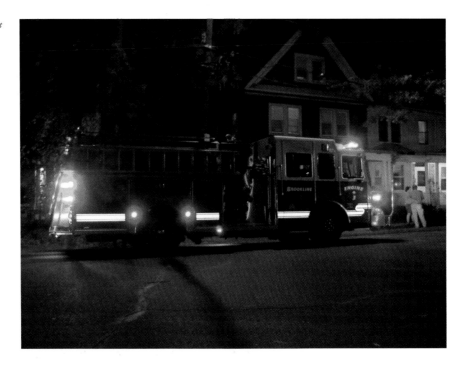

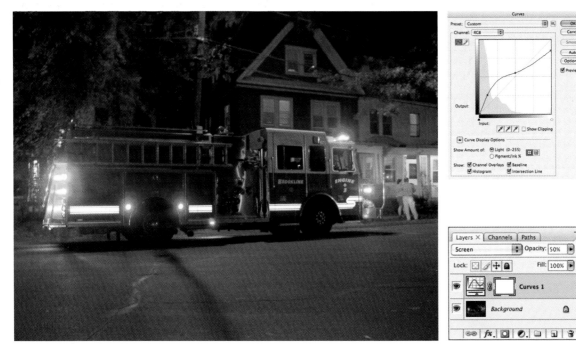

Figure 2-6 *This photo now shows more detail without actually changing the information contained in the image. A Curves adjustment layer is applied and then blended at a transparency of 50% with the Screen blend mode.*

Creating a Digital Process

The first step to making digital photography admissible as evidence is to create good procedures for moving a digital photo from the camera to the court. This requires a standard operating procedure (SOP), something every good police force ought to have. The SOP should include a way to document and store the image state immediately after it's transferred from the camera. The simplest way is to have one person designated to handle all storage cards, rather than having each police photographer handle his own. The designated person should burn the files directly to a CD or DVD and store them securely.

The second step is to hand over the image processing to someone who doesn't take the photos. A police district with a big budget can buy a professional photo-processing machine that automatically repairs the most frequent image defects with no human input or decisions. In addition, there are several competing software packages for secure asset management of photos. They protect privacy and ensure accountability by maintaining an audit trail of everyone who views or opens the image files.

A Famous Injustice

The most famous examples of questionable evidence prove how important it is to insist on good procedures and careful handling, especially when emotions about a case are high.

Emotions were never higher than in 1919, when two armed robberies took place in Massachusetts. In the first, two men unsuccessfully tried to hold up a payroll truck. In the second, four months later but with a similar MO, two guards were killed in a successful heist.

A few days later, Nicola Sacco and Bartolomeo Vanzetti, Italian immigrants and political radicals, fell into a trap laid for the robbers. They were both carrying guns, and they lied to the police to protect friends and political associates. They were arrested and charged (Figure 2-7).

This was a time of great fear in the United States. Communist revolutionaries had violently overthrown the czar in Russia. The trauma of WWI was still fresh. Americans were afraid that Europe's insanity was being imported by the waves of immigrants washing ashore. In this atmosphere, the two anarchists were very convenient defendants.

Vanzetti alone was charged with the first robbery, because Sacco had proof that he was at work at the time. Although dozens of people testified that Vanzetti had been selling fish on the street that day and could not have been at the crime scene, other witnesses were convinced to change their original testimony to bolster the prosecution's case. Vanzetti was convicted and given the maximum sentence.

Figure 2-7 Bartolomeo Vanzetti and Nicola Sacco, in handcuffs, soon after their arrest.

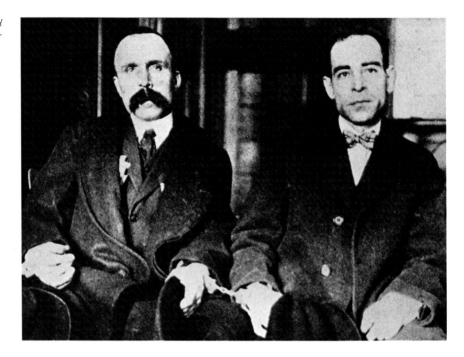

Then came the main event: the murder trial. Judge Webster Thayer made his position clear—it didn't matter if they'd actually committed these crimes. They were a danger to society and deserved to hang. In such a charged atmosphere, evidence was a means to an end. One "expert" witness tried to swap gun barrels while in court to make it possible to connect Sacco's gun with the crime. Others swore that bullets found in Sacco's pockets matched the murder weapon, despite there being serious doubt of any link. A cap was left behind by one of the robbers at the scene. It was too small to stay on Sacco's head, but the prosecution claimed it was his.

The appeals process went on for years, as cooler heads felt that the two had not received a fair trial. But ultimately the appeals were denied, and both men were executed in 1927.

To this day, arguments persist. A pair of gangsters claimed to have done the heists. More inconclusive ballistic tests were done decades later. Were Sacco and Vanzetti guilty? We'll probably never know. But if they were, their verdict is so tainted that it echoes in our courts, in our handling of evidence, and in our reactions to political trials, to this day.

Now You Don't See It...

Once you can be sure that the evidence for a case has been collected, shot, and treated well, you've got to figure out what it tells you. Sometimes that's simple: lots of clear prints, a smoking gun, or terrific crime-scene photos that tell the story and make the case. Other times, the information is right under our noses in the evidence pictures, but we lack the ability to see it. Unlike in the movies, fingerprints are seldom conveniently marked in blood on a white wall. They're probably partial prints on a paper bag.

Human beings were given limited imaging tools. Our eyes and minds are simply incapable of processing all the information a photograph can provide, and we need help. This is not an easy admission. The most basic challenge for digitally edited evidence is visceral. You look at the "real" pictures, and you don't see anything. You look at the "enhanced" pictures, and suddenly everything is obvious. Someone must be faking to get a conviction.

It will take many more court cases and decisions before assumptions change, but in fact, we are on the verge of a golden age of visual evidence. We're finally reaching the point where developers have turned their minds to some of crime's most difficult and frustrating puzzles and have created software, from large applications to small, focused plug-ins, to let us see better.

Now You Do

One of the most successful intersections of programming, imaging, and crime is in pattern removal. Imagine there's a footprint in some dust on a wood floor or a fingerprint on a striped chair. You take a picture, but there's so much visual information behind the print that it's hard to identify. Wouldn't it be a blessing to have that background disappear? With good pattern recognition software, that's exactly what you can do.

The magic behind fingerprint forensics is a powerful algorithm called Fast Fourier Transform (FFT). The math is far beyond the scope of this book, but the concept is fairly simple. Light and sound travel as waves. If they aren't just noise, then they have a pattern. Identify the specific pattern, and you can neutralize it. Whatever is left is the unique information you're looking for. FFT is used in noise-canceling headphones. It's also the math behind the feature that helps eliminate moiré (the rosette patterns from four-color printing) when you scan a picture from a book or magazine.

There is a growing number of commercial software programs for enhancing finger-prints and other forensic details, such as Foray's More Hits and Ocean System's ClearID (www.oceansystems.com/dtective/clearid/), both of which are part of much larger forensic image suites. Unfortunately, these programs run only on Windows computers. If you are an amateur forensics buff with a Mac, you'll need an Intel dual-core computer running a Windows version of Photoshop CS2 or better to get the benefit of FFT.

Here's how ClearID's Pattern Detector helps to separate an image from a distracting background. In this case, we have a fingerprint on a busy, patterned background (Figure 2-8).

In Figure 2-9, we see how the pattern detector separates image from background. The sliders in the filter window allow you to fine tune the relationship between the back-ground and the print, so you can avoid erasing important visual information by mis-take. The Power Spectrum image in the upper right is a visualization of the pattern frequency. The red dots represent the repeating pattern.

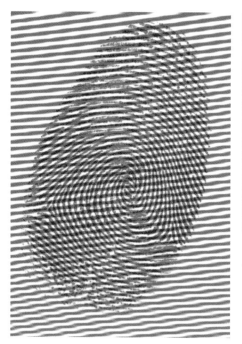

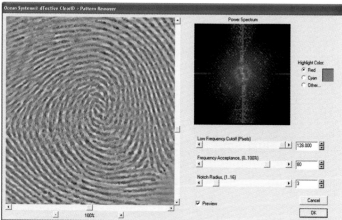

Figure 2-9 *Too few dots and you can't separate the pattern from the fingerprint; too many and you begin to eliminate not just the pattern, but the fingerprint data.*

Figure 2-8 *This background interferes with our ability to identify ridges and whorls.*

The last slider, seen in Figure 2-10, visualizes the red dots getting larger or smaller, making it easier to understand and become more confident in your adjustments. When you're ready, the script puts the result on a separate layer so you can see each change individually. Once you've eliminated most of the distracting background, you can use other filters in the ClearID suite to improve contrast and make the ridges clearer, as seen in Figure 2-11.

Figure 2-10 *When you hit the sweet spot, most of the pattern is masked out.*

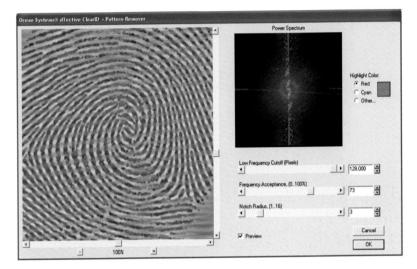

Figure 2-11 *Here, the Color Safe Curves filter is applied.*

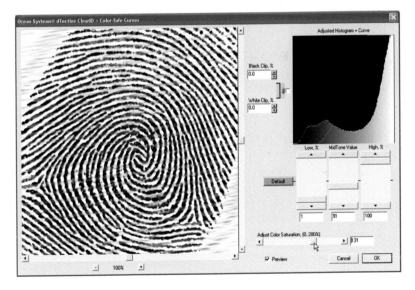

In this case, the final touch is a regular Photoshop feature. By applying a Channel Mixer adjustment level, you can turn the Red output channel to monochrome (Figure 2-12, left), eliminating most of the remaining background. The end result (Figure 2-12, right) is a fingerprint clear enough for an identification to be made.

Figure 2-12 Making the Red channel monochrome turns color noise into less-distracting light grey.

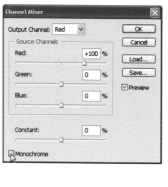

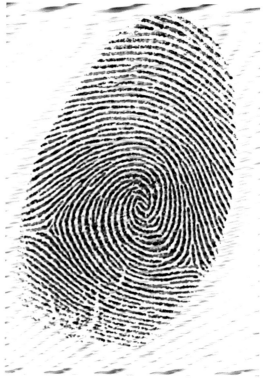

An Ink of a Different Color

Pattern removal is an important tool, but it isn't the only one in the arsenal. Another example of how image enhancement can clarify otherwise obscure evidence is when two or more different types of printed information overlap each other. People write over information in ledgers, in wills, and on checks. They alter documents after the fact. Sometimes there's a clear change. In other cases, the work is much more subtle. How can an investigator tell what was the original text or whether a change has even been made?

One tool that can help answer that question is an inexpensive Photoshop plug-in called Color Deconvolution (www.4n6site.com). Deconvolution is the untwisting or separating of two things that are deeply intertwined. This plug-in does just that to separate two overlapping color sources from one another. It takes advantage of the most

important theme of image forensics: The computer can see what a human can't tell is there. In this case, two colors that we may see as being exactly the same may actually be quite different in their balance of red, green, and blue.

Take, for example, an old postcard that holds clues to a family secret (Figure 2-13). The postcard was written in black ink but was then cancelled, and much of the writing was obscured. Since the writing is also black, in old-fashioned script and an unfamiliar language, it isn't possible to guess what might be missing.

Figure 2-13 *This postcard hides its secrets well.*

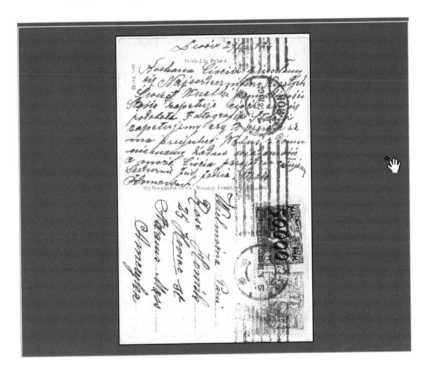

In the Color Deconvolution dialog box, you define the undesired color by selecting a sample of it (Figure 2-14). You repeat this process to define the desired color, which would be a sample of the text. Last, you define the background color, in this case, the light yellow in the postcard background.

Looking at the dialog box, you see two shades of black in the desired and undesired color boxes. But this filter sees these two grays as comprising distinctly different color combinations. When you select Remove, it makes pixels in the undesired color range invisible. When you press Preview, you can see the results, making it easy to make out the writing underneath (Figure 2-15).

Figure 2-14 The "undesired color" is selected from the postal cancellation.

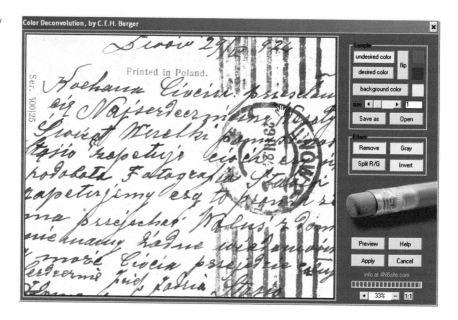

Figure 2-15 Preview lets you see your results. If they're not perfect, you can select a different sample and preview again.

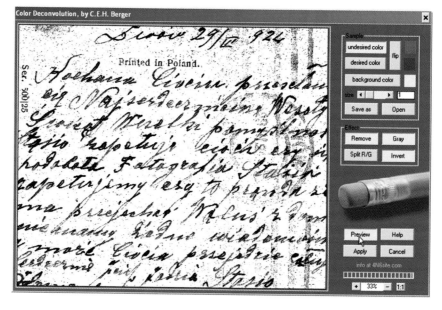

In addition, Color Deconvolution gives you several options for viewing the sample after processing (Figure 2-16), since each combination of colors and background lends itself to different effects for readability.

Figure 2-16 The original address list on the left is viewed from left to right in Gray, Split R/G, and Invert modes.

NAME	DASHIELL HAMMOND	PHONE	603 2019898
ADDRESS	35 BLACKBIRD LANE		
	CHICAGO, ILL		
NAME	████████████	PHONE	████████████
ADDRESS	████████████		
	████████████		
NAME	ANTONIO BANDARIOS	PHONE	781 609 1414
ADDRESS	35 RUSSAN ROAD ← SPEAKER (WIFE)		
	BOOTS, MA		
NAME		PHONE	
ADDRESS			

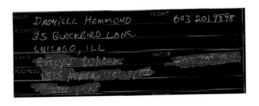

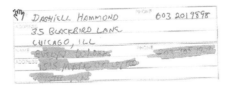

These tools are just a few that are challenging the courts to accept digital image evidence. Each is making it easier to match up criminals and their crimes. In some situations, they are helping judges to set precedents and write new case law that will affect future use of evidence. One of the most high-profile examples was a Connecticut murder case that went from ice cold to arrest and conviction entirely because of new imaging techniques (see the sidebar, "Bites and Megabytes").

The Case File: Bites and Megabytes

In every era, authorities have ignored or overlooked evidence that might free an innocent suspect. Suspects, in turn, have tried to turn the tables by casting doubt on the authority's materials and methods. Whenever a new technology appears in court, one side or the other is bound to claim that it's fatally flawed.

Judges have reason to be conservative about new technologies—it's terrible to convict an innocent. But it's just as damaging to leave a killer on the loose. In the case of Connecticut v. Swinton, technology finally caught up with the evidence.

In 1991, 28-year-old Carla Terry was found wrapped in a plastic garbage bag in a snow bank on a lonely side road in Connecticut. There were bruises on her neck indicating that she had been strangled and bite marks on her breast. Since bite marks tend to heal quickly on a living person if their skin isn't broken, their appearance on the victim indicated that they had been inflicted just prior to her death.

Alfred Swinton had been at the same bar as Terry that fateful night, and the police had reason to suspect him. They brought him in and made a plaster mold of his teeth. Unfortunately, bite marks are often very hard to connect to a specific set of teeth, and these did not appear complete enough to make the match. Despite some circumstantial evidence and some incriminating statements by Swinton, there was insufficient evidence for a conviction. Years went by, and the case went cold.

In 1998 came the thaw. Barbara Williams brought Lucis Pro (www.imagecontent.com), her new imaging software product, to the attention of Dr. Constantine Karazulas, odontologist for Connecticut's State Police Forensic Science Lab. She was certain it had a place in image forensics.

One of the problems with identifying bitemarks or other crime details is that the camera is much better at capturing contrast than the human eye is at interpreting it. Lucis sidles around this limit by translating the information into a range of differences that humans can comprehend.

Karazulas realized immediately that this was the tool that could finally crack the Terry case. By bringing the original autopsy photos into the computer, he could finally make the identification that had been missing for years.

Swinton was finally brought to trial and convicted on the new interpretation of the bitemark evidence. His lawyer challenged the admissibility of the digitally enhanced photographs. In a landmark decision, the appeals court accepted the admissibility of the digital images by determining that they met the gold standard of being a reliable procedure that enhanced reality without altering it. The ruling set a precedent for accepting digital imagery in the courtroom. The Lucis/Photoshop combination was validated, and Swinton is serving his 60-year sentence.

Prior to the Lucis software, it was so difficult to be certain of a match through established forensic practice, which involved tracing the bitemarks—a process grossly open to interpretation—that Karazulas had only felt confident enough to testify for the prosecution in 10 prior cases in his 40 years at the Forensic Science Lab. Since this groundbreaking ruling in 2004, Dr. Karazulas has brought the combination of Photoshop and Lucis together to help solve several other criminal cases, ranging from murder to child abuse.

Deconstructing Swinton/Terry

The work of a forensic odontologist is painstaking and detailed. As Karazulas stresses, it is less the work of investigation than it is corroboration. By analyzing bitemark evidence, his role is to confirm or deny the suspect's identity.

First, the crime lab takes dental impressions, from which they make plaster casts of the top and bottom sets of a suspect's teeth. The forensics investigator puts these casts on a flatbed scanner, oriented properly to identify right and left sides. A ruler is included with the casts to ensure scale and orientation (Figure 2-17). Next, the investigator scans or uploads the original photographs of the victim into the computer (Figure 2-18).

Figure 2-17 These dental impressions are the original Swinton plaster casts.

Figure 2-18 These pictures also include a ruler and an identifying number. If necessary, the two images are lined up in Photoshop so the rulers are exactly the same. The investigator then opens the bitemark image file in Lucis.

Lucis works by dividing contrast levels into finer categories and then enhancing the differences using two sliders. The first, called the large cursor, increases contrast. The second small cursor is used after the large cursor has found a good, sharp contrast. It eliminates small contrast variations that can confuse the human eye.

In a color image, the software can adjust the contrast of each color channel individually, without distorting the image information. In effect, it allows you to find missing information by expanding the gray scale in the area you define as critical and compressing it in areas that are currently obscuring that information. Shadows can be neutralized while bringing details that were invisible to the naked eye into bold relief.

In Figure 2-19, you can see the process in action through four different settings. Moving from left to right, the first two settings show increasing levels of contrast throughout the image. The third setting shows the effect of the small cursor in smoothing out small details and maintaining large contrast differences. However, the setting goes too far, eliminating some of the more subtle bruise lines as well. The last setting captures the best combination of large contrast and minimizes some of the small contrast variations. The comparison between the original file and the Lucis-processed one (Figure 2-20) is striking.

Figure 2-19 The last setting captures the best range for the bitemark contrast.

We save the file and open it in Photoshop, along with the file with the scanned plaster casts. The two files are matched to size using the rulers in each image. As seen in Figure 2-21 on the left, the files of the plaster casts are brought to a transparency level of 30%, so the teeth are clearly visible, but the Lucis-enhanced image will be able to show through. When the semitransparent top and bottom molds are lined up with the bruises from the Lucis-enhanced image (Figure 2-21, right), the match is made.

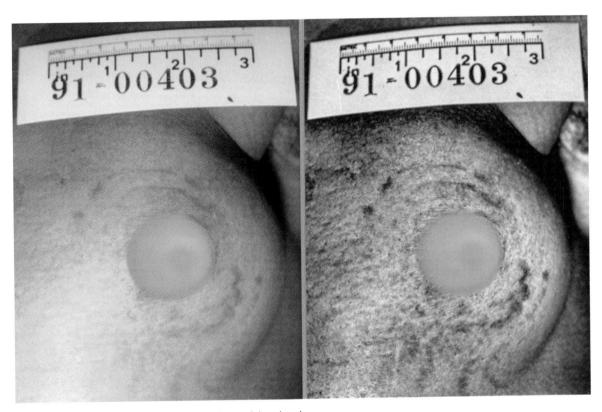

Figure 2-20 The Lucis-enhanced image shows the bruise lines made by each tooth.

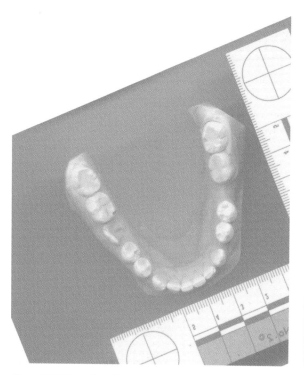 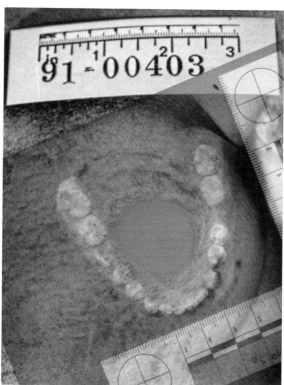

Figure 2-21 *The marks and the cast of the bottom mold are a perfect match.*

"PUT YOUR HANDS UP AND MOVE AWAY FROM THE MOUSE"

So far, Photoshop has been a forensic investigator's friend. Unfortunately, to paraphrase an old slogan, Photoshop doesn't commit crimes. People commit crimes. Fortunately, it appears that most Photoshop criminals aren't blessed with the dogged determination and attention to detail of the investigators. In fact, there's a decided element of the absurd when people try to create reality with a photographic image. This section reconstructs the crime, explains how it was discovered, and shows what Photoshop techniques, properly applied, might have done the job better.

Tick, Tick, Ticket

Most of the time, the perpetrators of cheap Photoshop frauds are the usual suspects. But not always. What happens when the officials turn to the dark side?

Kevin Maguire was careful and serious. He never parked illegally and believed that those who did got what they deserved when they got caught. So he was mystified and angry to find an expensive parking ticket on his windshield one Thursday the 16th. He looked all over for a "No Parking" sign but didn't find one. He felt particularly bad because he had come to town with a Boy Scout troop and hated to give them a bad impression.

Of course, he sent a letter contesting the ticket. Most cameras used by police have a function for date-stamping an image when it's printed, so they sent him a copy of the posted temporary-parking restriction sign. The minute he saw the photo, he appealed, bringing the picture with him, which had a time stamp in the lower right corner... with the following day's date, not the date from his Thursday ticket (Figure 2-22).

Figure 2-22 Didn't he get the ticket on the 16th? Where's the proof that the sign was up then?

When he showed up for the hearing, the police did as well, with the same photo, only this time with the date of his ticket on the date stamp (Figure 2-23). But when the two pictures were compared, it was obvious that this second photo had been doctored.

Figure 2-23 *Altering the image was a simple cut and paste that didn't stand up to scrutiny.*

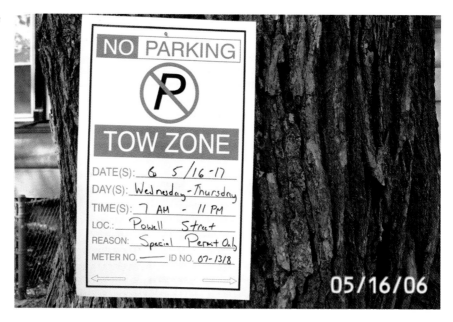

How could they tell? Close observation is key. One of the ways you can tell that an image has been altered is by how well the suspected change blends in with the rest of the image. In Figure 2-24, zooming up the suspected date shows that the "6" on the left (part of the "16" in the date stamp) has very crude edges. On the left side, it has a sharp, straight edge instead of a smooth transition. The "6" from the year on the right blends into its background.

Figure 2-24 *The "6" on the left shows signs of having been cut and pasted. The one on the right is correct.*

Of course there was a twist. When the ticket giver was prosecuted for doctoring the photo, it turned out that she hadn't done the deed. She was the supervisor of a group of meter maids who didn't like her style and faked the photo hoping that she'd be called on the carpet for it.

Back Dating

It may be hard to turn back the hands of time, but moving a digital date is a simple image-editing task. In this case, the traffic office editor needed to turn the date on the date stamp back from May 17 to May 16. Lucky for him, the number he needed was already part of the real date stamp.

To scam a date from a camera or camcorder, begin by selecting the number you want to reuse. Then expand the selection by several pixels to get all the transitions between the number and its background (Figure 2-25).

Make a new layer. Copy the selected number to this layer and position it over the number you want to replace. Click to lock the transparent pixels on the layer, which prevents painting elsewhere on the layer by mistake (Figure 2-26). Next, click the eye to make the layer temporarily invisible.

Figure 2-25 *In this case, the selection is expanded by 3 pixels.*

Figure 2-26 *Here, the selected 6 is copied to a new layer.*

Moving to the layer with the original time stamp, select the Patch tool, making sure that the Source radio button is selected. Draw a selection around the number you want to replace (Figure 2-27).

You want to erase all pixels from the original number without leaving any holes. To do this, move the patch outline to a place on the image that best matches the area you need to replace (Figure 2-28).

Once the background is patched, you can return to the copied number and make it visible. Using the Dodge and Burn tools, blend the edge of the number so it fits with its new background. The final result is a time stamp that stands up to scrutiny (Figure 2-29).

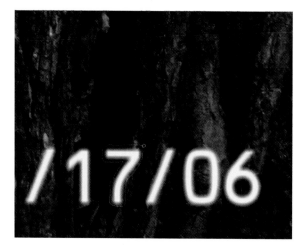

Figure 2-27 Here the 7 is selected on the original layer.

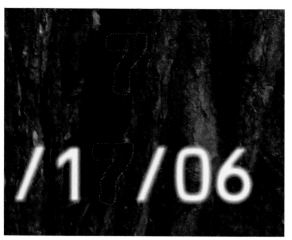

Figure 2-28 The section under the patch outline best matches the area that will be below the 6.

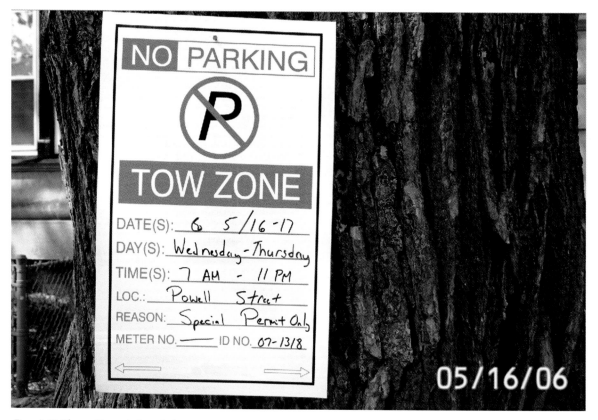

Figure 2-29 The new 6 is completely convincing.

Insurance Fraud

Hands down, the most frequent white-collar crime is insurance fraud. Many otherwise law-abiding citizens have a real blind spot when it comes to insurance—so many, in fact, that insurance companies claim that they have to charge hundreds of dollars a year in premium costs to cover their losses.

Perhaps it's the general concept. Every year you write a hefty premium check and don't even get a T-shirt in return. The temptation to get a return on the investment painlessly is too powerful for some people to pass up. And what could be easier than to create a false trail with your trusty camera?

There are probably successful frauds that are never detected, either because they have been managed with great skill or because no one has the time, energy, and need to investigate. But insurance companies are by nature suspicious, and a number of suspected cases of image fraud surface every year. Following are examples of some of those cases, adapted from insurancefraud.org.

Case 1: License to Steal

"Hi Joe. It's Ron. How's it hangin'? Say, do you still have that cool red Beamer? Hey, that's great! Say, how about helping out a friend? Can I put Michele's license plate on your car and take a picture of it? Actually, I could get you the plate and you could put it on yourself. She'd just like to have a picture of it on there. You know, for a joke."

What would you do if a casual acquaintance called you up with this request? Say yes and help him out? Tell him politely to get lost? Maybe it would depend on what you thought about the guy. In this case, Joe must have had some mental reservations. He called the California Department of Insurance (CDI). They told him to say yes, took the photo for him, and sent it to Michele's address.

Fast forward to Michele's tearful phone call. "My car was stolen! My beautiful red Beamer!" When she filed the false insurance claim and tried to back it up with the infamous Beamer picture, she and Ron got a couple of special photos in return: their mugshots.

Faking the License Plate

Somewhere out there, someone has probably pulled the same scam and gotten away with it. How? By eliminating the dangerous middleman. Starting with Figure 2-30, this is how an insurance scammer might pull off the photo part of the fraud.

In Figure 2-32, you'll see that these new numbers don't look right on the plate. What's wrong is perspective. The new plate doesn't match the vanishing point of the original one. With the Transform > Perspective tool, you can adjust the perspective to match that of the original license plate (Figure 2-33, left) and then move it into place on top of the original plate (Figure 2-33, right).

Figure 2-30 *Begin with a beauty shot of someone else's high-performance car, with the license plate clearly visible.*

Figure 2-31 *Shoot a photo of your own plate. Use the selection tools to separate it from your car and place it on a new layer in the beauty shot.*

Figure 2-32 *Scale your plate to match the size in the original photo.*

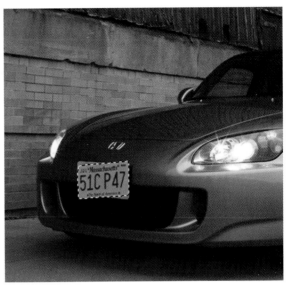

Figure 2-33 *The Transform > Perspective tool makes it easy to replace a flat plane with perspective.*

The result in Figure 2-33 looks pretty good, but it still seems pasted on. Why? Because you've made a flat change to something slightly bent. Some artistry is needed to add that last touch of reality. The Transform tools can help with this last step as well. Select Transform > Warp, which allows you to make structural changes in different places along the plate by adjusting the grid, as seen on the left in Figure 2-34. Adjust the new plate slightly to match the bend of the original and you have the perfect replacement plate (Figure 2-34, right).

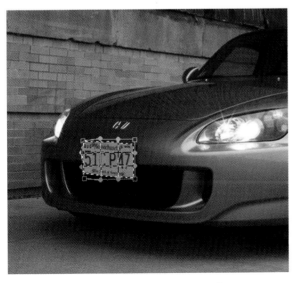

Figure 2-34 *A small change makes the plate swap more realistic.*

Verdict: With a good eye and a bad intention, you could make that car your own, at least in a photo.

Case 2: The Ransacked House

It's early Sunday afternoon, and Lina hears the kids playing behind the house as she walks down the hall to her apartment. She freezes. No point in putting the key in the lock…the door was jimmied. In the bedroom, the closets are open and her clothes lie in wrinkled piles. The jewelry box is empty on the floor. Yup, the expensive diamond engagement ring, the one she kept after she threw Shaun out, is gone. Bet the creep got one of his friends to do her place while she was at Lonny's last night.

Wish she'd bought that home insurance policy that agent tried to sell her last week. Hey! Let's just call that guy and tell him she's changed her mind. She'll take some pictures now that she can use later to set the stage when she reports the crime and puts in the claim. They'll never know the difference.

It's a shame she didn't buy that policy before the break-in, but reporting the items stolen and filing a false insurance claim solved her short-term problem. She won't have to pay the rent or buy any new clothes for at least a year, because that's how long she'll probably be in prison. The investigator was sharp. On her report, she said she'd found the break-in after coming home from work at night. He noticed the room was much too light for the time she'd reported. Why lie about the time…unless she had a bigger lie to cover? After a look at the digital EXIF data that came with the photo, she was busted.

Taking Care of Details

Ah, if you could only rewind your stupid decisions. Spending the money for apartment insurance would have solved everything. Not lying would have been wise. Or maybe just a good eye for detail and an online tutorial!

First, she'd want to set the camera's date and time to something very close to the incident. That guarantees that she won't be betrayed by the photo's EXIF data. Next, adjust the room light. This room was shot in the daytime, with a flash to fill in light. You can see the effect of the flash in the bright reflection from the jewelry box and the open cabinet door (Figure 2-35). You can tell that the room was lit with daylight because the walls are a neutral off-white, and the blanket is very white. The window shade was probably open.

Instead of the bright, neutral light of mid-afternoon, she wants a color shift that communicates that there was an incandescent light on and no daylight. By creating an adjustment layer and applying a warming color filter to the image, you can tweak your changes without changing the original file (Figure 2-36).

Figure 2-35 All the visual cues in the image point to a daylight photograph.

Figure 2-36 The same photo provides a subtly different lighting effect.

Case 3: In-Car-Ceration

"I don't understand how you can always go out. You make a lotta money as a teacher?"

"Well…look, can I trust you? If you want a little extra under the table, I can set you up."

"I don't want no one to get hurt."

"Don't worry. It's just for the insurance. I've got a cousin in car repair, and he has a great setup. We've been doing this for years."

One of the most pervasive anti-insurance scams is the faked accident. States with no-fault auto insurance are particularly fertile soil, since the accident is unlikely to have a day in court. Everyone in the accident may be in on the scheme, or sometimes the scammers ambush an unknown mark. One car drives below the speed limit with the frustrated innocent close behind. The other moves quickly to cut the slow car off, giving him an excuse to slam on the brakes. The innocent rear-ends the car. The rear-ended car ends up at a very special auto repair shop.

The repair shop's job is to make sure that the insurance claim is inflated faster than an allergy sufferer's nose in May. There are plenty of ways to do that. If the ring is really well established, there may be a cooperative insurance adjuster on the team. But even if they have to face a real adjuster with a camera, there are ways. The easiest is to simply swap cars, replacing a lightly damaged car with a near-total. Another option is a handy sledgehammer, turning a scratch into a dent and a dent into something well above the deductible.

Bending the Rules

Sometimes people who suspect a con assume the photo was digitally altered to add more damage to the car. Could that be the case? Here's what it would take to complete a plausible edit.

Most inexpensive online stock image sites have pictures of a variety of crashed cars. Find a photo of a car the same color range as your own with the type of damage you'd like to inflict (Figure 2-37). The exact color isn't important, but the substitution is easiest if the dented car is the same color but slightly lighter in value.

Figure 2-37 One of many available crashed cars on istock.com.

Using the photo as a template, shoot your own car from the same distance and angle as the stock photo (Figure 2-38),

Figure 2-38 Match the stock image with your own photo.

Get rid of everything from the stock image except the area with the damage. Use the stock image damage as a new layer in the image of your car, changing the blend mode to Multiply.

Multiply compares the pixels in the second layer with those in the first, multiplying the two values together. If one of the pixels in the multiply layer is white, it becomes transparent. Colors lighter than the lower level become translucent. Dark colors become darker.

Because the top car color is slightly lighter than the bottom one, places where it appears in your original selection will become transparent. Only the dent will appear on the layer, because it is darker than the lighter metal on the lower layer (Figure 2-39).

Unfortunately, the fender shapes aren't the same, and it's unlikely that you'd be able to find a source image that shows exactly the same car mode. As a result, you'll need to bend the dent with the ever-useful Transform > Warp tool to conform to the fender dimensions (Figure 2-40).

Figure 2-39 *Only the dent appears on the new layer.*

Figure 2-40 *You can Warp the dent to your own car's shape.*

Verdict: possible, but not likely. The work required to create a believable crash picture is out of the range of the casual user (Figure 2-41). Unless your fraudster is also a Photoshop ace, the blunt instrument in his hand will probably be a hammer, not a mouse.

Figure 2-41 *A finished, perfect dent requires computer time and effort.*

In short, in a Photoshop tussle between angels and devils, the angels still have an edge. From currency to murder to garden-variety greed, the skills of the investigators are holding their own. As our abilities to adapt and mimic reality improve, however, there's no guarantee that the balance on the scales of justice won't shift.

CHAPTER 3

ARTIFAKES

ART IS A PRODUCT of human creativity and imagination, but defining it more specifically is difficult. While some people recognize only classical painting or sculpture, others are devotees of performance and environmental art or extend the definition to crafts. Nor does uniqueness define art. Limited lithographic prints, editions of photographs, jewelry, or sculpture can be considered fine art. From there it is a short step to mass-produced work, like stamps.

Art doesn't have to be beautiful or even tasteful. Many a strange thing has become art through the alchemy of intention. One of the most famous instant art objects was Marcel Duchamp's appropriation of a urinal. Named *Fountain* and rotated on a pedestal, it remains an authentic art expression even though the original was lost and replaced by Duchamp with four re-creations (Figure 3-1).

Figure 3-1 The original 1917 version of Duchamp's Fountain, *no longer in existence.*

Like *Fountain*, most art has a low intrinsic value. The standard tools and materials needed for arts, crafts, and collectibles are very affordable. There's also no correlation between the time it takes to make art and what it's worth. An artist can spend $200 on materials, labor over one piece for two weeks, and sell it for $1,000, a rate of return at the poverty level.

ARTS AND CRAFTINESS

While there is no agreement about what art is, there is absolute unanimity on what makes it valuable. Most people, when purchasing something expensive, nonfunctional, and inedible, evaluate it as an investment. For art to appreciate like any financial investment, it must be authentic.

When does an artifact become an artifake? When it loses its authenticity. In a 1960s TV comedy called *Hazel*, the title character discovers that she owns a painting by a famous artist, worth thousands of dollars. The experts are stunned that the artist had painted a smiling portrait. Hazel's painting goes from priceless to worthless when she volunteers that the smile was a replacement…why have such an unhappy picture on the wall when a little paint can fix it? Alteration, duplication, reproduction—just as there is no such thing as being slightly pregnant, there is no question about authenticity. Either the art is completely genuine, or it is worthless.

HIGH STAKES IN FAKES

You can pay $5 for a meal to fill you up or $500 for a meal to fire the soul. But that's just a factor of 100 from one end of the price range to the other. Art is different. You can buy a street sketch for $25, while famous artworks are scraping the $150 million mark.

When the stakes are so high, so are the temptations for forgery and fakes. But forgery needs more than bad intent. Really good forgery is as hard as good art—maybe harder, and rarer. In fact, a few forgers who created new work in the style of other artists have created such exceptional art that they have become names in their own right, with their own collectors. Works by Elmyr de Hory, a forger made famous by an Orson Welles documentary, have dedicated collectors, and many are priced as original artworks in the open market.

Sympathy for the Devil

Perhaps because of the "gentleman thief" image that forgers have, many people identify with the forger rather than his targets. When a rich art buyer gets taken to the cleaners, people are as likely to feel a certain guilty pleasure as they are to commiserate with the defrauded collector or embarrassed expert (see "The Reich Stuff" sidebar).

In 1986, a couple bought a painting at an auction at Christie's for the bargain price of $38,500. Christie's gave them a 6-year warrant of authenticity as part of the deal and sent them on their way. For 13 years, they reveled in their valuable artwork. Then, in 1999, they discovered that their painting was a forgery. Despite it being well past the 6-year period, the couple sued the auction house. The case made it to the Delaware Supreme Court, where in 2007 the justices delivered a ringing judgment of *caveat emptor*. When it comes to art, there are no lasting guarantees, and even experts can make mistakes in good faith.

Things have only gotten worse since the couple bought their expensive mistake. The International Foundation for Art Research (IFAR) estimated in 2000 that the vast majority of the work they examine is forged, particularly prints by favorite painters in the canon, such as Picasso and Chagall. What's extraordinary about this statistic is that the IFAR deals mostly with artwork that has gone through "normal" art channels: galleries, antiquarians, professional dealers. They seldom see work below five figures.

The Reich Stuff

Most art forgers—at least the ones we know—start down the slippery slope in search of payback. The same critics who panned the artist's work could be made to gush at a different signature. Then imagine the pleasure at the unmasking! But there was always a catch: If the work wasn't quite good enough, the forger would be exposed and ridiculed.

If the work was too good, the forger could face a different dilemma. There wouldn't be fame, but there could be fortune. The temptation to do just one more piece would be overwhelming. But only one forger in history was so successful that he admitted to the forgery and no one believed him.

In 1945, in the aftermath of World War II, the Allies discovered Hermann Goering's personal treasure trove of European art (Figure 3-2), much of it looted from fleeing Jews or "purchased" at discount prices from Europe's finest museums. Among the loot was a previously unknown Vermeer, Christ and the Adulteress. *Unlike most of the stash, which was found in climate-controlled railroad cars, this piece was such a favorite that Goering had singled it out, giving it in parting to his wife's nurse.*

Figure 3-2 One of the galleries filled with fine art at Goering's residence, Carinhall. (Carinhall, Festhalle: Library of Congress, LC-USZ62-135646.)

Almost immediately, the Allied Art Commission began the Herculean task of returning the art to its lawful owners, or at least to its country of origin. They traced the sale of the Vermeer to Van Meegeren, a rich but obscure portrait artist and occasional art dealer in Holland, and asked for the painting's provenance. He refused to give it to them, which was tantamount to admitting collaboration with the Nazis. They charged him with treason and threw him in jail.

Few have faced a more ironic dilemma. Van Meegeren was not only the original owner, he was the original painter. This painting was one of a series of "Vermeers" that he had successfully foisted on the art world, each selling for millions of dollars—a princely sum in 1940s terms.

Vermeer was not a prolific painter, so it seems extraordinary today that no one questioned the sudden discovery of such a treasure trove. In fact, the foremost Vermeer expert of the day, Abraham Bredius, said of the first forgery, Christ and the Disciples, *"In no other picture by the great Master of Delft do we find such sentiment, such a profound understanding of the Bible story." To be fair, Van Meegeren had gone to enormous trouble—using the master's techniques, developing a system of aging canvases that passed every test then known, and forging an excellent signature. The fact that he painted the fakes in his own style, not Vermeer's, was entirely beside the point. Vermeer had often made it difficult to identify his work by painting in more than one style. Experts like Bredius simply tagged the work as Vermeer's "earlier phase" (Figure 3-3).*

Figure 3-3 *The detail from Van Meegeren's* The Disciples *displays a less-subtle style than the mature Jan Vermeer. (Vermeer,* Officer and Laughing Girl: *Courtesy The Yorck Project.)*

Van Meegeren obviously had a lot to lose by exposing his hoax. But finally, after six weeks of prison, he couldn't hold back—death was worse than unmasking. When not a single person believed his announcement, he offered to paint a brand new "Vermeer." In the presence of witnesses, that's exactly what he did.

Collaboration charges were dropped and replaced with charges of forgery. He was found guilty, but with a one-year sentence that was almost certain to be commuted.

Meanwhile, the Dutch public went wild. As the man who made a fool of Goering (Figure 3-4), Van Meegeren went from vilified Nazi artist to national hero in a Rotterdam minute. Perhaps fortunately for a man who, like most forgers, craved public acclaim, he didn't have to go through the inevitable stage of public apathy that follows. Sick from a life of alcohol and drug abuse that was a direct result of his bitterness, he died in 1947.

Figure 3-4 Hermann Goering, Nazi about town and fine art collector, was told that the Vermeer was a fake before he was executed. (Harry Truman Library.)

The Flip Side of Forgery

Unfortunately, the romance of art forgery can blind us to the fact that not all forgers are underappreciated starving artists, especially not in the global economy. For every multimillion-dollar Old Masters scandal that embarrasses art experts and dents an investment portfolio, there are hundreds of lesser but much more painful hurts to living artists and small-time collectors.

The Internet has become a crucial part of any artist's marketing effort. Many artists maintain their own sites, and certainly galleries that represent them do so, posting examples of their work online. But once a work is available, it could be only a short step away from being ripped off.

China (not exactly a haven for intellectual property rights) is peppered with painting factories. Dozens of workers paid a pittance by the hour copy art downloaded from the Web or scanned from books. That's where many of the eBay listings for "real oil painting reproductions" of Klimt and other big sellers source their stock (Figure 3-5).

Figure 3-5 This seller is a broker who buys reproductions painted in China and third-world countries.

But the Chinese factories make no distinction between work painted hundreds of years ago and that of living artists. They won't be paying royalties or licensing fees either way. So there is a good possibility that some pictures of favorite subjects, like dogs, cats, and horses, are copies of work painted within the past few years by artists whose livelihood is impacted by cut-rate copies.

Even worse, to avoid cross-checking in Google, factory sellers make up artist names for lesser-known works and apply these to the forgeries. To find the rip-offs, someone who knows the artists and their work has to see the listing and report it. Not an impossible occurrence, but the odds are against it.

SHOPPIN' AROUND

At least the Chinese factories actually have real painters with brushes who paint on canvases. Some of them may actually enjoy their work and take pride in a job well done. But a new category of fake exists: the instant painting.

When computer art was in its infancy, one of its problems was that it could exist only on a screen. The printers attached to computers were very low resolution. Some were slick wax-based images; others were washed-out inks with obvious dots. All of them degraded badly when exposed to light. Artists were elated when the Iris printer, the first large-format, high-quality printer, came online. Finally, their work could be printed on the same types of paper as other artwork, from watercolor paper to canvas. And it was archival, which meant that the inks were light-stable. The work could be mounted, framed, and displayed. To distinguish it from other forms of prints, the name "giclee" (French for "nozzle") was coined, since the Iris sprayed very small drops of ink from narrow nozzles.

Today, many printer companies make high-resolution color printers that can be used to print fine art, so what was once rare is now a standard. Prices have come way down, and almost anyone can afford to have a giclee print made or even own a wide-format giclee printer. Many artists do, and so do art fraudsters, who charge a premium for work that any amateur photographer with a copy of Photoshop could make for himself.

The way it works is that a seller takes a variety of photographs on classic themes, such as landscapes, seascapes, or children at play (Figure 3-6). In fact, these photos can come from anywhere, although if the seller wants to be at least technically accurate, she will take the photos herself so she can list the output as "original" watercolor prints.

Figure 3-6 Start with a picture with a topic that lends itself to watercolor effects. A slightly washed-out image is best.

Photoshop's Artistic section in the Filters menu contains many fine art effects that the computer mimics mechanically. If you put a photo through the Watercolor filter without preparation, it will still look more like a photograph than a painting and will have many unattractive mechanical defects (Figure 3-7). A good faker will make a few changes to the original image before using the Watercolor filter.

Figure 3-7 The filtered image ends up with a posterized sky.

Watercolor is like painting with light, and even black watercolor paint is translucent. The colors are very warm and clear. By increasing the saturation and light in an image, you can bleed out the underlying blacks and get closer to this pure color. There are many ways to do this, but the easiest is Image > Adjustments > Hue/Saturation (Figure 3-8).

Figure 3-8 Hue/Saturation helps to get rid of some shadow detail and brightens colors.

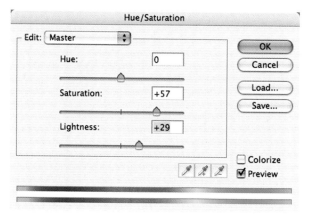

When you select Filter > Artistic > Watercolor, the defaults tend to create high-contrast images with an abundance of inauthentic black, as seen in Figure 3-9 on the left. For a seascape watercolor, the faker could change the shadow intensity to 0, which makes an enormous difference, as seen in Figure 3-9 on the right.

Figure 3-9 Changing the default settings in a filter allows you to fine-tune your effects and decreases the computer-ish look.

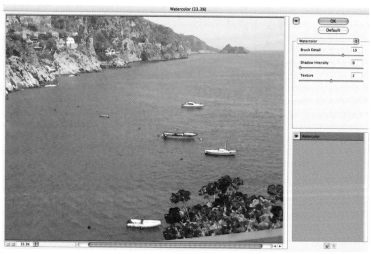

The finished computer image usually needs a little work to eliminate details that didn't come through the filters well, like the small buoys in the water (Figure 3-10). Once that's completed, the image is printed onto watercolor paper.

Figure 3-10 The finished computer image needs cleanup for false-looking small details.

But even with precautions and the texture of watercolor paper in the mix, a watercolor print misses some of the most prevalent watercolor effects, like pooling and brush irregularities. When the brush is full of water, the water creates valleys and bumps on the paper. In Figure 3-11 on the left, a close-up of an authentic watercolor painting shows how water bends and warps the paper, allowing puddle edges to appear.

The computer filter that mimics this effect can't "see" the actual painting, so you'll get watercolor edges, as seen in Figure 3-11 on the right, but none of the irregular pools you'd expect in areas with big amounts of similar colors, like sky and water. It isn't possible to predict where these effects would appear, and throwing them in randomly would be even less likely to work. Pooling and irregularities are not completely random and are often encouraged to develop in specific places by the artist.

Figure 3-11 Watercolors pool in the valleys and leave irregular shapes (above). There are no big pools in computerized watercolor (below).

A successful faker solves this problem with a nice watercolor brush and some water applied directly to the computer print. Doing this softens the background areas, adds real brushstrokes, and lets colors pool. The finishing touch is to use the brush to break up the edges of the print so you can no longer see the straight, sharp rectangle that proves you used a photo. Alternatively, you can cut the print down to eliminate the edge entirely. The result is shopped on the Internet with various labels. Giclee is one, but so is "mixed media" or "watercolor print" rather than "watercolor painting."

AUCTIONS

So where do the forgeries gather? At all forms of auctions, but particularly at Internet sites. Although eBay has been trying to decrease fraud, it's not the only auction site online. Additionally, eBay's emphasis has been on brand violations, particularly on fake accessories like purses.

To identify artwork and art collectibles, to recognize real certificates of authenticity, or to tell the difference between a real and a fake version of an artwork requires expertise. It doesn't lend itself to a box on a fraud checklist.

Avoiding Auction Forgeries

If you are going to buy art and art collectibles in online auctions, your chances of being taken in are very high. That's true no matter how knowledgeable you may be; even the experts have made authenticity mistakes. But you can at least weight the odds in your favor by steering clear of the most consistent auction ploys by asking these questions.

- *Who is the seller? Look not just at his ratings but at what he sells. Does he seem to know and specialize in this material (Figure 3-12)?*

- *If you're looking at an antique photo or other art collectible, what is the average winning bid for work of the same type, size, and condition? Don't bid on pieces whose starting price seems too tempting. There is no free lunch.*

- *If there is a named artist attributed to the piece, is there a market for his work outside the auction space? If so, what is the price range? If you find the artist's work in the same medium and size for $5,000 at a reputable gallery site, and the auction bidding starts at $99 or below with no reserve, something is fishy.*

- *Beware of marketing language and emotional narratives. You are not buying a bedtime story with your art collectible, and a good story doesn't change the value of the piece. You are looking for a seller who offers factual details and exact language that will help you make your selection. Avoid people who say they "don't know much about" the piece (Figure 3-13). If it's true, they could be passing on a fake inadvertently. Most likely, it's a marketing ploy to make you think you can take advantage of their ignorance.*

- *Does the listing have spelling errors? An occasional typo may not be significant, but if the misspelling allows the seller to weasel out of a promise, a scam could be afoot. If you're being offered a Maygreet print, don't assume the seller can't spell Magritte.*

- *What size are the pictures? There's no good reason to post small images, especially when art collectibles can vary in value because of small details. Even very small objects, like carte de visites, can be photographed large enough to see them clearly.*

Figure 3-12 It's hard to believe that a seller who lists wines, gaming tokens, and Star Wars jigsaw puzzles is also a specialist in 20th-century folk-art painters.

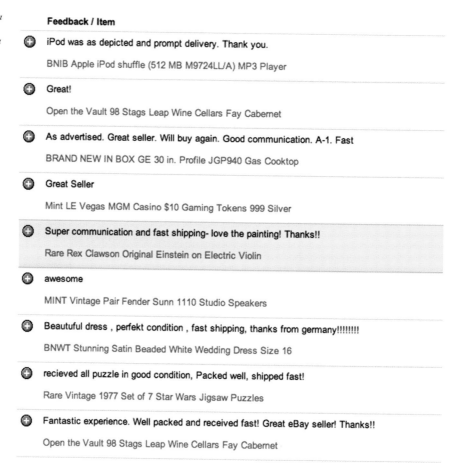

Feedback / Item

⊕ iPod was as depicted and prompt delivery. Thank you.

BNIB Apple iPod shuffle (512 MB M9724LL/A) MP3 Player

⊕ Great!

Open the Vault 98 Stags Leap Wine Cellars Fay Cabernet

⊕ As advertised. Great seller. Will buy again. Good communication. A-1. Fast

BRAND NEW IN BOX GE 30 in. Profile JGP940 Gas Cooktop

⊕ Great Seller

Mint LE Vegas MGM Casino $10 Gaming Tokens 999 Silver

⊕ Super communication and fast shipping- love the painting! Thanks!!

Rare Rex Clawson Original Einstein on Electric Violin

⊕ awesome

MINT Vintage Pair Fender Sunn 1110 Studio Speakers

⊕ Beautuful dress , perfekt condition , fast shipping, thanks from germany!!!!!!!!

BNWT Stunning Satin Beaded White Wedding Dress Size 16

⊕ recieved all puzzle in good condition, Packed well, shipped fast!

Rare Vintage 1977 Set of 7 Star Wars Jigsaw Puzzles

⊕ Fantastic experience. Well packed and received fast! Great eBay seller! Thanks!!

Open the Vault 98 Stags Leap Wine Cellars Fay Cabernet

Description

I BOUGHT THIS IN AN ANTIQUE STORE, THE DEALER WAS NOT SURE WETHER IT WAS A DAGUERREOTYPE OR AN AMBROTYPE. THEN I OPENED IT, I THOUGHT WHAT AN INCREDIBLELY HANDSOME YOUNG MAN.THE PICTURE SHOWS THIS YOUNG MAN WITH TINTED CHEEKS.PERHAPS, ONE LAST PICTURE, BEFORE HE PUT ON A BLUE OR GRAY UNIFORM ,IN THAT COMING BLOODY CONFLICT? IT MEASURES 3"X2 1/2". THE FRAME STILL HAS IT'S LATCH. THE FRAME HAS LOTS OF WORN GOLD PATTERN. NOT A PICTURE THAT SAT ON A SHELF. THIS PICTURE WAS OPENED ALOT. PERHAPS HIS MOTHER KEPT IT IN HER APRON. PERHAPS HIS SWEETHEART KEPT IT UNDER HER PILLOW EVERY NIGHT, AND LOOKED AT IT EVERY DAY. PERHAPS HE NEVER CAME HOME, LIKE SO MANY. IF THIS PICTURE WAS ALL THAT WAS LEFT, IT IS WELL WORN AND WELL LOVED.WHAT A SHAME IT ENDED UP NAMELESS AND FORGOTTEN IN A STRANGERS STORE. SOMEONE LOVED THIS YOUNG MAN VERY MUCH, A NICE TRIBUTE. PLEASE ASK QUESTIONS NOW , AS I ACCEPT NO RETURNS. I DO HOWEVER INSURE FULLY, TO PROTECT US BOTH.OH. RESIDENTS MUST PAY SALES TAX.

Figure 3-13 This may be a sweet story, but the capital letters, pretention of ignorance, and unwillingness to accept returns point to a classic scam artist.

■ *Are the pictures a little (or maybe a lot) fuzzy? Does the seller apologize for not being a good photographer? It's hard to shoot a really bad photo with a tripod and a digital camera, and it's very easy to retake a picture if something unusual happens to ruin the shot. A fuzzy photo means that there is something to hide (Figure 3-14).*

Figure 3-14 *It's hard to believe that anyone would trust a picture this fuzzy, yet the item did have bidders.*

■ *If the item is an antique, does it look too good in the photo? By this time, most antique photographs have weathered 150 years in less than archival conditions. An online photo that accurately portrays the piece will probably show nicks, scratches, tarnishing, or other wear and tear.*

■ *What are the payment terms? Don't buy from someone who wants you to wire them the funds "because they don't trust (fill in the blank here)." They will probably disappear after they've grabbed some quick money from unsuspecting buyers. On eBay, your best bet is someone who prefers a PayPal account, because at least there is some accountability.*

■ *Does the seller have a return policy? Anyone you buy art or art collectibles from should clearly state what that policy is. If they don't, or if they don't cover issues like insurance, shipping, and breakage, move to a different listing.*

Understanding Feedback

Many online buyers think that they can avoid getting stuck with a fake by buying only through eBay sellers with good reviews. This is not true. The eBay ethic makes it very easy to write a good review and very hard—in fact, often unpleasant—to write even a neutral one. Of course a really bad rating is a red flag, but you have to see beyond the raw numbers to glean anything useful about the seller when it comes to art and collectibles.

When you dig through the reviews, you'll find that collectors frequently sell to each other. That action pumps up the listed number of feedbacks, so a person with 400 reviews may only have sold to 50 different people.

A person's statistics can be built on his purchases and have nothing to do with his ethics as a seller. He can build his solid reputation by buying a variety of inexpensive goods and paying for them promptly. Once he has hundreds of reviews, most people won't notice how he got them or understand that the difference between buyer and seller matters.

Collectors tend to break up sets. A canny eBay user can buy 10 cheap pieces in separate auctions on the same day from one source. As a result, he'll get 10 favorable reviews for what is essentially one transaction (Figure 3-15). This is also a great strategy for building statistics fast.

Figure 3-15 This buyer will gain points quickly because he is purchasing many inexpensive items from the same seller.

laceyling (5364 ☆)	Apr-22-07 20:47
—	Private
laceyling (5364 ☆)	Apr-22-07 20:45
—	Private
laceyling (5364 ☆)	Apr-22-07 20:45
—	Private
laceyling (5364 ☆)	Apr-22-07 20:44
—	Private
laceyling (5364 ☆)	Apr-22-07 20:44
—	Private
laceyling (5364 ☆)	Apr-22-07 20:43
—	View Item
laceyling (5364 ☆)	Apr-22-07 20:43
—	Private

The types of favorable reviews are also important. Look through feedback for most eBay collectible sellers and you'll see few comments about authenticity and knowledge. The gold standard (A+++++) for a seller is the "good experience," which usually means being friendly, shipping quickly, and packaging with care (Figure 3-16).

Figure 3-16 This collectibles seller's eBay feedback notes are filled with praise for what would be considered standard commercial practice anywhere else.

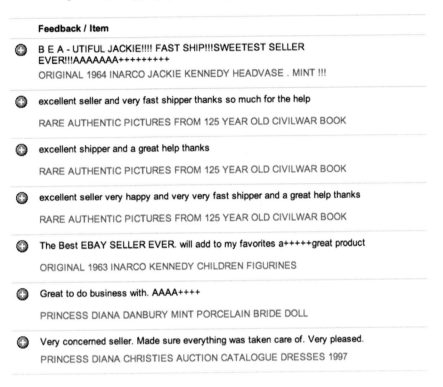

Feedback / Item

➕ B E A - UTIFUL JACKIE!!!! FAST SHIP!!!SWEETEST SELLER
EVER!!!AAAAAAA+++++++++
ORIGINAL 1964 INARCO JACKIE KENNEDY HEADVASE . MINT !!!

➕ excellent seller and very fast shipper thanks so much for the help
RARE AUTHENTIC PICTURES FROM 125 YEAR OLD CIVILWAR BOOK

➕ excellent shipper and a great help thanks
RARE AUTHENTIC PICTURES FROM 125 YEAR OLD CIVILWAR BOOK

➕ excellent seller very happy and very very fast shipper and a great help thanks
RARE AUTHENTIC PICTURES FROM 125 YEAR OLD CIVILWAR BOOK

➕ The Best EBAY SELLER EVER. will add to my favorites a+++++great product
ORIGINAL 1963 INARCO KENNEDY CHILDREN FIGURINES

➕ Great to do business with. AAAA++++
PRINCESS DIANA DANBURY MINT PORCELAIN BRIDE DOLL

➕ Very concerned seller. Made sure everything was taken care of. Very pleased.
PRINCESS DIANA CHRISTIES AUCTION CATALOGUE DRESSES 1997

A person can even be an honest seller with good ratings and still be dealing in faked merchandise. An amateur who sells a variety of collectibles may just be recycling something bought at another auction and may be just as clueless as you are. Ignorance may be an excuse for Christie's, but remember that they did offer a six-year guarantee.

After the Purchase

Unless a buyer brings the work to an experienced appraiser for authentication, he may never know he's bought a forgery. There's little incentive to do this checking. Professional appraisal fees start at about $200 per piece, and many artworks online sell for that or less. There's also the element of time. Most sellers accept returns only within a week's time. Perhaps a blatant fake can be identified quickly, but in most cases an appraisal will take longer than the return time allows.

COLLECTING PROBLEMS

Fine art forgeries make the news, but the biggest percentage of fake art is in the lower-priced but lucrative collectibles market.

Collectibles generate enthusiasm even in people who are not connoisseurs. Although some are genuinely unique and extremely expensive, most art collectibles are just pricey enough to feel like an investment without breaking the bank. They weigh very little, so they're easy to package and insure. Framed, they make good wall hangings and add a sense of history to a living room.

Millions of people take part in online auctions for art collectibles on a budget that runs to thousands a year. And most of them know very little about the works they purchase and how relatively easy most of them are to fake. As a result, most frauds are perpetrated not on the rich and famous but on the working and middle-class, for whom $385 lost to a fake on eBay can have the same financial impact as the $38,500 had on the couple in Delaware.

From stamps to trading cards to old postcards, anything that can be printed on paper can be faked with varying levels of time and energy. And if it can be faked, chances are it has been. In particular, the barrier to entry for fakes is low for vintage and antique photography. Photoshop manipulation reigns supreme at every stage, from the creation of the artwork to its advertising online (see the case file, "Old Faux at Home").

There is almost no penalty for being caught. In 2002, a group of concerned philatelists (stamp collectors) documented consistent, deliberate fraud in the stamp market. One person, operating two accounts, would buy stamps with flaws or stamps that were the less-expensive version of a rare edition. After patching, reperforating, and chemically erasing cancellations, he'd sell the stamps as unflawed originals at an outrageous profit.

The group brought their documentation to eBay, who suspended the two accounts. In almost no time, the fraud was back in business, with new accounts and a clean reputation. Most recently eBay suspended the replacement accounts, but the philatelists know they'll be back soon enough. These persistent stamp collectors even tried to interest the police, pointing out that the fraud had burned up at least half a million in illegal profits, but so far nothing has been done. Clearly, if people aren't careful and vigilant on their own, no one is going to act for them.

The Case File: Old Faux at Home

Vintage photographs are a particularly vulnerable market for several reasons. Obviously, many people have the tools to do the job. But unlike paintings or stamps many photos are completely anonymous. They lend themselves to speculation that drives the market. Who was that sad-looking woman? Did that Union soldier make it home? Because there is no registry for these images and often no way to connect them to a specific photographer or place, there is tremendous room for a faker to maneuver.

How easy is it to fake a vintage photograph? If you're talking about paper prints, the answer is "child's play," particularly if the child is artistic and computer savvy. A faker can begin with a real vintage photo or even a print from a book, scan it into a computer, and with just a little filter work have a very good quality copy. Print it on the right looking paper or use one of the many aging techniques, and you have an instant antique.

In this case, we can start with a carefully shot contemporary photograph (Figure 3-17) and turn it into a believable albumen print in relatively short order.

Figure 3-17 This rustic villa is a farmhouse in rural Sicily. Conveniently, it has no electric wires, parked cars, or TV antennas to mar its timelessness.

We begin with a color photo taken with a digital camera. Like most digital photos, it has a 4x3 aspect ratio, which is not a standard vintage size. So the first step would be to crop the modern image to 4"x5-1/2", the standard size for a scenic cabinet photograph (Figure 3-18).

Figure 3-18 Crop the image to the standard cabinet size.

Step two is to turn the image from color to grayscale. You could just change the mode to Gray from RGB, but by doing so you miss the chance to fine-tune the image. Instead, go to Layer > New Adjustment Layer > Black and White. This function allows you to play with the mixture of the RGB channels (or those in a CMYK file) to brighten, darken, or shift emphasis in the gray picture. Using the adjustment layer will allow you to fine-tune the image exposure after you've seen the results of the photo distressing techniques you'll apply later.

In the first version on the left in Figure 3-19, the Red and Green channels have been slightly increased. In the middle, both have been increased substantially. In the last, only the Red channel is emphasized—the Green and Blue channels have been decreased. Although the variations are practically limitless, in this case the goal is to mimic the effect of an older, overexposed picture, so the first variation is the best for the purpose.

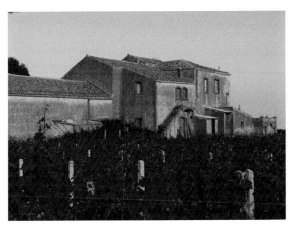
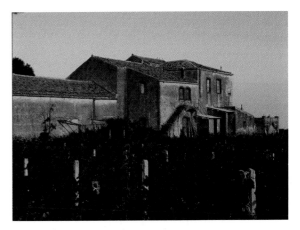
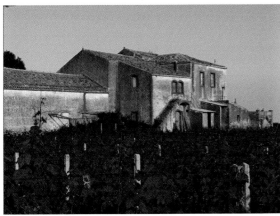
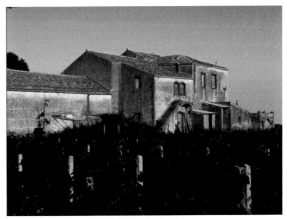

Figure 3-19 These three examples show how much variety you can bring to the grayscale process by mixing channels.

Albumen prints would always yellow, but more in the highlights than in the mid-tones or dark areas. To create this yellowing, check the Tint checkbox and move the Hue slider to the yellow area, then select a fairly light saturation. By playing with these sliders, you can select the exact shade of sepia yellowing you want (Figure 3-20). When you have made your selection, double-click inside the color swatch and write down the HSB numbers. You'll use them as reference a little later.

Figure 3-20 These settings in the Black and White layer allow a range from a delicate light sepia to a rich warm tone.

Digital prints are very crisp and dark. But antique paper prints started out softer and did not sharpen with age. A simple way to soften and lighten the image without losing too much detail is to decrease the opacity of the image to about 80% (Figure 3-21).

Figure 3-21 At a Layer Opacity of 80%, the image loses its digital sharp edges.

So far we've created a vintage-style effect. Now it's time to start aging the image. Depending on how they are stored, different parts of a print will be exposed to variations in light, heat, and moisture. To mimic that irregular fade, select the Background layer and click the foreground color in the toolbox. Input the HSB numbers, but increase the B (brightness) to 100% (Figure 3-22). Switch to the Background Color box and input the same numbers, but change the B (brightness) to about 45%. You'll end up with two brownish shades somewhat lighter and darker than the overall sepia tone.

Figure 3-22 Working from the sepia hue prevents stray color or desaturated tones from marring the natural look.

Create a new layer and call it Fader. Go to Filter > Render > Clouds. This provides pretty heavy patterning. To control it a bit, select Layer > Layer Mask and set it to Reveal All. Select the Linear gradient in the Gradient tool, and then create a gradient that goes from a mid-tone gray to white. Making sure that you have selected the layer mask box in the Layers palette, draw a gradient from the left to the right of the image (Figure 3-23).

Figure 3-23 Combining Clouds with a layer mask adds to the authenticity by created an effect that could be the result of one side of the image receiving more light than the other.

Change the layer blend mode to Hard Light, which will brighten light areas, darken dark areas, and eliminate the mid-tone gray (Figure 3-24).

Figure 3-24 Hard Light de-grays the clouds, allowing the sepia to come through.

When the albumen or silver solution was applied, it was not perfectly even. The irregularities of the application can become noticeable as striping over time. To add this last effect, select the Magic Wand tool, set it to select all layers, and click a few times around the image to randomly sample a variety of shades and areas. When you're done, select Edit > Copy Merged. Paste the result into a new layer (Figure 3-25).

Figure 3-25 This select grabs random amounts of sky, building and vineyard to realistically affect the entire image.

Select Filter > Texture > Grain, and choose an Intensity of about 20 and a Contrast of about 50. Either Horizontal or Vertical will work, since the direction of the grain would have been determined by which way the paper had been pulled from the solutions. Tone down the effect by varying the transparency (Figure 3-26).

Figure 3-26 How much area you selected for applying the grain will determine the amount of transparency you'll select for the layer.

For the finishing touch, you can mimic another aging effect. Old photos often exhibit something called foxing, which is reddish staining (like a fox's head). Too much and you devalue the image, because it obscures the picture. But just a little adds some honesty and randomness. To fake a little foxing, select a dull orange-red tone. Using a small soft airbrush, add a few random splotches of different sizes and irregular shapes (Figure 3-27).

Figure 3-27 The foxing is limited to a less important part of the picture in the upper left corner.

You can print the picture on a thin, very smooth gloss paper. How old do you want your fake to be? If you're hoping to pass this off as a cabinet photo from before 1890, you'll need to mount the print on heavier card stock cut to 6-1/2" x 4-1/2". The easiest way to do this is to find a real cabinet card, scan in the card mount, and print it on antique white or buff card stock. You can spray mount the photo itself on the card stock.

Voila! A unique, ready to sell, turn of the century photo of an Italian farmhouse awaits some good storytelling and a starting price.

VINTAGE PHOTOS CHEAT SHEET

Four types of photo technologies make up the vintage photo market. As so much online fraud is misrepresentation, it helps to be aware of the categories. Only one is on paper. The other three—daguerreotype, ambrotype, and tintype—are on hard media. All of these are positive images, so looking at them is like looking in a mirror: everything is reversed. And with the exception of tintypes, whose process allowed up to 16 copies of an image to be made on a plate at one time, they are one of a kind. The only way to duplicate them is to photograph them in a different medium.

Daguerreotype

Heyday: 1840 to 1855. Less common: 1855 to 1860.

This beautiful process is easy to identify if you know what to look for, so any seller who lists "daguerreotype?" in his auction ad is already sending a message to beware. A daguerreotype (often called a "dag" online) is sealed with a glass sheet because the picture is on a hard silver plate. It will tarnish rapidly with exposure to air (Figure 3-28). In fact, if the seal has been broken or compromised at all, you'll see a bluish cloud at the edges. But most obviously, the surface is shiny and reflective. Depending on the angle at which you hold the picture, the image will change from positive to negative.

Although millions of dags were made, only a fraction of them survive in mint condition. They were fragile, so they were always protected in a decorative frame, usually within a velvet-lined case.

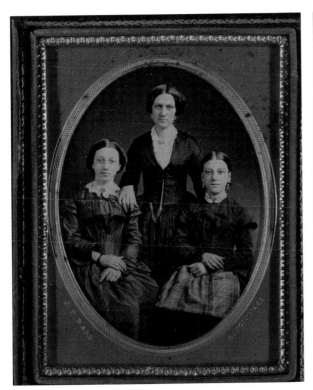

Figure 3-28 A remarkably well-preserved daguerreotype photographed by James Presley Ball. The back of the case (right) is sealed firmly against air and moisture. (Library of Congress, daguerreotype collection, LC-USZC4-10715.)

Ambrotype

Heyday: 1855 to 1860. Less common: 1860 to 1865.

Ambrotypes were a much cheaper process than dags, so they quickly replaced them as soon as they became available. An ambrotype looks very much like a daguerreotype at first glance. Ambrotypes are usually in a frame or case, but they don't flip from positive to negative in different light. They are printed on a sheet of glass, which doesn't tarnish, so they should not show discoloration at the edges. Since the emulsion is very easy to damage, they are usually sandwiched with glass on the emulsion side and sealed with black lacquer or a mounted sheet of black felt.

Like dags, ambrotypes are direct positive prints, which means that they are a mirror image of the subject. Wedding rings will appear on right hands, and shirts will button backward on men and women.

Tintype

Heyday: 1860 to 1900. Less common: 1900 to 1930. Occasionally still used through 1950.

Tintypes are common. They look like ambrotypes, but because they are printed on a thin iron plate they are very sturdy. Unlike ambrotypes or dags, they are magnetic, making it very easy to identify them. Early tintypes came in cases, but to keep costs down they soon were given a coat of lacquer to prevent scratches and were placed in paper folders. Many tintypes were tinted before having the lacquer applied (Figure 3-29).

The tintype process, because it's so similar to film developing, was still occasionally found at carnivals and county fairs well into the 1970s, so there are significant numbers of real tintypes that are not even antiques.

Figure 3-29 This tintype of an unidentified family in Ontario, Canada, really shows the passage of time. (Archives of Ontario, 10024785.)

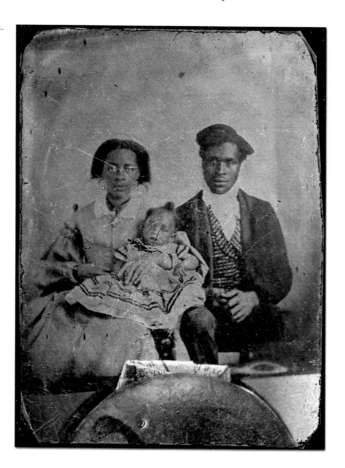

Albumen Paper Print

Heyday: 1855 to 1905. Less common: 1905 to 1925.

Paper prints from the pre-film era are much lower quality than other antique prints. However, being very inexpensive and a good way to make prints in multiples, they were used for a variety of purposes, ranging from the carte de visite (essentially a business card with a small picture and a signature) to cabinet cards, which were larger portraits. Stereographs were two pictures shot from slightly different angles, as seen on the left in Figure 3-30. They were the first attempt at mimicking the way our binocular vision works with photography. Placed in a viewer, they would give the impression of 3D images. Stereographs were a very popular form of entertainment, like watching The Travel Channel is for some people today. Families would get together in their living rooms to share stereograph pictures (Figure 3-30, right).

Paper prints were also used to duplicate the one-off hard picture processes, so there are many albumen prints that have a vignette effect not for artistic purposes but because they are really copies of tarnished daguerreotypes.

Figure 3-30 A travel stereograph from 1906 might have been passed from hand to hand at an after-church family get-together. (Library of Congress.)

ANTIQUE SCAMMING

An antique photo scam can take different forms. The first is by making new photos look old. That's easier with paper prints than it is with any other photo types, but the photos themselves are also less lucrative. A scammer needs to have a mini-assembly line going to get a good return on volume and must also concentrate on rare subjects or photo sizes.

Another method is to pass off an old photo as one that is more expensive. Since such a small percentage of photos have identifiable subjects, faking an ID by putting a note on the back is the simplest method to increase value. The other way to up the price is to fake a signature on the front of a picture of a famous photo subject. Hundreds of Abraham Lincoln carte de visite pictures were printed for family collectors, so they are worth very little. But fake Honest Abe's signature, and the price skyrockets.

A variation of this scam is to sell as vintage an image that was created in modern times using an antique process (Figure 3-31). Legitimate photographers from the 1960s to today have been creating tintypes and ambrotypes for history buffs. These images can find their way into the open market as vintage photos.

Figure 3-31 This really is a tintype, but it was photographed in the twentieth century.

Because the process is real, these scams can be very hard for the average person to recognize. The only way is to become familiar with the materials that have been substituted because the old ones are no longer available and to be suspicious of certain claims. Some things to watch for as you shop:

- Daguerreotypes were not made during the Civil War, so claims that combine this process with events from the 1860s are false.

- People in the 1800s were a lean and hungry bunch. Only the very richest could afford to be plump. Unless the subject is a wealthy middle-aged banker, beware a man without cheekbones.

- Images of American Indians and African-Americans are rare. A seller with a stash of these is probably manufacturing them.

- Tinting is easy, but gold tinting, common on buttons and epaulettes in the vintage era, is very hard to do well.

Being the easiest to cover up and requiring the least work, misrepresentation is the most frequent form of fraud. The seller can hype the quality, type, and condition of the photo through creative description and alteration of the online image. If fraud is mostly about pretending to authenticity, that makes image editing one of the most important parts in the package.

Putting the Faux in Daguerreo

Because it is the rarest and therefore the most lucrative photo type, the daguerreotype is the gold standard of antique photography. In fact, some pictures with unusual subject matter, like Indians, African-Americans, or sickbed portraits, can earn prices into four figures. However, a scammer runs up against a problem: the nature of the daguerreotype process itself. It is difficult and time consuming and requires many specialized and finicky steps. There are some modern photographers who have mastered the process, but most do it out of fascination with the results, not to defraud.

A fake daguerreotype could never stand up to serious examination, so how does the trade persist? Serious examination is the exception, not the rule. It costs so little to create a fake that a $50 sale turns a tidy profit and even makes both parties happy—the buyer thinks he's spent almost nothing for an $800 antique. Should the buyer look carefully at the product and scream foul, the seller can apologize profusely, claim that they were scammed as well, and cheerfully return the cash.

So a scammer must sell the sizzle at a price that prevents the buyer from looking too critically at the product he receives. Photoshop can bolster both the sales and the satisfaction.

The picture in Figure 3-32 was advertised for sale on eBay as a daguerreotype. It is almost definitely a fake and has gone through at least two stages of cleanup—the first possibly in its creation.

Figure 3-32 This eBay image, advertised as a daguerreotype, was sold on eBay for $127.50.

The merchandise shot appears to have been photographed with a flash, based on the sharp reflection on the edge of the oval frame, but there is no reflection from the picture's metal surface. That's not impossible, but it is very difficult, because a daguerreotype is essentially a mirror.

More seriously, if this is really a daguerreotype, the image should be oriented as if the person were looking in a mirror. If the image is accepted at face value, that means that the man in the picture is writing right to left on the paper with his left hand.

When you zoom in on the picture, the vest appears to have been altered to make it appear that it is buttoned in mirror image (Figure 3-33). The watch fob is smudged, and there is an almost straight line of edit on the right side of the buttons where the real opening of the vest probably was.

This editing is the tipoff that some seller along the way was not an innocent bystander. Newbies in the antique photograph trade are warned to look at the direction that women's and men's clothes are buttoned. But nowhere is it written to consider the writing arm. The fraud wasn't caught because it looks "right" to anyone accustomed to seeing pictures in our usual orientation.

Figure 3-33 The vest and watch fob have been edited.

The latest seller, however, did not do the original creation of the "daguerreotype" itself. He purchased the piece a month before for $55 less, so he made a tidy profit. The image from that sale shows problems with the watch fob and vest, but it also displays a much more bedraggled object (Figure 3-34). The glass could have been carefully cleaned, but it's unlikely that a daguerreotype in a sealed case could be so thoroughly rejuvenated in the month between the sales…except through image editing.

Figure 3-34 The seated-man picture as shown on eBay for its previous sale.

The online state of affairs is unlikely to change as long as there are people willing to collect and other people willing to help them do that while helping themselves to a profit at the collectors' expense. Even if online auctions try to do a better job of safeguarding their buyers, they are ultimately limited by the format. Unless they are willing to hire real experts and investigators and ensure honest auctions—a move that would completely ruin their profit model—*caveat emptor* will remain the only law.

PART II

PROFESSIONAL MISCONDUCT

We live in a political world

Under the microscope

You can travel anywhere

And hang yourself there

You always got more than enough rope.

—Bob Dylan, "Political World"

MAKE MELDS AND INFLUENCE PEOPLE

ALL POLITICS IS LOCAL. The rule hasn't changed, but the definition has. Now local is determined by how many clicks take you from one Web site to the next. On the Internet, a county clerk with a $10,000 war chest can be one click away from party headquarters. With everyone connected, close state representative races can come under the same microscope as national ones. And that microscope can sometimes turn up some nasty bugs in high and low places.

POLITICS AND PHOTO FRAUD

Every campaign season, the Internet is flooded with fake political images, brought to us through the simplicity of computer image compositing. Some people simply discount the political torrent as a trivial example of bad art online. That's a mistake. Propaganda and Photoshop are a match made in, well, some place otherworldly. After sex and celebrity, political propaganda is the most pervasive motivation for defrauding with Photoshop.

Propaganda is an enormous topic, since its history overlaps advertising and all modern forms of mass communication. What follows here is just enough background to put it, and its photographic handmaiden, into context.

The Birth of Propaganda

From the Latin *propagare*, propagandize once meant merely "to spread." It wasn't until the beginning of the twentieth century that propaganda took on its modern sense, as the spread of an idea with the goal of influencing public opinion. The concept, however, is as old as organized religion and the political state. It crops up in political treatises ranging from Machiavelli's *The Prince* to the Indian book of statecraft, the *Arthashastra*.

Why a new word for an old concept? The era leading up to World War I was one of massive political and social change, with the end of many monarchies and the birth of new mass movements and theories. Statecraft and the role of the citizen had undergone a profound change. People were mobile, more of them could read, and newspapers (the first mass media) allowed information to travel quickly. Leaders still needed a cooperative populace, but they now needed to convince as well as control.

One of the new ideas born in this era was that masses of people could be molded to think, feel, and act in specific ways by the systematic application of selective information. If this sounds like marketing and advertising, that's not surprising. Edward Bernays, Freud's nephew and a man who is remembered mostly as the father of public relations in the United States, was also the first practitioner of psychology-based propaganda. He made no distinction between the two spheres; the only difference was the product.

World War I offered a perfect laboratory for his theories, which proved enormously successful. British political propaganda so successfully branded Germany as an evil empire of Huns that the royal family, cousins of the German royal house, had to change their name from Saxe-Coburg-Gotha to Windsor. Bernays masterminded America's entry into the war on the British side through a vitriolic campaign that accused Germans of horrific atrocities, including bayoneting babies (Figure 4-1). Unlike the real horrors of WWII to come, these stories were all either total inventions or updates of atrocities from prior wars.

Figure 4-1 Reminding the public of the 1915 sinking of the British ship Lusitania, *this poster shows the German navy as a colossus, gutting the innocents in its path. (Library of Congress, Prints & Photographs Division, WWI Posters, LC-USZC4-4963.)*

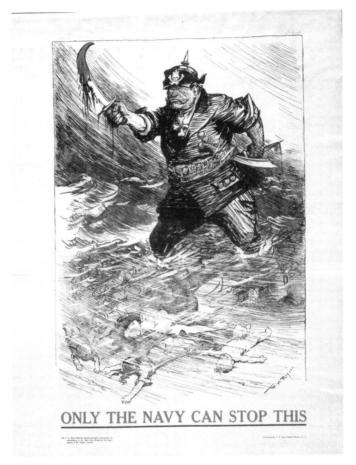

ONLY THE NAVY CAN STOP THIS

The success of these campaigns had an enormous influence. Not only would they result in the birth of marketing, PR, and the advertising industry, they would serve as the template for growing and disseminating both fascism and communism. Both Germany and Russia suffered major political upheaval at the end of the war, and both, after a brief period of openness and social ferment, came under the thumb of tyrants. Hitler and Stalin had even fewer reservations than Bernays did about using propaganda as a tool of control.

Propaganda 101

Not all propaganda is pure falsehood. As characterized in Propaganda and Persuasion *by Garth Jowett and Victoria O'Donnell, there is a continuum that runs from truth to complete fabrication.*

The first level is white propaganda. The source of the information is known, and the information itself is generally true, but may only tell a part of the story. It's slanted to prompt positive feelings toward the source or its goals.

Grey propaganda, like its name, is shadier. A seemingly neutral party (like a TV station) might be publishing the information, but the content is provided (by leaks or direct dictation) by the source. The information itself is a careful mix of truth and lies. Spin doctoring is a good example of grey propaganda. When nothing but a bald-faced lie will do, the propaganda is black. The information is dis-, and can range from sly innuendo to loud accusation.

No matter what the color, effective propaganda relies on a group of underlying concepts. From fascist posters from the 30s to this month's online jab at Hillary Clinton or John McCain, these strategies are the foundations of persuasion.

Symbolic Transfer

Symbolic transfer is the deliberate effort to shift the qualities of a symbol to another object. If you put a lion in a deodorant ad, you're trying to equate the strength and grace of the king of the beasts with the product. Further, you imply that if you use that product, people will see you as regal and powerful as well. The poster in Figure 4-2 relies on both the general qualities of the lion and its specific role as Great Britain's equivalent of the American bald eagle by playing on the dual concept of the pride.

Symbolic transfer can be positive or negative—imagine putting a snake on a can of soda instead of a red bull. No sane advertiser would do it unless they were advertising the competition. In the Italian poster in Figure 4-3, the poisonous snake is cleverly decorated with copies of the German Iron Cross. Even without the translation, the meaning is clear.

Figure 4-2 This poster tries to convince other countries in the British Commonwealth to send their young men to serve in the British army in World War 1. (Library of Congress, Prints & Photographs Division, WWI Posters, LC-USZC4-10913.)

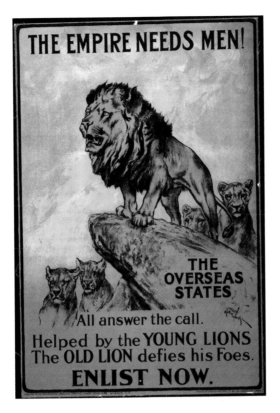

Figure 4-3 The translation of this Italian World War I message: We're strangling the German snake...Time to defang it. (Library of Congress, Prints & Photographs Division, WWI Posters, LC-USZC4-12065.)

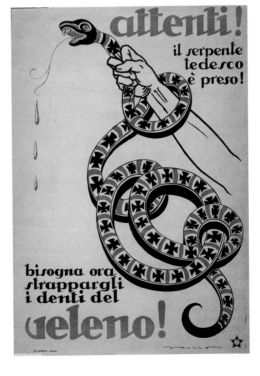

Identification

Identification is a bit like symbolic transfer, but for people, not things. It takes advantage of our desire to admire a person and be like him (Figure 4-4). The transfer can take place between the main focus of the image and the person (or symbol) shown with him, or between the image focus and the person viewing the image. For example, a politician might stand proudly in front of a waving flag, or with a little more subtlety, she could shake hands with a revered older statesman.

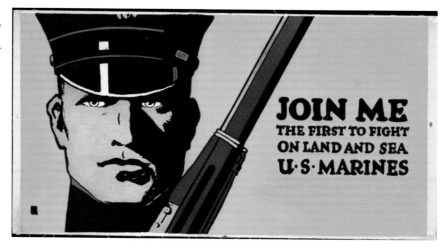

Figure 4-4 *The idealized Marine is there to convince young men that if they enlist, they too can reach mythic proportions. (Library of Congress, Prints & Photographs Division, WWI Posters, LC-USZC4-10018.)*

Objectification

Objectification is the opposite of identification. Instead of getting up close and personal, it pushes the subject away. The ultimate in objectification is to equate a subject with something horrific and morally debased, as the examples in Figures 4-5 and 4-6 illustrate. In American society, smoking is fast becoming an antisocial act. To quickly objectify a villain in a story, sometimes all you need to do is show her with a cigarette in her hand. Substitute a cigar for the cigarette, and you not only have a villainess, you have a rich and arrogant one who smells bad.

Belonging

Most people want to be admired and loved, particularly by people who are obviously admirable and desirable themselves (Figure 4-7). Propaganda takes advantage of this need by offering admission to a group. In a political campaign, the group may be a cadre of square-jawed soldiers. It might be a happy extended family or even several people working to build a new home for victims of crime or disaster. It may offer a chance to be included in a supportive family or society.

Figure 4-5 This bloody arm rises from the waters like a shark, poised to attack the defenseless American ship in the background. Buy war bonds, or hear the Jaws *theme. (Library of Congress, Prints & Photographs Division, WWI Posters, LC-USZC4-3349.)*

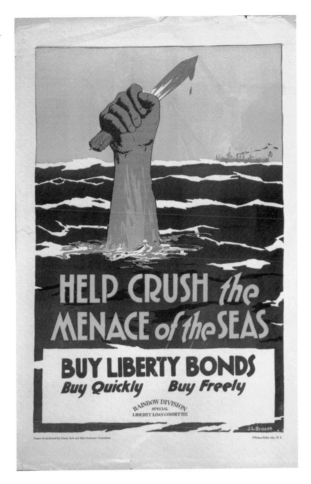

Figure 4-6 Two fiends, one of them looking suspiciously like Kaiser Wilhelm II of Germany, are checking out the monthly murder report. (Library of Congress, Prints & Photographs Division, WWI Posters, LC-USZC4-2794.)

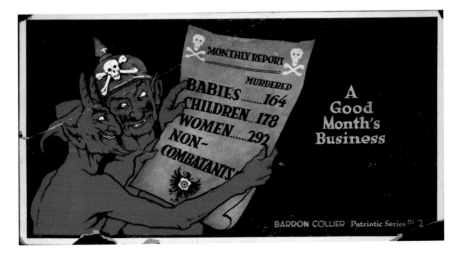

Figure 4-7 Wives, girlfriends, and children will look up to the man who joins the army to fight for Britain in this World War I poster. (Library of Congress, Prints & Photographs Division, WWI Posters, LC-USZC4-10915.)

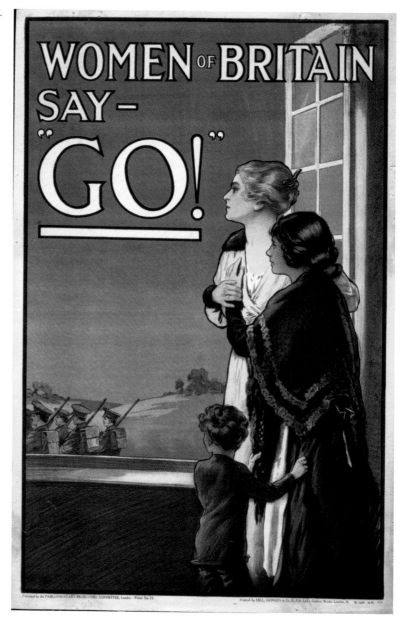

Consequences

In case you aren't sure about how you feel about an issue, effective propaganda will help you make up your mind by linking your action to positive or negative consequences (Figure 4-8). Show your political opponent making a speech against new taxes, then show schools being closed in a neighborhood, and you connect a negative outcome with a vote for your opponent.

Figure 4-8 The consequences of inaction hardly get worse than this. Long before disaster movies, this poster shows a shattered Statue of Liberty above a fire-bombed New York. (Library of Congress, Prints & Photographs Division, WWI Posters, LC-USZC4-1347.)

Raw Emotion

Get past the mind to the heart, and there's nothing you can't move. Baby animals caught in traps or killed push past the intellect directly to the emotions. In propaganda, you could connect slaughter to the policies of your opponents, either by implying that they are directly responsible or that they are willing to allow horrible things to happen through sloth or greed. Most successful attempts to mobilize for war depend at some point on raw emotion to galvanize the population (Figure 4-9).

Figure 4-9 *As politicians are well aware, it's all about the children. This poster tugs at the heart very successfully, even close to a century later. (Library of Congress, Prints & Photographs Division, WWI Posters, LC-USZC4-9655.)*

OUT OF THE STUDIOS AND INTO THE STREETS

Mass propaganda began with text, expanded to illustration, and reached its most persuasive heights with photography. Unquestionably, it is the photographic image, real or false, that carries the biggest stick in the propaganda arsenal. Major advances that made image production fast and affordable conveniently coincided with Bernays' theories.

Although photography had existed for decades, not until the pairing of flexible celluloid film with the Kodak Brownie camera in 1888 could anyone, not just a studio artist with special equipment, afford to take a picture. Suddenly people brought their little cameras with them everywhere, documenting the large and small events of their lives (Figure 4-10).

Figure 4-10 This original 1900 Kodak Brownie was simplicity itself compared with any other camera, before or after. Its only add-on was a viewfinder. (Courtesy Regis Boissier, candidcamera.free.fr.)

The government, the military, and the press, also had cameras everywhere, but they were hampered by technology. It was possible to tell a story quickly in text by using the telegraph and typewriter. But photographs were what gave reality and presence to stories, especially those that were geographically distant, and the public loved them.

The hitch was that photographs couldn't be printed as they were shot. They had to be sent out for etching, which had two deficits. First, etching took time, so you couldn't include an image in fast-breaking news events. Second, etching was really the creation of a new illustration, not an exact copy of the photo. The message and impact of a war correspondent's photos depended on the interpretive artistry of engravers. The image and its impact almost always changed in the translation (Figure 4-11).

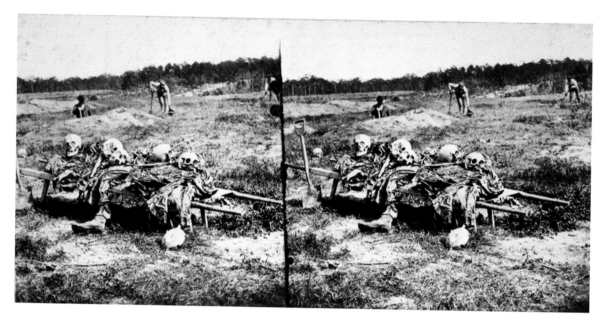

Figure 4-11 A stereograph by groundbreaking Civil War photographer Alexander Gardner (above). The result recomposed and interpreted by the Harper's Weekly *engraver (right). (Above: Library of Congress, Prints & Photographs Division, LC-USZC4-1854; Right: Library of Congress, Prints & Photographs Division, WWI Posters, LC-USZ62-98262.)*

Finally, in 1897 it became possible to print half-tone images on full-speed newspaper presses, allowing immediate illustration of local stories. In 1921 the last puzzle piece dropped into place with the development of the Wirephoto, a paper-based FAX machine that allowed instantaneous transmittal of images along with text. Initially, the quality left a great deal to chance. The bigger the image, the more time it would take to transmit, and the more likely that the transmission would be interrupted or garbled. It was not until 1935 that all the major news services had dependable Wirephoto systems, finally making it standard practice to send photos internationally.

Image for Propaganda

To use photography as a persuasive tool, you needed to shoot a photograph that illustrates your point. Ideally, you'd have a stringer conveniently on the scene. The problem, which is still true today, is that many important events don't send out invitations before they take place. For example, New York City has a population of over eight million, and a large percentage of New Yorkers own a camera. Yet there are comparatively few shots of either airplane hitting the Twin Towers, and an even smaller subset of those images were shot by professionals.

To solve the problem of creating appropriate visual propaganda, governments or other large organizations have some options. First, there's the planned event. The whistle-stop tour is a proven winner and is often used to generate photo opportunities. You can increase the possibility of good material by sending in ringers to ask useful questions of a touring candidate or official. But a planned event is publicized and can be hijacked. Opponents can bring protesters to the scene in the hopes of sparking a confrontation.

Alternatively, with a pool of extras and time, you can re-create an event. This was a favorite tactic employed by the Russian Bolsheviks for important political events that had taken place at night, when photography was very difficult.

Or, if the event never happened but should have, you can stage it. Wars are particularly good candidates for staged photos, because there is so much chaos surrounding them and so few unbiased witnesses. The German military was accused of staging pictures of British bombings of Red Cross trains in 1917. Staged photos for propaganda purposes are becoming embarrassingly frequent in the Middle East.

Enter Photomontage

All of these strategies required planning and resources and weren't always practical. What if you wanted your candidate deep in conversation with someone who was already dead, or needed to show a turnout of thousands for a meeting that only drew hundreds? Thus was born the use of photomontage as a propaganda tool.

Photomontage was spearheaded by the Dadaists, who were antiwar socialist activists in Germany during World War I. At first they cut out pieces of photographic images from books and magazines and combined them with their own illustrations. Figure 4-12 shows an example of one of the first photomontage pages by George Grosz, one of the most important and well-known of the Dada artists. Some of them went on to work with original photo prints and brought the technique to Bolshevik Russia after the end of the war. In both countries, their rulers adopted photomontage as a primary tool for persuasion through imagery.

Dissecting a Propaganda Montage

Josef Stalin found photomontage particularly useful. Sometimes he used the technique to insert himself into historical contexts where he was never present. In particular, he found it useful to enforce his fictionalization of himself as the right-hand man and chosen heir of Lenin.

In fact, Lenin had clearly come to mistrust Stalin, but far too late. In 1922 Lenin had already had the first in a series of strokes that would leave him helpless and mentally impaired and eventually lead to his death in 1924.

In the picture seen in Figure 4-13 supposedly taken in 1922 soon after Lenin's first stroke, Lenin and Stalin pose amicably for the camera. So how do we know that this image is faked? There are several clues hidden in plain view.

Figure 4-13 This 1922 meeting between Lenin and Stalin almost certainly never happened. (Courtesy David King Collection.)

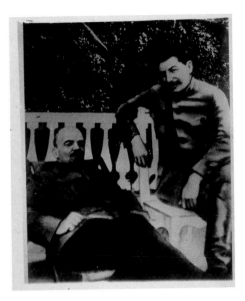

This photo is a composite of at least two separate originals, both of which have been heavily retouched. There are even hints to suggest that a third image was used to provide a background for the men. The following telltale hints point out the most obvious clues that this image is a fiction.

Telltale #1: Since this is an outdoor daylight picture, the primary light source must be the sun. Look at the strong light on Stalin's clothes and face (Figure 4-14). He was shot in bright sunlight coming from the front and to his left. Yet most of the light on Lenin comes from the opposite side, and it is considerably less strong. For Stalin, it's a bright sunny day. For Lenin, the day is cloudy and the light diffuse.

Figure 4-14 Only Lenin's hand and a bit of his jacket are bright, and the jacket has been touched up unskillfully with a brush.

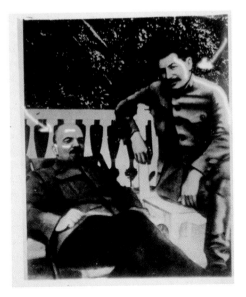

Telltale #2: The chair that Stalin sits on has been painted into the picture and disappears under his legs (Figure 4-15). Unlike Lenin's lounge chair, it casts no shadow. Neither does Stalin's leg, which should be blocking the light from reaching the space below the chair. Stalin was probably sitting in a different style of chair that didn't fit with the outdoor scene of Lenin's veranda.

Figure 4-15 Stalin's chair has no background beneath it and fades away.

Telltale #3: The balustrade behind the two men is two-dimensional, like a cutout pasted in place. As indicated by the straight line in Figure 4-16, the balustrade is neither straight nor parallel to the ground. The highlight shows that the pattern of the balustrade warps and falls apart behind Stalin's chair.

Telltale #4: Subtle but clear…the two men are looking at two different cameras. As indicated in Figure 4-17, Stalin's cameraman is in front of him and slightly to the left. Lenin is looking into a camera that is slightly to his right.

Figure 4-16 No shadows fall on the balustrade, nor does it have edges that suggest thickness.

Figure 4-17 Each man is looking at the cameraman, but that person is differently positioned for each of them.

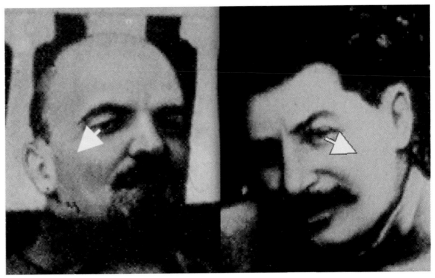

Spotting the Propaganda Fakes

The photomontage is still alive and well as a propaganda tool. In fact, it's more prevalent than ever because Photoshop tools make the task so comparatively easy. Although we're at the dawn of technologies for identifying faked images, such software is unlikely to be available to average viewers, who will still have to determine truth from falsehood for themselves. Fortunately, although there are many extremely talented and meticulous compositors, most people are less gifted and sloppier. It's a fact that, at least for now, most falsified imagery is discovered by a sensitive or suspicious human eye.

Innocent elements, properly altered and put in the right context, can be used for disinformation, which doesn't make every composited image into propaganda. Even some montages with political content don't qualify. Many are satire or just gross sophomoric fun.

Some quick reasons to suspect that an image is a propaganda composite include the following.

Source

Is it posted anonymously, or does the person who has posted it not know who shot the image or where it came from? Lack of attribution is important for low-quality images that are passing as real, because the files used have probably been appropriated illegally.

Quality

If you've found the image on the Internet, can you find any large versions of it without bad JPG artifacts? Most of the time, like with the Kerry–Fonda image (Figure 4-18), there is only a small, bad-quality JPG because the image was created with small, compressed files, not an original. In fact, some files are so useful they get picked up, edited slightly, and resaved again, with each version dipping in quality.

Unless the person who posted the file had access to a real photograph or high-resolution digital image, no matter how hard you search for a file size larger than 50k, you won't find it.

Benefit

Who stands to gain? If the sources and their cause benefit mightily from the image, alarm bells should ring.

Likelihood

The nastiest propaganda is the stuff that you already believe is true. The Kerry–Fonda fake newspaper image and the image of Bush reading a children's book upside down were both extremely effective because many people were prepared to believe them.

THE BEST OF THE WORST

Now that we know what's being manipulated and why, it's time to analyze a few examples of montage propaganda. Some of these are crude attempts, but even the crudest have adherents who believe that they are real. The Internet blogosphere includes an army of watchers on both sides of the political spectrum who look with vigilance for any opportunity to unmask a fake. Like them, we can use a little visual investigation to reveal some of the hints that these are false reality.

Fonda Fakery

A really effective piece of propaganda is one that rests on a small kernel of truth and an already present belief. Combine the two, add a heaping helping of untruths and illegal intellectual property, and the propaganda is sure to develop a toxic half-life. The infamous picture of John Kerry and Jane Fonda is such a document (Figure 4-18). It combines all of the best principles of propaganda identification, objectification, and raw emotion to speak very directly to a targeted audience.

Figure 4-18 This image purports to be a newspaper clipping from the 70s of John Kerry and Jane Fonda sharing a stage. (Portions copyright Ken Light and Owen Franken.)

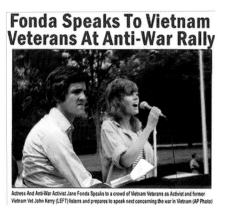

At the time, John Kerry was the Democratic Party's presidential candidate. The kernel of truth was that he served in Vietnam but came home as a vocal peace advocate. At a time of growing controversy about another war, someone thought it would be great fun to identify him with something anti-American. Jane Fonda would be perfect. Her trip to North Vietnam was not merely ill considered. It remains a touchstone of hatred and contention decades later. The only problem was that there wasn't a good picture of the two of them together that would imply that he supported her actions. Enter Photoshop.

The two images used for this collage were shot a year apart by different photographers, each of whom retains copyright and would have been unlikely to have freely given rights to create this derivative work. In fact, Ken Light, the photographer who shot the Kerry half of the false image, has sued the person suspected of making the photomontage for infringement.

Combining two grayscale images is generally easier than doing the same with two color photos, but in this case both had similar light source directions (usually a dead giveaway). The difference can be detected with software but is next to impossible to notice with the naked eye (Figure 4-19). Adding the faked news headline and caption provided a sense of context and fake reality that the image alone might not have had.

Figure 4-19 Most of the image was a photograph by Ken Light. The image of Jane Fonda, in red, has been grafted onto the original.

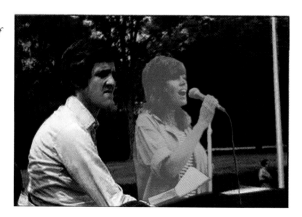

A Presidential Flip-Flop

There's more than one way to create political "dirty trick" propaganda, and it doesn't always have to play on anger. The same "kernel of truth" concept can be delivered through satire or humor. The person who created this Photoshop special had a popular idea but a bad sense of 3D orientation (Figure 4-20).

There are three clues that this edit is a hoax. As you can see from the overlay of lines on the mockup of an upside-down book (Figure 4-21) that is based on the one the girl is holding, the dark mark on the spine was never repositioned from top to bottom. The second clue is that the picture isn't shaped right for the back of the book. It's too wide, and there's no white margin on the right.

The last clue requires a little thinking about vanishing points. All the straight lines on the book should be parallel, as they are on the mockup. A glance back at the book Bush is holding shows the picture off-kilter on the back.

Figure 4-20 Bush apparently holding his book copy upside down.

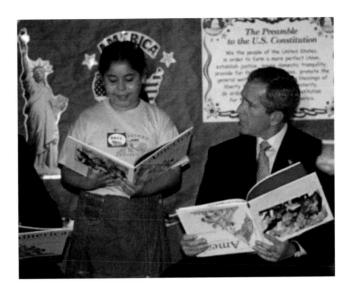

Figure 4-21 This mockup shows what a real book held upside down would look. The arrows point to the spine and margin. The green lines are parallel to each other.

Appropriation Is the Sincerest Form

Sometimes you know exactly the look you need for an ad for your client. There's got to be energy, enthusiasm, and excitement. But it's just so hard to find exactly what you need in a campaign photo. Hey! Look at this one! With just a little editing it could be the perfect background (Figure 4-22).

Well, it was perfect, until the image theft was discovered. The discovery would have been awkward no matter what. But Bret Schundler was running for governor of New Jersey as a Republican. The campaign photo that an eager staffer appropriated as background for the online ad was not merely stolen—it was stolen from a memorable photo from a well-publicized Dean for America campaign rally. And there were lots of Dean staffers (some from New Jersey) who could identify themselves in the picture (Figure 4-23). Oops.

Figure 4-22 A shot from the Schundler for Governor campaign gear site.

Figure 4-23 The original image, shot for the Dean for America campaign at Falls Church, Virginia in 2004. (Image courtesy John Pettitt/Cloudview.com.)

It turns out that the same marketing firm that did work for Dean had the Schundler account. The campaign pulled the image when the problem went public, saying that they had been aware that the image had been from a different campaign, but not that it had been from Dean's. But the fact that no one thought this unpaid appropriation was a problem before the ad was posted is a reminder that there is no ethical propaganda.

No one ascribes this gaff to the candidate himself, who by all accounts had no input on this embarrassing decision. But it's the kind of publicity that makes people laugh, and when you're running for office you want the public to be laughing with you, not at you.

Help for the Height-Challenged

No one expects politicians to tell the whole truth. But at least if they're going to lie, you hope they'll do it with finesse. Howard Kaloogian's 2006 campaign failed to rise to that expectation. Some of his issues had to do with invented or misquoted endorsements, hardly a Photoshop issue. But they raised a flag with the gotcha blogosphere crowd who called him out on several image-related issues.

The most relevant for propaganda purposes was a formal photo of Kaloogian and President Bush. Having your picture taken with a statesman you admire is a standard "identification" strategy. But there's something wrong with this picture. The two men are literally arm-in-arm—so close, they've practically merged (Figure 4-24).

Figure 4-24 A campaign photo of Republican candidate for California congress Howard Kaloogian, with President Bush.

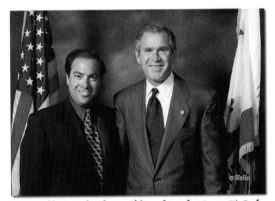

Honorable Howard Kaloogian (left) and President George W. Bush

With a little help from image forensics it's easy to see that the image has been altered. In Figure 4-25, Color Deconvolution software (see Chapter 1) shows that the two suits overlap. In Figure 4-26, to confirm the original forensic analysis, the colors of the two suits are sampled. Although both mens' suits appear to be neutral colors, Kaloogian's suit has a warm cast to it (left color sample), while the President's suit has a cooler magenta tinge.

Was the photo a fake? The lighting on both faces indicates that both men were in the same room at the same time. The highlights on the foreheads match well. But George W. Bush is 5' 11". In the photo, Kaloogian looks to be about 5' 8", yet pictures of him elsewhere imply that 5' 6" is a better guess. In raising his shoulders, the artist didn't raise his stature.

Figure 4-25 Color Deconvolution software (see Chapter 1) shows that Kaloogian's suit color bleeds into and overlaps Bush.

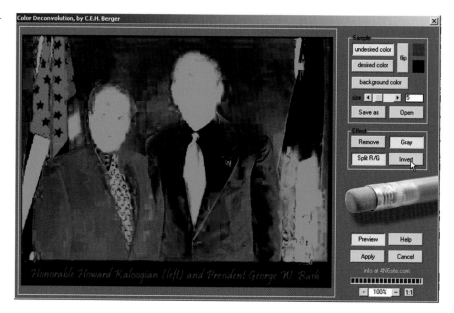

Figure 4-26 Checking sampled colors in Photoshop adds confirming evidence to the Color Deconvolution analysis.

A Great Way to Increase Enlistments

Photomontage is a convenient propaganda tactic in more ways than one. It's both practical and inexpensive. Crowd scenes, as Hollywood knows, involve hundreds of extras, yet most people never look at the field of faces. As 3D computer graphics improve, not only science fiction characters but even human extras will be replaced with terabytes.

Stalin's artists were the first to recognize the cost-effective aspects. Instead of having to find a group of willing workers to create a wall of faces behind their leader, a photomontage of a Stalin colossus and pictures of reusable workers could be whipped up by a montage artist instead (Figure 4-27).

Figure 4-27 This 1930 photomontage is composed of many repeating images of workers, literally standing behind their glorious leader. (Courtesy David King Collection.)

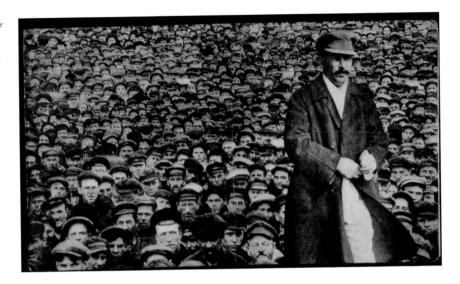

It's hard to think of Stalin as a role model in this day and age, yet any "new" visual idea has probably been thought of before. In this case, the Bush campaign already had footage available, but it didn't exactly meet their needs. Rather than trim the scene or select other material, they figured that a little cloning wouldn't hurt. To be fair, most probably the people who were responsible for this error of judgment never saw the original montage that it resembles (Figure 4-28).

Figure 4-28 To fill in an edited part of this campaign video, groups of soldiers have been duplicated several times. Each duplicated soldier is indicated with a color-coded rectangle.

It's the Middle East—
You Can't Trust Anything

This picture (Figure 4-29) supposedly showing a Christian Lebanese militiaman shooting at Lebanese soldiers was broadcast on Lebanese TV by General Michel Aoun, a member of the Lebanese parliament and former Prime Minister of Lebanon. This photomontage combines the work of professional photographer Bruno Stevens with a generic background shot (Figure 4-30).

Figure 4-29 The comparatively crisp shooter does not match the light or overall lack of sharpness of the background.

It's almost surprising that this picture passed muster, but it was originally shown on TV where resolution is likely low. To match the background, the shooter's face should be bright with dark shadows on his neck, since he would be facing the sun if he were really on the scene. In the original photo, which had been published months earlier, there is no militia logo on the shirt arm.

Figure 4-30 Without the shooter, this original picture just shows some soldiers gathering while people look on.

The Case File: The Great Russian Rubout

Stalin brought the creation of propaganda through photography, montage, and retouching to a surreal height. Never before or since has there been so thorough and successful a campaign to control not just people's opinions, but the reality of their own personal histories. Whenever a party leader was purged in fact, he was also eliminated from all books, paintings, and photographs.

The tools for this removal ranged from the crude to the surgically precise. A party functionary might just take a knife or scissors to a picture, leaving gaping holes where the purged once were. Sometimes the easiest thing to do, especially with a photo containing many purged members, was to crop the photo down. Often only Stalin himself remained. If the offending person was in the middle of a shot, he could be inked or airbrushed out, replaced by a soft-focus blend or copy of the background. The Photoshop Clone brush would have been a Soviet artist's best friend in the 30s.

The most creative solutions involved a combination of techniques, by cutting away some people, airbrushing vestiges of their existence, and recomposing the picture as if they had never been there. This case study shows how the same task would be done with Photoshop tools.

But to even the playing field, instead of removing people around Stalin, we get to remove the rubout artist himself from a conference held in Teheran with other Allied leaders in 1943 (Figure 4-31).

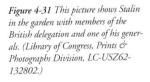

Figure 4-31 This picture shows Stalin in the garden with members of the British delegation and one of his generals. (Library of Congress, Prints & Photographs Division, LC-USZ62-132802.)

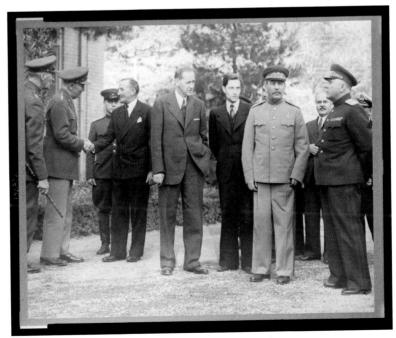

Like the Soviet apparachniks, we won't worry about collateral damage. Our goal is to delete Stalin, but it will be much easier if we don't try to retain everything currently in the picture...or everyone. That means the man with the moustache will have to disappear as well. We also are under no obligation to keep the dimensions of the finished photograph...no one will ever know.

The easiest way to remove Stalin is to cover him with someone else, since we can't just cut off the right side of the picture—two people are looking over in that direction. The general in profile looks safe and has an ample belly to help us out.

Before we try anything time consuming, it's good to figure out where our general will end up. This gives us something to work from and helps us determine how much masking to do (Figure 4-32).

Figure 4-32 The two vertical lines help to align the general in his new position, which will cover Stalin easily, account for the action in the photo, and result in the least amount of work.

Before Photoshop, artists would physically cut the photo where we only have to move pixels. Then they would have to use a thin blade to cut away the excess on the left edge. We'll use Quick Mask to do a better, more believable job.

The Quick Mask button is on the Photoshop toolbar (Figure 4-33, left). Once in Quick Mask, it's best to work in three stages. First, use a medium-sized hard-edged brush to outline the general, without worrying too much about getting the outline perfect (Figure 4-33, center). Next, switch to a smaller brush to touch up the places you missed. Use the Eraser tool to delete portions of the mask if you go too far outside your target. When you have an inline that creates a closed shape, use the Fill tool to paint the center (Figure 4-33, right).

Figure 4-33 If you are going to move a large area, filling it is faster than painting it.

The general is painted carefully on the left, but we don't have to bother much with the right, as long as Stalin is covered.

To make the edge as clean as possible, you can press Q to turn your Quick Mask into a selection. Press Cmd+J and your selection becomes another layer. Temporarily turn off the background, and you can see how good a job you've done (Figure 4-34). If you're not satisfied, step backward, press Q again, and return to Quick Mask to fix your mistakes.

Figure 4-34 The general needs to be cleanly separated from the background in front of him.

Once you have a clean edge, go to the Refine Edge dialog box to feather the edge to make the transition between the background and foreground smoother (Figure 4-35).

Figure 4-35 The Refine Edge dialog box lets you smooth, expand, or contract your edge globally.

The general will need a little touchup, but before we do that we still have a piece of Stalin's jacket as a reminder of his existence. Fortunately we have an easy solution. In Stalin's time, an artist would have to use pen and ink to re-create the rest of the dark pinstripe suit. But since the owner has one visible shoulder, we can easily make a second one. Select the left shoulder and flip it horizontally (Figure 4-36). Move the shoulder into place in a layer between the background and the general's layer.

Now that we can see his entire left edge, it's safe to touch up the general. The cleanest way to do that is to sample a shade from the Background layer to paint with. Lock the transparency of the general's layer so you won't inadvertently paint where there isn't any edge, and use the brush to delete any light fringe you find (Figure 4-37).

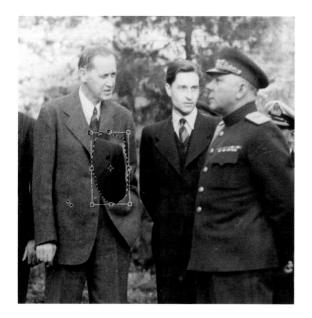
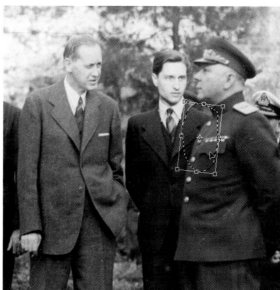

Figure 4-36 Delete any excess above the suit with the eraser on a fine setting.

Figure 4-37 A slight fringe shows around the general's mouth on the left, but it is clean on the right.

All that's left is to make a good transition in the trees above the rubbed out Stalin and the general. Use the Eraser tool at about 25% transparency to selectively allow more of the tree to show and blend the general's background into the original. Stalin is nothing but an ugly memory (Figure 4-38).

Figure 4-38 Crop the image down to its new size, and enjoy the poetic justice.

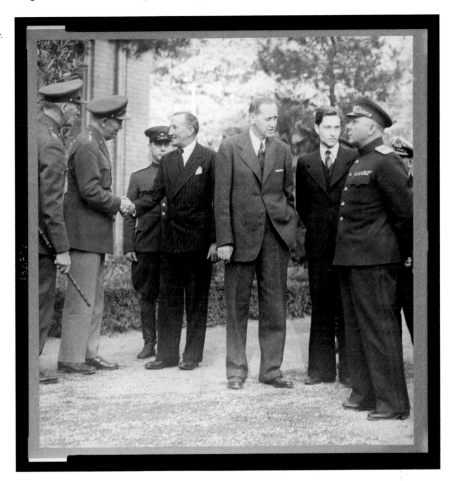

Propaganda is generally a political tool wielded by an organization. But from the beginning, its most effective delivery system has been the press. Sometimes the press is in complicity, knowing that the information is being fed to them and using it anyway. Other times, like the consumer, the news establishment is clueless and is used as a vehicle for an ideological or personal agenda. The next chapter takes on the fakes and frauds of the news profession.

Chapter 5

Editorial License Revoked

IN A FREE SOCIETY, we assume that we have a free press, which means that journalists and media outlets are not officially controlled. They can report facts and publish editorial opinions instead of official disinformation. Alas, having the right to report honestly doesn't mean that our news is untainted. Deliberately or inadvertently, the media can both create and disseminate false news and propaganda.

FAUXTOJOURNALISM

Ethical journalists are concerned about the cancerous growth of "fauxtojournalism"—the deliberate creation or alteration of photographic reality. With so many examples of falsification being discovered of late, it's clear that every media outlet has an undiscovered pile of fakes in its photo library, some of which have probably made it into print.

What's most disturbing is the disconnect between the official concern that edited images will undermine the media's credibility and the reality: People already view the media cynically. Based on data from the Pew Research Center for the People and the Press (Figure 5-1), the Project for Excellence in Journalism charts a clear and continuing drop in trust for all forms of the media since 1998. As of 2006, less than 30% of the people polled believed "all or most" of what even the most trusted media outlets said.

Figure 5-1 Not only are all news media considered less trustworthy than they used to be, but the difference between the most trusted sources and the least trusted sources has shrunk.

This freefall can be based on many things, but the rash of fauxtography probably doesn't help. No wonder so many people make no distinction between established news media and online blogs as trusted sources of information. In many cases, watchdog blogs have unmasked false images accepted by the traditional media as fact.

But what constitutes a false image? Agreement on exactly when the line is crossed can be difficult, not only for the publishers but for photographers as well. Many photographers (and viewers) believe that photography is the capture of the perfect moment. If

the moment wasn't exactly right, or something minor in the setting that you couldn't control appears, that's too bad. The image should still stand and fall on its own merits. A growing number of people with digital cameras who have learned that perfection is attainable with a little mouse skill often see it differently and are not only more accepting of edits, but fail to understand what might be wrong with making changes.

Most professional photojournalist organizations take the slippery slope approach, saying that any alteration should be unacceptable. Yet that stance is both difficult to enforce and may even be wrongheaded. For example, a raw camera image can and often should have changes made in luminance and hue to correct the image for color shifts and over- or underexposure. Doing so can make a profound difference in image clarity. Even in court, it is acceptable to enhance an image to allow details to be seen more easily (see Chapter 2) as long as the information is not altered in the process.

The difficulties with a strict approach are obvious when you consider that not all image edits poison their image, and that some tricks, like clever cropping, are considered legitimate practice yet can make an extraordinary difference in the image message (Figure 5-2). Conversely, some of the most revered photojournalists of the analog age used their original photo negative as just the first step on the route to a powerful image. How many of these giants would be able to make a living as photojournalists in today's shifting ground, when one person's artistic enhancement is another's heresy?

Figure 5-2 The bucolic but pedestrian scene in the crop shifts radically in content when the entire image of a house rebuilt on the ashes of a Mt. Etna lava field is revealed.

SETTING AND ENFORCING STANDARDS

Short of instituting a crime lab's level of standard operating procedure on top of image editing (far easier to manage in the deliberate atmosphere of a forensic lab than it is in the frenetic, multisource, high-volume media world), fakes will inevitably slide through. To keep the damage to a minimum, the news media needs some way to know how much change an image has undergone.

Self-Policing

Attempts have been made by photographers themselves to bring this about. One organization called TrustImage (www.trustimage.org) offers a label that photographers can add voluntarily to a photograph. The label certifies three things: that the photo was not the result of compositing, that only a very limited number of newspaper-acceptable image changes have been made, and that it does not misrepresent the original setting. They hope that eventually this movement will become a standard in the industry.

There is also a drive in England by the National Union of Journalists to add a mark to an image to indicate that it has been turned into a photographic illustration. Like the TrustImage movement, this mark would require that photographers voluntarily analyze and label how much they have done to an image (Figure 5-3).

Unfortunately, although both systems were conceived in the late 90s, neither has gained any traction yet. Honor systems require the photographer to make a firm decision on a squishy process.

Figure 5-3 The mark with the line through it indicates a manipulated image; the one without is a "genuine" photo.

And changing technology will only make it harder to draw the line. One of the most requested new camera features is the ability to edit an image while it's still in the camera. Currently, in-camera edits are of limited range and quality. Most professionals wouldn't use them. But eventually they will be available and reasonably effective in a high-end camera.

When a computer isn't needed for basic image enhancement, photographers will make some darkroom adjustments in the field. In fact, the time might not be too far away when a camera would need to be equipped with auditing software to distinguish between in-camera-as-shot and in-camera-as-improved.

Software Analysis

It's inevitable that eyeballs or the honor system will require the help of software. The best fakes take full advantage of Photoshop's sophisticated tools to create changes invisible to the naked eye.

Adobe Systems is working on an ongoing basis with Hany Farid, professor of computer science at UMass Dartmouth in Massachusetts, to build on his research in image analysis (see Chapter 8). However, a magic bullet is still years away and would require a suite of interlocking applications, since there are too many different ways in which an image can be changed and several techniques and post-edit actions that can mask the work of a skilled artist from some software tests. As with most controversial attempts at control, a hacker ethos could keep pace with the identifying software by developing methods of eliminating the telltale mathematical clues.

It's also true that even when a software solution is in place to weed out the worst offenders, determining when an edit crosses the line will still need to be done by the individual media outlets. If the current rash of rules is any predictor of the future, there will be no unanimity. Best would be a type of rating system that could provide consistent guidelines for ranges of image alterations and intentions. For breaking news, the standard of purity might be much higher than for a magazine or editorial piece.

Dodge and Burn

In an imperfect world, photographers often shoot when it's impossible to get the correct light for all parts of an image. Almost from the beginning of chemical photography, they've gone into the darkroom to correct what nature and light refused to provide. So it's not surprising that Dodge and Burn were among the very first photographic tools in Adobe Photoshop. Both are corrections or enhancements with direct connections to darkroom techniques.

Dodging was used when the printed images lost shadow detail (Figure 5-4). The photographer might just shade a portion of the image with his hands for a few seconds while exposing the print in the enlarger. If more precision was needed, he would cut a piece of cardboard to an approximate size or shape for protection instead. This cardboard piece came to be known as a mask.

Figure 5-4 *When shooting this picture, there was no way to add light to this church tower without losing the detail in the sky.*

Burning was the opposite of dodging. If an area of the print was too bright, and details were lost in the highlights, you'd add exposure time to the area. This time, if you were creating a mask, you'd use it to protect the part of the image that was correctly exposed and place it in position for the few additional seconds.

If this sounds time-consuming and inexact, you're right. Photographers would have to experiment with several prints to nail down the correct amount of time needed to under- or overexpose the areas to get exactly the right amount of light.

In Photoshop, there are several methods for gaining the same result. The Dodge and Burn tools are useful for small areas or to paint with light and shadow. Many editors accomplish both dodging and burning at once with Levels or Curve adjustments, which can redistribute the overall light and contrast nondestructively.

In Figures 5-5 and 5-6, the same image is adjusted with Curves for two different effects. In Figure 5-5, the adjustment holds the highlights in the sky and the midtones fairly constant while brightening darker midtones and shadows. In Figure 5-6, the process mimics a darkroom burn process. The sky is protected from any change, while the tower is burned to eliminate details and provide a dramatic form against the sky.

Figure 5-5 *This version of the image uses a Curves adjustment layer to dodge the church tower, making it possible to see the building surface.*

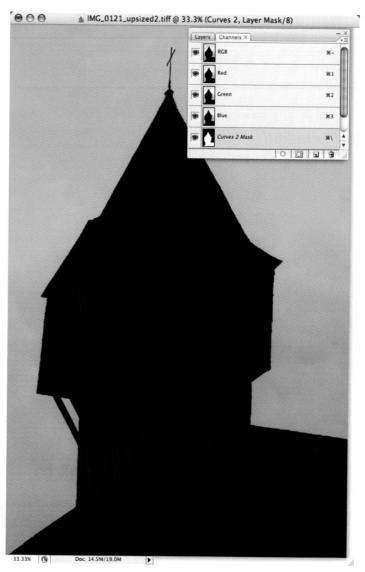

Figure 5-6 *We use a different Curves adjustment layer with a mask that protects the sky (on the right) to burn the tower, turning it into a silhouette.*

THE SLIPPERY SLOPE VERSUS THE SLIDING SCALE

But until some universal code is in place or analytical software makes an image's working process transparent, inquiring minds will need to create categories for themselves. When is an image edit merely a misdemeanor or even a laudable creative act, and when is it a hanging offense? There are several elements which, when considered together, might help to brand an image change acceptable or a lie.

Intent

Why make the change? A change of lighting balance can be intended to make the photo more informative and clear. If the change doesn't alter the nature of the information, it should be acceptable.

On the other hand, some edits are made with an editorial purpose. They change the image content, its meaning, or the viewer's attitude toward the event. When the change is deliberately manipulative, it creates a fake.

One of the reasons that intent is so important is that the same tools that can create an artistic image that heightens the image's impact without altering it can also radically change the message.

The stages of image manipulation shown in Figure 5-7 began with the version of the tower that was burned to turn it into a silhouette. A new Curves adjustment layer is added to this image, and three separate adjustments are made. First, the black "S" curve increases the contrast of the sky. The result of this change can be seen in the first image to the right of the Curves dialog box. The red curve radically increases the amount of red in the image, as is obvious in the next image. The blue curve decreases the Blue channel, which has the effect of strengthening both the Red and the Green channels, creating the yellow shading seen in the next image. Finally, the blend mode of the adjustment layer is changed to Color Burn, which applies the color changes and darkens the effect overall. The result is the ominous image on the far right.

The changes in this version of the image definitely step over the photojournalistic line.

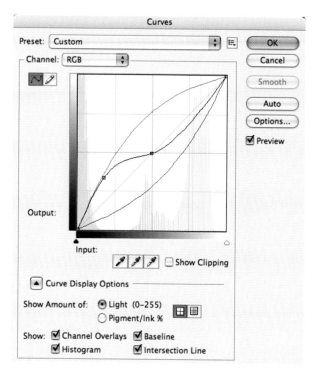

Figure 5-7 Using the same image of a church tower from the Dodge and Burn sidebar, it's possible to stray very far from the original image.

Extent

How much of the image is changed? That question must be considered on two scales—the actual amount of pixel real estate, and the importance of the changed pixels to the image content. For example, desaturating can affect all the pixels, but printing a color image in grayscale is considered a reasonable editorial decision. Editing a person in or out, on the other hand, is a major change even if the person represents a small fraction of the total image pixels (Figure 5-8).

Figure 5-8 Although only a small portion of this image has been altered, the change is significant because it removes people who had been present at the scene.

Result

Even when the intent is benign and the edit amount is small, if the editing alters or creates a message, the result is fauxtography. Almost any composited image is likely to have an unacceptable result, since by definition compositing creates a fantasy that could not have been photographed even with the most perfect light and sightlines. In Figure 5-9, the horizontal image of a monarch butterfly resting on a bunch of flowers is a composite. The butterfly was copied from the image on the right. The intent of the composite was purely artistic, but that doesn't make the image a truthful photograph.

When considering results, it's also worth considering how truthfully the work is presented. If it's a composite and is presented to a publisher as such, it's the publisher's responsibility to identify the image as an illustration.

Figure 5-9 The butterfly really visited the flowers on the left, but not at the moment of the picture. The flowers on the right were luckier, but the composition wasn't ideal.

Sanctioning

The publication of an edited image takes at least two parties: the photographer and the news organ. When the photographer makes changes without informing the publisher, the result is unsanctioned. When the publisher knowingly accepts or even encourages the changes, the result is sanctioned. In general, sanctioned changes should be considered more damaging than unsanctioned changes no matter what type of media is involved, but particularly in hard news. Such alterations move the publisher squarely into the propaganda realm.

Staging

Unlike the other considerations—although it may not contain a single edited pixel—a staged image has no shades of grey.

An image is staged if the photographer poses actors (paid or volunteers) and props instead of taking spontaneous shots of real action and events. All fashion photographs are staged, and we expect them to be. Equally, we expect our news images to be captured, not tame.

When photojournalism was in its infancy, there were no established ethics about staged photography. In fact, pretty much all photographs were staged of necessity. With early technology, exposing a photograph took several seconds, and the subject had to be perfectly still. For posed portraits, people either sat down or stood braced to keep themselves locked in place.

Pictures of events were more like still lifes, since people moving quickly in or out of the frame could not be captured on film. That is one practical reason why the great pioneers of American photography during the Civil War shot pictures of corpses rather than combat. The pictures were still lifes in yet another way: They were frequently carefully arranged for best effect. Photographers stage-managed more artistic configurations or misrepresented the subject or setting to make an emotional or editorial point. Alexander Gardner, a groundbreaking American photographer, posted the graphic American Civil War photograph, "Home of a Rebel Sharpshooter," in Figure 5-10. He dragged the dead body to a trench and turning the head to face the camera.

Figure 5-10 Alexander Gardner previously shot this body in its original position with its face turned away, identifying it as a Union sharpshooter. (Library of Congress, Prints & Photographs Division, Civil War Photograph Collection, Sketchbook of War, Alexander Gardner, LC- DIG-ppmsca-12562.)

As technology changed to allow the capture of movement, so also did news photography. Photographers, acutely aware of how their work could be turned into propaganda through montage and retouching, put more emphasis on capturing true moments. By the middle of the twentieth century, an ethical photojournalist might enhance a picture in the darkroom but would never stage an event.

The slippery slope concept is correct in one important way. There's not much point in being semi-ethical when it comes to staging. Once a photographer breaches the barrier between a spontaneous image and a composite, the concept of staging the image to begin with doesn't seem that serious. It's easy to justify: "Something like this has happened somewhere, I just didn't happen to be there when it happened. These are the pictures I would have taken if my timing had been right!"

Once photographers reach this point, they are no longer photojournalists—if indeed they ever were to begin with. They are propagandists (see Chapter 4).

GUIDELINES APPLIED

Like the Motion Picture Association's rating system, there's obviously a lot of leeway for individual interpretation within the definitions. That's necessary to prevent a knee-jerk reaction against justifiable image improvement. Photographers should still be allowed to make changes that do not mislead. As for serious changes that step over the line, as Justice Potter Stewart famously said about hard-core pornography, "I know it when I see it." If the work violates our sense of fairness and honesty, it's fauxtography no matter how difficult the changes may be to quantify.

So, when have photographers merely transferred accepted analog techniques to the digital realm, and when have they stepped over the line? Let's follow the increasingly dubious tracks.

The Rating Scale

When considered as an interactive scale, image editing in the media might be reduced to a rating system similar to this:

Warning:
Unsanctioned, artistic intent, minor enhancement, no shift in message

Misdemeanor:
Sanctioned, artistic intent, minor enhancement, no shift in message

Felony:
Unsanctioned, artistic or editorial intent, major edit, change in message and content

Capital Crime:
Unsanctioned or sanctioned, persuasive intent, major edit, change in message and content

Unsanctioned or sanctioned, persuasive intent, creation of content (i.e. staged images, whether edited or not)

Verdict: Artistic License

In 2006, award-winning North Carolina photographer Patrick Schneider was fired by the *Charlotte Observer* for editing a photo (Figure 5-11). This wasn't the first time that he had been called out for doing what comes naturally to a photographer raised in the analog world. He was warned in 2003 for using similar adjustments. At no point did Schneider deny the accusations, but he did defend them as being well within all previously accepted guidelines for photojournalism.

To understand the type and magnitude of change that prompted the pink slip, examine Figure 5-12. This sunset image of an attractive aqueduct is well composed but somewhat flat. In Figure 5-13, Curves are used to enhance the luminosity and saturation of the sky. This effect could have been accomplished with film and darkroom exposure and is often referred to as "The Hand of God" by photographers.

Figure 5-11 *This image started its life with a dull brownish background. However, the silhouette and composition were the same as the unaltered photograph.*

The criteria for censure seemed to be that the images were too good to be natural. There's an element of sour grapes to this argument—photography has never been natural, although it once used to be harder. Beautiful toning meant that the photographer was an artist who spent long and painful hours in the lab. Is the result any less valuable when it takes only minutes to do something that used to take hours?

Philosophical issues aside, these edits should have passed the intent/extent/result test. No average newspaper reader, confronted with both versions of the images, would have thought they'd been misled about the subjects portrayed. But Schneider was guilty of making artistic decisions in an environment where all image changes are tossed into the same bag as political hoaxes and deliberate lies. Public trust in journalism will not be regained by firing ethical practitioners for using a legal professional tool with finesse.

Figure 5-12 *There are many ways to move an image from pallid to striking without changing its content.*

Figure 5-13 *Toning an image was a standard darkroom technique to shift the colors of an image through the addition of chemicals.*

The Eyes Have It

One of the ironies in the Schneider case is that W. Eugene Smith, the famous *Life* photographer active from the 40s through the mid-70s, is a member of journalism's pantheon. Smith's oft-quoted line about his working philosophy is "I have tried to let the truth be my prejudice."

This quote surfaces frequently as a call for limits when photographers grapple with the temptations of image editing. Yet what Smith was referring to was the importance of being true to the underlying humanity and essence of his subjects. It certainly did not refer to his techniques. He did some of his most important work in the darkroom— dodging, burning, and even image compositing.

According to Jim Hughes in *W. Eugene Smith: Shadow and Substance*, in creating his famous Mad Eyes photograph of a startled black woman in a Haitian asylum Smith spent months reinterpreting it, "making it darker, eliminating extraneous people and elements." Last, he bleached the whites of the subject's eyes, an act that laid bare the terror Smith remembered seeing in her face when she ran toward the light. In other words, he completed in the darkroom what he remembered seeing but the camera couldn't quite capture. This was definitely an artistic and editorial step beyond simple dodge and burn. By current standards, one of the most brilliant and ethical of all photojournalists would be barred from the newsroom.

More importantly, the creation of this moving image proves that an image cannot and should not be judged by its technology. The same technical process, in different contexts and with different intent, can change the category of an edit from benign to belligerent. In 2005, *USA Today* had to hurriedly retract a photo of Condoleezza Rice. The whites of her eyes had been radically bleached, making her look like an extra from *Dawn of the Dead* (Figure 5-14). Despite the paper's insistence that the change had been unintentional, there were no other obvious changes in tone and contrast in the image.

Figure 5-14 What is artistry in one image is falsity in another.

Bad Cover Age

The most troubling and blatant examples of fauxtojournalism have surfaced on publication covers, where reality is less important than message. Images can find their way onto a cover that would never pass editorial muster on a news story. Practically speaking, although the cover may be about news, its purpose is marketing.

Editors may have the last word, but most covers are conceived and composed by graphic designers and illustrators, whose educations include a high-quality diet of photographic composites from the Bauhaus and beyond. This makes for good design and powerful illustration but can conflict with photojournalism's teachings.

The difference between the two approaches is illustrated in a famous pair of covers from Time *and* Newsweek. *Both treated O.J. Simpson's 1994 murder arrest as front page news and both used Simpson's booking shot as the cover image, but each brought different decisions to the cover.*

Newsweek's photo was a direct, unaltered print of the mug shot. They made their editorial statement with the provocative red text "Trail of Blood" (Figure 5-15). Time's cover was something very different. The illustrator chosen to create the cover was known for his dark, sometimes disturbing style. His version of the mug shot was no longer a photograph. It was a grim, deeply shadowed illustration (Figure 5-16). Whether deliberate or unintentional, it was easy to interpret the result of this work as prejudicial.

Figure 5-15 The Newsweek *version of the mug shot.*

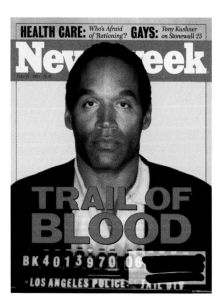

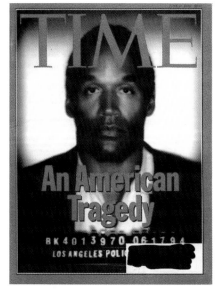

Figure 5-16 In the Time *magazine version, aggressive toning crosses the line when it moves from heightening what is already in the image to changing the content.*

Only subscribers ever received this first cover. The outcry was so intense that Time *immediately pulled the first printing off the newsstands and replaced it with a different image.*

You might think that such an expensive and painful lesson would make these publishers think twice about their guidelines for photography in cover art. Yet stories of composites and edits continue to surface. They range from a Martha Stewart head–body composite in Newsweek *to Ronald Reagan crying a Photoshopped tear in* Time. *The only difference? Now, in tiny type that no one in the general public reads, there's a disclaimer that the art is a photo-illustration.*

Verdict: Misdemeanor

National Geographic is one of the most respected magazines in the world and practically defines quality photography. That's why it was a watershed when they published a cover for a lead story on Egypt in 1982, well before Photoshop was even a glimmer in Adobe's eye.

Another image was originally meant to grace the cover, but it had to be pulled at the last minute. A picture of the pyramids was selected instead. The picture was in landscape format, but *National Geographic's* cover format is portrait. With deadlines looming, artists moved the pyramids to fit on the page. At the time, using a digital process to turn a photograph into an illustration was rare and required a high-end Sytex publishing system. When confronted about the change, the editor defended the decision, claiming that it was nothing more than if the photographer had shifted position to a different point of view.

Like the Schneider example, this decision was made for artistic purposes. However, the result changed the image content, creating an image that had not existed in real life. Although this was not the first altered image on a cover, *National Geographic* was in a different category from the *National Enquirer* or even *World Tennis* magazine. Inadvertently, the magazine opened the door for progressively more frequent and more serious alterations.

The Case File: Keeping It in Perspective

Even if all professional photographers adhere to strict standards, they are not the only people supplying the media with pictures. Digital photography is so pervasive, and the overall quality of the images so technically good, that nonprofessional images can be found in the media. In addition, there are no longer any unique negatives to control. Once an image is on a computer, any staffer who has pretensions to Photoshop skill can "improve" a photographer's image without his knowledge or consent.

For example, the *New York Times* published a highly dramatic image in April 2007 about flooding in Connecticut after a storm (Figure 5-17). The picture was shot through a train window. Apparently the person didn't turn the flash off before shooting, because the image was marred by a lens flare (Figure 5-18). Rather than give up on a dramatic picture of a house being washed away in the rain, it was time to call on Photoshop.

Besides the lens flare itself, the image has two editing problems. First and most obvious is the patched pink siding that doesn't align. Second is the window frame next to the patched siding, which has obviously been retouched with the Clone tool.

Figure 5-17 The image edits are visible on the left side of the house.

The touch up on the lens flare is visible if you look carefully, but it is much easier to see when you use Levels to posterize the image. This is a standard investigative trick for finding an image edit that involves brightness changes.

Figure 5-18 On the left, the almost hidden lens flare. Changing brightness makes the flare more obvious.

In this case, the editing should have been easy to identify because it showed faulty perspective and leftover marks from the Clone tool. Yet it still made its way into the paper in full color. Sadly for the news staffer, he lost a great opportunity because he didn't know how to use Photoshop's Vanishing Point tool.

Vanishing Point is found in the Filter menu. However, Vanishing Point is a filter the way Mount Everest is a rock. It makes things like touching up lines in perspective simple instead of practically impossible. Using the filter is surprisingly simple. The most critical step is the first one: selecting the points that will define the perspective grid. In Figure 5-19, these are the three white boxes connected with dashed blue lines. If your image contains existing lines with a vanishing point, like the aluminum siding that wasn't touched up above and below the edits, you can take advantage of them to set up your grid.

Figure 5-19 Unless you'll need it later for something else, make the grid no larger than absolutely necessary to do your repairs.

Once you've drawn the grid, use the Marquee tool to select a portion of the image that you'd like to use (Figure 5-20, left). Select the Transform tool next, and then click and drag to expand the selection across the grid (Figure 5-20, right). The siding now looks consistent and betrays no sign of patching.

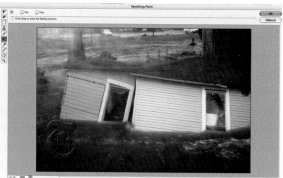

Figure 5-20 Expand the selection to fill the grid area, and you have parallel lines with a correct vanishing point.

You can't fix the window frame in Vanishing Point, but Photoshop has other options for patching damaged pixels. One of those is not the Clone tool, although most inexperienced retouchers reach for it automatically. It is not an all-purpose solution and is particularly ineffective for objects with straight lines.

In this case, some simple and underused tools are best. Using the Polygonal Lasso, select the opposite side of the window frame, which is still intact (Figure 5-21, left). Copy it to the Clipboard. Select the damaged portion of the left window frame. Refine the edge with a 1-pixel feather, and then use Paste Into to drop in the good patch (Figure 5-21, right).

Figure 5-21 An old fashioned but effective cut-and-paste can fix the window frame.

The patch doesn't quite match the brightness, but that's an easy fix. Change the blend mode of the patch layer to Lighten to make the patch match the rest of the frame (Figure 5-22).

Figure 5-22 Change the blend mode of the layer with the patch.

Verdict: Felony, Part 1

Sometimes a photo edit is not deliberately meant to mislead, but that's the result. When terrorists bombed a train in Madrid in 2004, dozens of people were killed or injured. This traumatic incident required the immediacy of a picture. One shot was particularly compelling, but it had a problem: a bloody body part along the tracks.

Although the photo appeared on the front page of almost every British newspaper, not one ran the picture as shot. *The Guardian* opted to leave the limb in place but to desaturate it. One or two papers grayscaled the whole image. But most publications deleted the bloody limb, replacing it with cloned gravel. In their eagerness not to offend, they minimized the ugly reality.

If the image is so important and compelling that it must be printed, some edit choices are more truthful than others. There is almost always an alternative to retouching, including the worst case—finding another image.

Verdict: Felony, Part 2

Unfortunately, the slide from image correction to image enhancement to falsification can be easier to recognize after the fact than before an image is published. And the more respected the photographer, the easier it can be for him to step over the line. Sometimes it begins with a simple attempt to optimize an image or to delete or crop around a minor problem.

At least that's how one of the most high-profile fauxtojournalism scandals began, according to Brian Walski, the photographer who tarnished his reputation doing it. Walski was a highly regarded photojournalist covering the war in Iraq. One day, he shot several pictures of Iraqis taking refuge under the protection of British soldiers. They were good pictures, but none really captured the tension he felt at the scene.

As he montaged two pictures together, magic happened. Suddenly he had an award-winning composition on his screen (Figure 5-23). Tired and tempted, he flattened the photo and sent it off. Such was the composition's power that it had pride of place not only in the *Los Angeles Times*, Walski's home paper, but in *The Chicago Tribune* and *Hartford Courant* as well.

Figure 5-23 Two images, divided by the red line, were used to compose this image.

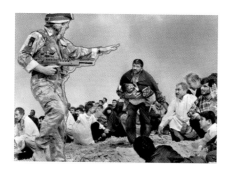

Problem was, Walski clearly had spent so much attention on the relation between the two most important elements—the soldier and the man carrying a child—that he neglected to notice that his montage included the same man in two places: one from each photo (Figure 5-24). A sharp-eyed staffer in Hartford, searching the faces for news of a friend, recognized the duplicity.

Figure 5-24 This man was present in both photos.

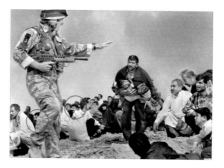

Looking retrospectively at the photo, the difference in scale between the soldier and the person sitting at the bottom of the picture in the foreground might have sent up a red flag to someone actively looking for a problem. But otherwise the technique was faultless.

Walski himself had never filed an image composite before and was both honest and appalled that he fell into the trap. Unfortunately, past history was no help here, and he was fired by the paper.

Verdict: Capital Offense

There's a big jump from felony to capital offense. It comes when all three major elements converge in a fraudulent picture that was definitely created deliberately. In 2006, *El Nuevo Herald*, the Spanish language version of the *Miami Herald*, splashed a disturbing photo in their Sunday supplement. On the right side of the image, four

scantily clad prostitutes were soliciting a tourist in Havana, Cuba. On the left, two Cuban police officers were talking to another tourist and obviously ignoring the ladies of the street. The caption accused the Cuban government of failing to confront the prostitution problem, just as the image indicated.

Great copy, incredible story…truly incredible. Someone at the paper had taken two separate images by two different photographers and montaged them. Was this a deliberate political choice or just a clueless disconnect between an art director and a designer as the paper claimed? With approximately one-third of Miami's population being Cuban-Americans, the possibility of choice versus chance was all too real.

The Case File: Smoke and Mirrors

In the last circle of photojournalism hell burns the news photographer who passes off propaganda and personal opinion as fact. Former Reuters stringer Adnan Hajj is doubly toasted. Although caught for what may be the least professional bit of photo editing ever published (Figure 5-25), he had apparently been actively subverting the news coming out of Lebanon and other parts of the Middle East for most of his Reuters career. His portfolio, consisting of hundreds of images now deleted from the Reuters catalog, violated every photojournalism taboo.

Figure 5-25 On the left, what appears to be the real image; on the right, Hajj's dubious masterpiece.

Let's follow the remarkably clear trail of image alteration, made particularly easy because either Hajj didn't know enough about Photoshop to do a credible job or because he had become so accustomed to getting away with his fakes that he no longer wasted time making the final product look real. It appears that Hajj didn't want a blue sky. The easiest way to eliminate it was to overexpose the entire image by making the sky brighter (Figure 5-26).

Figure 5-26 On the first pass, the image was overexposed so heavily that midtones, not just shadow details, have disappeared.

He next wanted to darken the smoke. But instead of using Curves, or even Levels, he went for the much less flexible Brightness/Contrast. As these are one-dimensional sliders, it's impossible to increase contrast in only the darkest or lightest areas. That's why not just the smoke is darker. The buildings are excessively contrast-y as well because Contrast effects the entire image (Figure 5-27).

Figure 5-27 The contrast in the image has been increased to heighten the stark feeling.

A little smoke is never as good as a lot, so Hajj added background smoke. There are many ways he could have done this, but one easy way might have been to select some of the smoke and stretch it further into the sky (Figure 5-28).

Figure 5-28 *The column was stretched upward to serve as a base for more smoke elements.*

A good image editor knows the beauty and the limitations of the Clone tool, once known as the rubber stamp. Although the icon remains, the name has changed because the copy is now much more perfect than a simple stamp. If you leave the Aligned checkbox on, what you draw will be precisely what you source, with every pixel in the same relation to the one next to it. Most good retouchers vary the position of the source and style of adding it to keep the look natural. In this case, no effort was expended (Figure 5-29).

Figure 5-29 *The smoke was cloned very badly. The patch on the left was selected and used as a pattern, rubber-stamping in the grid seen on the right.*

One can only assume that Hajj really enjoyed cloning. The extra buildings on the left might have been cloned to convince people that more than one building had been hit, but there's no other explanation for extra building duplications seen in the circle on the right of Figure 5-30.

Figure 5-30 Mystifyingly, two buildings were cloned. Even without the smoke pattern, someone should have noticed these extra items.

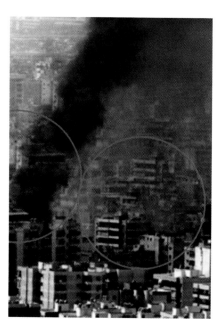

Hopefully, Adnan Hajj was an aberration. The fact that he had an agenda should have been caught long before these images were published. But given how obvious his work had to get before he was finally nabbed, the question remains: What if he hadn't been such a lousy artist?

Unfortunately, the rash of embarrassing and disturbing edited and staged images we've seen in news photos is not over. At a time when the media is equally concerned with dropping revenues and plummeting trust, the temptation to tart up an image won't go away. An objective measure will help, but unless every photographic source, every illustrator and designer, and every editor can agree on the same criteria and code of ethics, Photoshop will remain the tempting tool for fauxtojournalism it is today.

CHAPTER 6

WEIRD SCIENCE: FAUX FINDINGS

LIKE THE HOT NEW CELEBRITY who is called an overnight sensation but has been working in the business for years, most scientists build knowledge slowly and in relative obscurity. Unless a tidbit surfaces in the media, most of us know nothing about lipids, muons, pluripotence, or speculations about an obscure comet's mass. Then, suddenly, enough pieces of different puzzles come together, and we find that we have a new medical test, some hints about the beginning of the universe, cloning through skin cells, or a demoted planet.

METHOD ACTORS

Science is the way we search our external reality for knowledge. This search is systematic and incremental. Scientists start from an organized base of accumulated knowledge and their own careful observations. Based on what they observe, they develop theories about unknown or unproven subjects of interest.

A developed theory must be tested, not just conceived. The iterative progression of thinking, developing, testing, revising. and retesting is known as the scientific method. Our entire technological society has been built and continues to rely on the consistent application of this meticulous process.

Put that way, the scientific process sounds dry and procedural, but it begins with imagination and flights of fancy. The world is filled with problems and mysteries begging for someone to show an interest. Good scientists can't help but pay attention to those questions, because they are natural-born puzzle solvers.

The Case File: Preservation Hall

Buildings and artifacts that still remain from centuries past are lottery winners. Through chance or care, they've beaten the odds. Their contents can offer us knowledge now, but even they won't last forever. Exposed to modern air, smog, or just too many tourists, their colors fade and their details disappear.

So archaeology is a race against time. Any advance that offers us a way to beat that race is a bonus for historians. When it comes to the ancient tombs in Egypt, we're looking at one of the oldest continuing historic and social records in the world. Many more artists and historians want to study them than can be given access.

The obvious solution is to take high-resolution photographs and make them available online. But most of the images in the tombs, particularly in the less-grand tombs of the artists and artisans who created the pharaoh's mausoleums, are so small that their elaborately painted walls and ceilings can't be photographed without extreme distortion. That's why the collaboration between computer science professor Dr. Hany Farid and his father, Dr. Samir Farid, is so valuable. Their work points toward a way to reproduce more closely the authentic experience of visiting the tomb, while ensuring its continued preservation.

A perfect example is Sennedjem's tomb in Luxor—burial grounds for the artisan and his entire family. It measures 5.12m x 2.61m (16.8 feet x 8.56 feet) with a vaulted ceiling 2.4m (7.87 feet) at its highest point (Figure 6-1). That's smaller than many college dorm rooms, but every inch is covered with artwork, including the ceiling.

Figure 6-1 The two opposite ends of the Sennedjem tomb are rich with images in a confined space that is difficult to light and photograph.

The ceiling is the most problematic section. It is so deeply curved that adjoining panels, when photographed with a wide-angle lens, curve in opposite directions, making it impossible to piece them together using a panorama function (Figure 6-2).

Figure 6-2 These two images are shots of adjoining panels in the tomb. Because of lens distortion, each panel bows inward, making it impossible to overlap the two borders to see the panels in sequence.

Photoshop offers a filter meant to correct for lens distortion, hidden in Filter > Distort > Lens Correction (Figure 6-3). But if you attempt to correct one of the Sennedjem pictures using the tools in this dialog box, it becomes obvious that the filter was never meant to address such an extreme case.

Figure 6-3 *Any distortion correction that begins to correct the curvature in one direction immediately distorts the image an equal amount in another direction.*

There are many options in the Lens Correction filter, but only one of them is explicitly meant to correct lens curvature. The algorithm for the fix assumes that all the distortion comes equally from the center of the image. There isn't any way to set a different center point for the correction, let alone correct for points of varying amounts and directions of distortion.

It would seem that this is an insurmountable problem. How can you turn two reversed curves into a perfect rectangle? Researchers approached the problem first by defining it. They divided each exterior border line into eight key initial points, starting at each corner (the yellow dots seen in Figure 6-4). Then they drew the rectangle that the panel would describe if it could be seen with no distortion, mapping another eight equidistant points on each side (Figure 6-4).

Using these points, they wrote a series of equations that determined the distance each initial point would need to move to reach the undistorted position. In Figure 6-4, the red rectangle is the desired outcome. The red points that represent the final desired positions for the initial points are connected to them with yellow lines.

Figure 6-4 This panel mapping was used by the researchers to reprogram the distortion.

The mapping was used to create a lattice structure. This served as the basis for the algorithm used to re-render the image as the scientists believed it should appear without lens or extreme perspective distortion. The two adjacent undistorted panels can be seen in Figure 6-5.

Figure 6-5 The system's success is particularly obvious in the spheres, which end up as round circles, as they were intended. The standing man no longer tilts backward.

There was still some clean-up to do, because lighting the panels evenly was extremely challenging. Rather than try to do this visually, they took into account the fact that the only light on the images was the camera flash. Light decreases from the center of the flash at a measurable and fairly consistent rate. That makes it something that can be modeled with another algorithm to make the lighting even and consistent on each panel. After correcting for the distortions and lighting, the two adjacent panels can be placed on two layers in Photoshop and lined up together (Figure 6-6).

Figure 6-6 *The panels are easier to appreciate when they can be seen in context.*

The last step was to apply the same process to all 16 pictures taken inside the burial chamber. The result: a panoramic, undistorted view of the entire space with ceiling and wall panels stitched together (Figure 6-7).

Figure 6-7 The image begins on the south wall with the doorway to the tomb and follows the wall clockwise from south to north to the east end.

Getting Experimental

Theories are the most accessible part of the scientific process. Every cheesy science-fiction movie seems to have one scene where a scientist says something like, "What if we put the thingamabob into the whatchamacallit? If that works, I'll bet that we can defeat the aliens, cure cancer, solve global warming, and make buttered toast fall butter side up!"

Imagine that it's late at night, and you find two AAA batteries loose in a drawer. Do they still have any juice? Your theory might be, "The remote hasn't been working too well, probably because one (or both) of the batteries is old. What if these batteries are good? If so, maybe I can watch TV now instead of having to run out in the snow for new batteries."

Theories are good, but they have to be tested. To determine the validity of a theory, a scientist frames a hypothesis: a narrow statement that predicts the test's outcome. Your hypothesis might be: At least one of these new batteries has a charge.

Next is to design an experiment to put the hypothesis to the test. Experiment design is the real creative challenge of science, because there can be many variables to consider and more than one way to test an idea. You want to end up with the simplest and most straightforward experiment that gets the information.

In this case, the test is fairly easy. Your remote needs two batteries. That means that you have to test both unknown batteries, as well as the ones in the remote already, since one of each might be good. You'll start by labeling each one in some way to avoid mixing them up. Then you'll create a testing protocol: first test, batteries A and B; second test, batteries A and C; and so on, until you've tested all the combinations. If the remote doesn't work with both of the newer batteries, that doesn't mean it might not work with a different combination. If the remote works with some combinations and not others, you'll analyze the combinations. Perhaps it always works if battery C is in the mix. If so, maybe the remote can actually run with only one battery, and battery C is the live one.

If the remote doesn't work with any combination, the hypothesis is false, and you're heading for the convenience store. But if it suddenly works when you put both of the old batteries back in the remote, the theory needs to be reconsidered. Maybe there's a problem with a contact in the remote, or maybe you had the batteries in wrong before. If you don't consider these possibilities, you might be tossing out the wrong battery, and pretty soon you'll be standing up to change the channel. The moral is that sloppy methods have real consequences.

The Method and History

Two societies contributed much to the development of the scientific method: the ancient Greeks and the Islamic world during its Golden Age.

The Greeks were the first to apply logic to the mysteries of the physical world. However, because they based their logic on deductive reasoning alone, their science contained a fatal flaw. They assumed that if their reasoning was brilliant, the conclusion was proven. For example, Aristotle believed that men had more teeth than women because his male horses had more teeth than his mares. Having counted the horses' teeth (Figure 6-8), it apparently never crossed his mind to verify the idea by counting teeth in humans.

Figure 6-8 Like humans, horses have different numbers of teeth as they grow up. Unlike humans, some horse breeds have varying numbers of teeth in mares and stallions.

Close to a millennium would pass before Arabic mathematicians realized that pure logic had limits. If two conflicting theories both seemed brilliantly argued, how could you determine which one was true? To answer that question, they invented the experiment to compare one theory against another. Unfortunately, because of religion and politics, this and other advances were slow to make their way west.

The beginning of the age of scientific method can be traced to Galileo (Figure 6-9). In his famous experiment, he tested another of Aristotle's logical deductions—that heavy objects fall faster than light objects. This seemed like such a common-sense truth that for more than 1500 years no one challenged the conclusion. Yet much we now know about engineering, weapons, and physics depends on the realization that everything falls at the same rate, no matter what its mass.

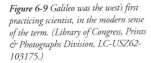

Figure 6-9 *Galileo was the west's first practicing scientist, in the modern sense of the term. (Library of Congress, Prints & Photographs Division, LC-USZ62-103175.)*

By the end of the seventeenth century, the iterative process of testing an idea had become the standard. As more scientific experiments were done, another important concept was added to the method: Even if you get the predicted results, the testing isn't over. Others must be able to reproduce the experiment and get the same results. If the results always meet expectations, a new piece of knowledge can be used as the base for additional hypotheses.

But there is also the possibility of correction. If any newly designed experiment fails to support the hypothesis, either the most recent experimenter has made a mistake or some or all of the theory is suspect. This reconsideration of previous results can happen when better methods or technologies are developed, allowing scientists to make more accurate observations.

This is a painstaking and incremental process, but its dedicated application is what gives scientists the ability to determine truth from falsehood.

The Case File: Historical Mystery, Full Face

Everyone loves a good mystery, but usually the question is "Whodunit?" In the Hillmon case, the sleuths had a curious puzzle. The weapon, the killer, and the corpse were all in hand. The problem: Who was the corpse (Figure 6-10)?! It would take almost 130 years before his identity could be confirmed.

Figure 6-10 *The mystery body, photographed during the inquest into his death. (Courtesy Mimi Wesson and Dennis Van Gerven.)*

In 1879, John Hillmon left his wife Sallie in Lawrence, Kansas, in search of a new ranch site, accompanied by an acquaintance, John Brown. Before he left, Hillmon took out a large life insurance policy...somewhat unusual for the day. Two weeks later, Brown's rifle accidentally discharged right through his companion's head, killing him instantly.

When his grieving widow tried to collect on the policy, Mutual Life Insurance Co. was suspicious. This looked like a setup to them. Maybe Hillmon and Brown had killed a third party—Frederick Walters, a missing person about Hillmon's age—to split the cash.

In the days before blood tests, fingerprints, or DNA samples, identity was determined visually. Unfortunately, people often have poor memories for faces—a fact that often makes eyewitness testimony fallible. Some people who had met Hillmon and viewed the corpse were not sure it was Hillmon (Figure 6-11). Hillmon wife's testimony was suspect since she had so much to gain. The insurance company refused to pay the claim.

Figure 6-11 To the untrained eye or a casual acquaintance, the person in the coffin might look as much like Frederick Walters on the left as John Hillmon on the right. (Courtesy Mimi Wesson and Dennis Van Gerven.)

Sallie Hillmon sued in 1882. Suddenly, Brown changed his story, swearing that Hillmon had indeed done Walters in for the money. Yet before the trial's end, he recanted, claiming that the insurance companies had threatened to try him for Hillmon's murder if he didn't agree to lie. The conflicting evidence and testimony

led to a hung jury and a new trial in 1885. The new trial ended the same way as the first, leading to yet a third trial in 1888.

In the third trial, Sallie Hillmon won, but the story still wasn't over because the insurance company appealed. The case went all the way to the Supreme Court, once in 1892, where it set a famous legal precedent on hearsay evidence, and yet again in 1899 after two more trials. Finally, the parties settled out of court.

But the puzzle remained after all the trials: Was the occupant of the grave really Hillmon? In spring of 2005, University of Colorado legal professor Mimi Wesson brought the puzzle to a colleague, anthropology professor Dennis Van Gerven. Her theory: The evidence, when reexamined, did suggest that the corpse was Hillmon. Could Van Gerven help her prove it?

Van Gerven looked at the photos of Hillmon, Walters, and the body (Figure 6-12). Hillmon had a very pronounced hooked nose, with a deep depression between the eyes, as is obvious in this second photo. This is a distinctive feature that would persist as part of the body structure in the skull. He was sure that if he could examine the corpse, he could use standard forensic techniques to overlay the photos of Hillmon and Walters with that of the skull. His hypothesis was that the two men were facially dissimilar enough that the superimposition would enable him to make a positive identification for one of them.

Figure 6-12 *Hillmon's hooked nose is particularly obvious in this photograph. (Courtesy Mimi Wesson and Dennis Van Gerven.)*

Mysteries sometimes fight to stay unsolved. When Wesson and Van Gerven received permission to exhume the body, the grave was found embedded in the middle of an underground spring. There were a few bone and tooth fragments and precious little else. What about DNA? Yes, there were living descendants of both candidates who were eager to help. But, no, the years of flowing water had washed away all traces of human DNA.

But Van Gerven wasn't ready to throw in the waterlogged towel. Maybe they didn't have a corpse, but they did have some excellent pictures and Adobe Photoshop. Instead of using photo superimposition on the skull, what if he used the pictures of the corpse and the living men? He would not be able to make a positive identification this way, but that wasn't required. There were only two possible men to which this corpse could belong. Because of Hillmon's distinctive nose, Van Gerven should be able to identify the body through the process of elimination.

The first step was to make sure that he would be comparing three apples. There was a second picture of Walters, facing forward and oriented similarly to the second picture of Hillmon (Figure 6-13). The pictures needed to be lined up and oriented, so this similar orientation was key.

With Photoshop, it's relatively easy to match two images in size. The first step is to straighten both photos. You do that by drawing a line along a straight edge with the Measure tool and then selecting Image > Rotate Canvas > Arbitrary. The exact angle needed to straighten the picture appears in the dialog box. Click OK, and Photoshop automatically does that rotation.

The front view of the corpse didn't provide enough information, but the side view very clearly showed the facial structure and the distinctive curved nose (Figure 6-14). This was the photo to use. It needed to be rotated to an upright position.

Van Gerven knew that there were benchmark anatomical areas of the face that would help him compare the photos. He selected the top of the nasal bone between the eyes and the lower margin of the chin and drew horizontal lines to define them on each man's portrait. He did the same for the rotated side view of the corpse. Doing this allowed him to align the profile with each man's picture independently.

When images of Walters and the corpse were lined up, problems were immediately clear. There was no physical correspondence. Their noses were different lengths, the brow lines didn't match, and there was no hook-like structure on Walter's nose. But the same could not be said of the Hillmon–corpse superimposition. The match was about as perfect as it could be, from hairline down to chin (Figure 6-15).

Figure 6-13 *The second picture of Walters makes it easier to compare the two sets of features. (Walters photo courtesy Mimi Wesson and Dennis Van Gerven.)*

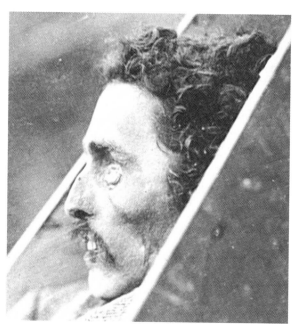

Figure 6-14 *The unknown corpse image needed to match the angle of the two upright living photos. (Courtesy Dennis Van Gerven.)*

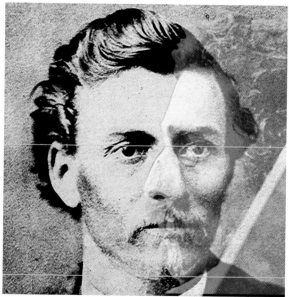

Figure 6-15 *Clearly, the Hillmon image and the profile look like they belong to the same person. (Courtesy Dennis Van Gerven.)*

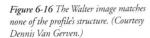

Figure 6-16 The Walter image matches none of the profile's structure. (Courtesy Dennis Van Gerven.)

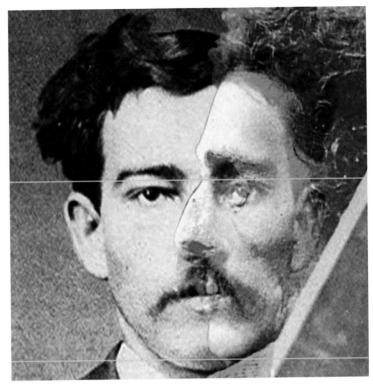

Van Gerven's work with Photoshop is a classic example of a scientific investigation done right. He and Wesson definitively eliminated Walter as the man in the coffin, cleared Hillmon's name, and vindicated his wife's stubborn belief.

TESTING THE LIMITS

It can be hard to test a promising hypothesis and have it fail, but an honest scientist accepts the results and uses them to move forward. Unfortunately, although most researchers undoubtedly follow good procedures and practices, a significant number play fast and loose with this process because the stakes can be very high.

Most scientific research requires time, expensive equipment, and a support staff. To get access to these resources, researchers must do two things successfully. For one, they need to secure funding in the form of grants or partnerships from the government and corporations.

Additionally, they must regularly publish papers in a scholarly journal—one with a staff or consulting group of referees who are experts in the same field as the author of the paper. These jurors are charged with determining the paper's suitability for publication, based on the quality of the research and its significance.

There is a strong connection between these two needs. Researchers who don't publish work in their field don't get grants. And researchers who don't get grants usually can't fund their research, their labs, and their graduate students. Additionally, there is a lot of competition for scarce space in the most prestigious journals. Jurors have a strong bias toward papers that demonstrate positive results.

Cheating Ways

Obviously, if a researcher spends a year working through a series of experiments meant to prove a hypothesis and gets negative results, life is not so pleasant. Cheating (just a little, of course!) is a tempting solution.

There are many ways to cheat. Plagiarism and idea theft happen in small businesses and boardrooms as well as in the research lab. But science fraud is not merely an ugly ethical breach. Because of how research knowledge is built, subverting the scientific method can lead to decades of wasted work.

Fake science is often no more than simple sloppiness. Everyone makes mistakes, but some people are too rushed or lazy to go back and redo their work. They fudge the data instead. Fraud can also happen through deliberate misrepresentation of findings. An investigator confronted with results that ruin a grand theory may misreport the result, report only the results that support his hypothesis, or even invent experiments that "prove" his work.

You would think that someone would catch on. But the cases that have come to light make it clear that most frauds are caught by chance. Very few reviewers ask to see an author's raw data unless they already suspect fraud, so misrepresentation can continue for years, particularly in an esoteric or obscure scientific area.

Then there's the deliberate scientific hoax. Ugly but fascinating, it's often so obvious in retrospect and so unthinkable until revealed. Hoaxing is not the work of the faint-hearted. To defraud your peers requires a combination of knowledge, planning, credentials, and audacity. Sometimes a talented scientist who has previously done solid work goes bad. Other times, a look at the breadcrumb trail uncovers a consistent career pattern of fudged and falsified work.

Piltdown Man

No discussion of scientific fraud takes place without mentioning the most famous and persistent hoax ever. It began in 1912 with the unearthing of a skull and jawbone in Piltdown, England, and for 40 years it misdirected the fields of anthropology, archeology, and evolutionary biology.

At the turn of the century, British naturalists were frustrated. They were searching for a missing link between man and ape to provide evidence for evolution, which was still a relatively new theory. The only candidate so far, the Heidelberg man (Figure 6-17), was a single jaw with a combination of apelike shape and humanlike flat teeth found in Germany. Why couldn't something more impressive be found in England? As geology pointed the way toward ancient rocky deposits, the game was afoot, and both academics and amateurs grabbed their picks.

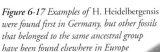

Figure 6-17 Examples of H. Heidelbergensis *were found first in Germany, but other fossils that belonged to the same ancestral group have been found elsewhere in Europe and in Africa.*

So when Charles Dawson, an amateur archaeologist and friend of Sir Arthur Conan Doyle, brought Arthur Woodward, an esteemed member of the National History Museum, fragments of an unusual skull dug up by workmen, Woodward scented the find of a lifetime. He quickly joined Dawson at the dig. They found more pieces of this very human-looking skull.

Soon, very close to the skull fragments in the gravel, they found a jawbone that looked like a modern ape's except for its very human teeth. Did the two pieces belong together? All the pieces of the skull that might have clarified whether or not they came from the same body were missing, but it was hard to imagine how two such ancient bones could have been found so close together if they weren't related. Woodward "reconstructed" the fragments and jaw into the longed-for missing link.

It's not as if everyone accepted this proposition as fact. In 1915, Gerrit Miller, an anthropologist at the Smithsonian Institution in Washington, D.C., made a clear and reasoned case for keeping the skull and jaw separate. Yet even he didn't guess the truth: that the entire

Piltdown Man was a clever forgery. Instead, even as other finds around the world pointed consistently to a very different evolutionary path, people were forced to make room for Piltdown's big brain and primate jaw.

Finally, in 1953, anthropologist Joseph Weiner investigated and then documented the details of the hoax. A closer look found that the teeth of a modern ape jaw had been filed down to look like human molars. The skull had probably been dug up from a medieval grave, and all the bones had been stained to make them appear old.

Even after all this time, the forger has not definitively been named. Most people believe the finger points to Charles Dawson himself, particularly after Weiner's research found a pattern of deception in his earlier archeological digs. Yet almost every other man involved in the story has had his turn in the role, and some of them are almost as likely candidates— which doesn't speak well of the level of academic honesty a hundred years ago.

The Neverending Fraud

Outside the scientific community, we don't always realize how serious such fakery can be. But bad science contributes to the misuse of millions of dollars in government and corporate grants. It misrepresents reality to the public, creating panic or prompting bad political and social decisions. It can delay medical cures by misdirecting effort and funding to fantasyland.

And once a bad paper gets published, it lives a kind of half-life in the community. Even if the authors retract a paper (or are asked to retract it, which is much the same thing but considerably more embarrassing), the paper is still searchable online and continues to live in its original form in libraries and labs. Doctoral students looking for citations to bolster their own work may continue to cite it.

The Korean Stem Cell Scandal

The high-profile science fraud cases that do splatter the news media come to light in part because the field they're in is hot. There are dozens of other researchers competing to be the first to make a breakthrough. When someone beats them to it, they do the experiments to see if they get the same results. If they can't, they try to find out why. Ultimately, no fraud can withstand such a concentrated assault. But that process can take a long while—frequently years, like the Piltdown Man fiasco.

But so far, only one scientific fraud could be mentioned in the same breath as Piltdown Man. Both were at the heart of a brand new and controversial field of study and took advantage of an overheated cowboy atmosphere. And both depended on false visual evidence—in the case of the Korean stem cell scandal, through Photoshop invention.

Woo Suk Hwang was South Korea's most important scientist and a source of great national pride. With a background in veterinary medicine, he jumped into the animal cloning field, claiming a steady stream of successes in cloning farm animals. His first big splash internationally was his paper, published in the prestigious journal *Science* in 2004, claiming that he and his team had cloned a human embryonic stem cell. This paper reverberated far beyond his homeland, since everyone had thought this was impossible with existing technology.

2005 was a triumph for Hwang. In May, he published a follow-up paper, claiming to have created not one, but 11 human embryonic stem cells, each from a different donor, and each donor with a serious medical need. Suddenly, all the "somedays" for treating disease with stem cells were "nows." By creating so many different lines, he had proven that it was possible to tailor a medical solution for individuals. Almost as a footnote, he announced in August that he had cloned a dog—also a first.

Everything began to fall apart at the end of the year. One paper co-author pulled out of his relationship with Hwang on the discovery of ethical breaches in the collection of the donor eggs. The investigative Korean TV program *PD Notebook* announced that it was about to run an investigative report questioning not just his ethics in this case, but the authenticity of his entire body of work.

Despite the Korean public rising up in fury, an anonymous post on an official messaging center for young researchers accused Hwang of duplicated pictures in his supporting figures (Figure 6-18). The floodgates sprang open, with hundreds of people finding obvious attempts to deceive in Hwang's supplemental supporting images.

What they found was stunning in its audacity. Hwang had apparently had one of his team members turn two donated cell lines into 11 cloned lines by using images more than once. The image editing strategies were very simple, counting (correctly, unfortunately) on the assumption that no one at the journal would give the pictures more than a cursory glance.

Some of the fakes were covered by keeping the brightness of the images very low (Figure 6-19). When the brightness was adjusted, it was clear that the same image appeared twice.

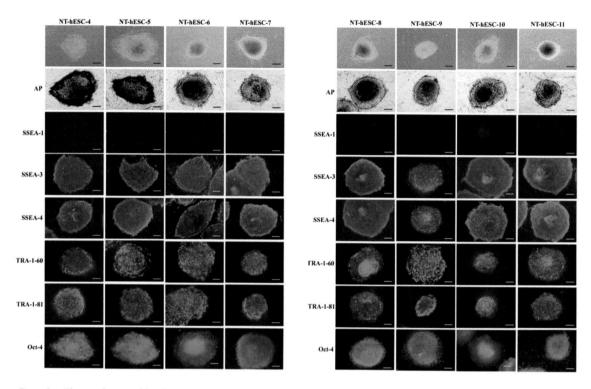

Figure 6-18 These two figures are fakes; they do not represent real cloned cells.

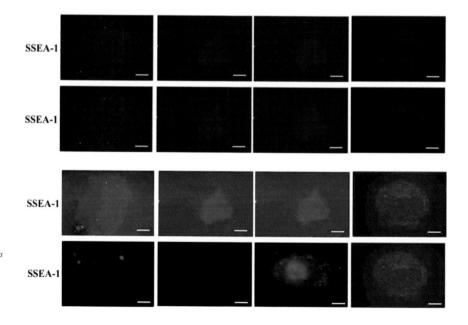

Figure 6-19 These rows of cell images from the two figures above are very dark. A change in brightness on the right reveals why: Duplicated images were used to fill out the figures.

In other cases, a single image was divided into two, either to separate two cells on the same slide or to crop one cell into two images (Figures 6-20 and 6-21).

Figure 6-20 These two cells, which were split between the two pages in Figure 6-18, are two halves of the same cell.

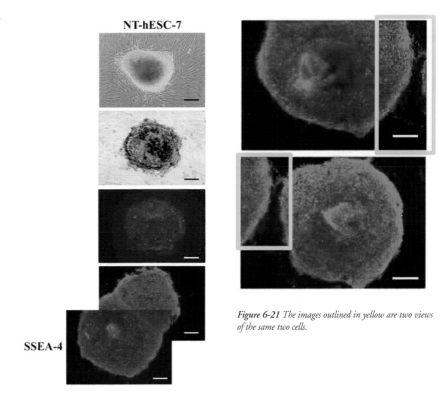

NT-hESC-7

SSEA-4

Figure 6-21 The images outlined in yellow are two views of the same two cells.

At first, Hwang claimed that some of the figures had been inserted in the paper by mistake, which was sloppy but an honest mistake. But little by little, it became clear that Hwang and his team had not successfully cloned a single human stem cell.

Having resigned in disgrace and been indicted for fraud and embezzlement in 2006, Hwang has still never admitted to any form of misconduct. He blames his team of researchers for deliberate sabotage and for creating false data on their own. As of June 2007, he was looking for new partners in other countries to continue his research.

Moving Forward

One of the outcomes of the Hwang shocker has been the increased scrutiny given to other papers involving stem cells and cloning research. All of the major scientific journals have published new guidelines on how to prepare figures and have warned that they will reject new papers that don't live up to standards.

Clearly, they're going to be kept very busy. According to Mike Rossner, managing editor of the *Journal of Cell Biology* and a leader in holding researchers accountable, has estimated that about 20 percent of all papers accepted for publication in his journal have had at least one figure that they had to reject because of inappropriate image editing. Some of these errors can be traced to poor Photoshop skills and a lack of understanding of what can inadvertently take place when you attempt to make an image "prettier." Others can only be described as out-and-out falsification.

One journal, *New Scientist*, has gone so far as to look at some groundbreaking papers retrospectively. The result so far has been the discovery of several figures that were recycled from earlier papers, with obvious clumsy attempts to treat them as different, like flopping the figures horizontally and adding background textures. It seems clear that the scientific community should brace itself for more examples of creative Photoshopping.

The Case File: A Practical Guide to Scientific Fraud

Not all grand science fraud has been perpetrated by Photoshop jockeys. Physicists in nanotechnology still cringe when the name Jan Henrik Schon is mentioned. In 2001 he figured out how to make a transistor, the basic computer building block, from a single molecule. Or not. Of the 21 papers in this wunderkind's name, 16 contained not just false data, but the same false data, minimally changed from figure to figure. None of his co-authors at Bell Labs ever checked his work, and all of his original experimental data had "disappeared" when his hard disk crashed.

But Schon's low-tech tactics are in the minority. It's Photoshop's role in scientific paper fraud that has made headlines lately. Disturbingly, the worst of the problems with Photoshop science are found in cell biology, an area with life and death implications for people suffering from diabetes or spinal cord injury.

Many of the ways to determine whether a cell experiment has been successful are through figures. In most cases, these are digital images captured through some form of electron microscope. There are many types of these microscopes, each optimized to view cells and other objects in a specialized way. Each requires special techniques and protocols that the scientist or lab technician needs to master to get good results.

In addition, electron microscopes don't capture any color information. In fact, many of the things that they image, including cells, are transparent. The color in printed cell images captured with scanning electron microscopes has been added (Figure 6-22).

There are some advanced versions, like the fluorescence microscopes, that are integrated with imaging software that translates grayscale information into color. But in all cases, if the samples are not prepared properly, or the wrong settings for the microscope are used, the output can be wildly off.

Figure 6-22 On the left is the original slide, on the right the one with color added. Usually the added color is green, because it makes details easier to see. (Courtesy Dennis Vaccaro.)

How can you recognize when there is something wrong with a figure? It's actually very, very hard—much more difficult than it is in any other fakery. Most cell pictures are zoomed to capture details from microscopic sources. As there is no visual scale to help orient the image and no light source to check, the hints that the trained eye can see that point toward alterations are of little use.

Figure 6-23 One of the cell clusters in this image has been duplicated, but it could be very hard to find if you had no reason to look for it. (Courtesy Dennis Vaccaro.)

But most important, because scientific areas are so specialized, in order to really be sure that an image has been altered, it needs to be examined by someone in the same specialty. With dozens of papers submitted for publication every month and several journals competing for the same works, finding a reviewer with no professional ties to the author who also has the time and inclination to act as a whistle blower if needed is a daunting task indeed.

The federal Office of Research Inquiry provides several forensic tools as Photoshop droplets to help editors locate potentially hidden image problems. The only problem is that educated reviewers are still needed to interpret the droplet results.

So it is hopeless? Not at all, if you are motivated. Some types of errors constantly reoccur. Spot-checking figures for these problems first can provide a quick way of weeding the pack.

Crowded House

Sometimes it's very important for an experiment that multiple cells or types of cells appear in the same sample at the same time. For example, in Figure 6-24, there appears to be a colony of one type of cell on the left and a rounder, slightly different type in the upper right. Finding these two types of cells growing together could make someone's doctoral thesis a success. But other times, either because the experiment itself was faulty or the time-consuming preparation for the culture was botched, they don't appear. How much easier to just splice two cell images together than to spend days redoing the work (Figure 6-25)? In the same image seen with a change in brightness in Figure 6-25, there is a slightly different color halo with a fairly regular edge around the cells in the upper right. Because the lab technician or junior team member knows that this work has been successful before, it's easy to rationalize the image editing—so easy that this is a common problem.

Figure 6-24 Two types of related cells appear to be growing in the same medium. (Courtesy Dennis Vaccaro.)

Figure 6-25 By radically changing brightness, color and/or saturation, splices like this reappear. (Courtesy Dennis Vaccaro.)

Policed Blotter

To examine a DNA sequence, scientists slice it into small bits with a gel. Then the strands are covered with a membrane and blotted, somewhat like using a paper towel to pick up a counter spill. At this point, scientists bake the transferred DNA and the membrane. The heat makes the DNA double helix unravel.

Before it can reattach, they introduce protein strings, called probes, whose own sequences have been engineered to match crucial segments of the DNA. If the DNA segment that matches the probe is present, the two will link up. They wash away any of the unused probe, and the pattern of the strands can be captured on film and examined.

These pattern strips tell scientists exactly what DNA sequences were present. If a sequence they expect to see is missing, then the experiment probably didn't get the results they wanted. They could redo the experiment, or this could be a Photoshop moment. The reconstruction of a gel blot in Figure 6-26 has been altered to show a DNA sequence that wasn't present.

Figure 6-26 Note that the blots in the second column in the bottom section have been duplicated in the fourth column.

You can edit to duplicate sequences deliberately, but most papers with blot problems are victims of cluelessness rather than evil intentions. They are the result of "cleaning up" the blots to make the most important information easier to see (Figure 6-27). The major problem with cleanup is that it often throws the genetic

baby out with the bathwater. Sometimes "random" blots show the presence of other genetic information that could be relevant but has been deleted by the cleanup. You can check for background cleanup by looking at the histogram of the image (Figure 6-28). If there is a razor-tooth effect in the midtones and high points at the white and black levels, it's probable that someone used Contrast too heavily on the image.

Figure 6-27 An image that looks like this is suspiciously clean. Most blots are much less high contrast.

Figure 6-28 This histogram pattern suggests that contrast was applied.

Improper Recycling

Sometimes a figure is completely correct in its original context but also is somewhat ambiguous. For example, gel blots are so irregular and only have content in the context of an experiment. They mean nothing without explanation.

This fact is all too useful for some researchers. It's unusual to see the same figure duplicated in the same paper, but using the same figure in two or more papers to show different results is becoming somewhat common. The faking ranges from adding a background, changing size or orientation, splitting one image into two, and mislabeling. The perpetrators count on reviewers and editors looking only at the current paper and its data, so using the same image in papers published in different journals can be very difficult to catch.

The journal *New Scientist*, in an extremely unusual move, went back to a paper whose conclusions have proven difficult to reproduce and examined it carefully. The figures and conclusions here are based on their investigations.

The image in Figure 6-29 is a reconstruction of a gel blot. The figure caption in the paper it appeared in identified the image as "real" bone cells that were used as a control. That means that they would be a benchmark that would be compared against stem cells that became bone cells. In the same paper, the image also appeared reversed and slightly edited as shown in Figure 6-30.

Figure 6-29 An image similar to this one was identified as a gel blot of a bone cell.

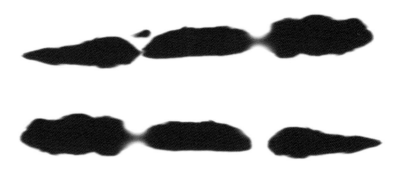

Figure 6-30 The same figure, now identified as collagen from stem cells that had become bone cartilage cells.

The reason the double-dipping in these figures is so questionable is that the control was reused to illustrate that the stem cells did become bone cartilage cells. Perhaps that is exactly what happened, but this reversed image not only doesn't show it, it implies that the process didn't take place because the experimenters couldn't get a gel blot from the cartilage cells.

In a patent request, not a paper, the image is used again (Figure 6-31), with yet another change. This time, the caption said that the image was a protein found only in bone cells and that the gel blot was taken from stem cells that were successfully turned into bone cells.

Figure 6-31 The same image, used to illustrate a different protein.

The researchers in this case claimed that, even if the images were mislabeled, their work had been reproduced, and the image's duplication didn't change the results of the experiment. Of course, that remains to be seen, but even if true, that doesn't excuse the substitution.

It's very likely that the reuse and abuse of figures in Photoshop will continue. The result of this and other experiences is that publications will be expected to do more extensive checking, not just of the papers submitted to them, but of the researchers' histories. That process is so prohibitively time consuming that it's inevitable that more bad science will slip through, and more "creative imaging" will find its way into print.

PART III

BODY OF
EVIDENCE

The power of reason, the top of the heap

We're the ones who can kill the things we don't eat

Sharper than a serpent's tongue

Tighter than a bongo drum

Quicker than a one-night stand

Slicker than a mambo band

And now the day is come

Soon he will be released

Glory hallelujah!

We're building the perfect beast.

—Don Henley, "Building the Perfect Beast"

CHAPTER 7

THE SKINNY ON CELEBS

THE FRENCH CRITIC Roland Barthes observed that a photograph's message depends on the viewer's knowledge. Unlike a painting, which records a creative process that is both selective and interpretive, a photograph is also connected to an instant of time and place. Because of that connection, we treat the photograph as a frozen moment of truth. Obviously, this book calls that treatment into question. Yet even when the photographer makes no interpretive or aesthetic changes to the image, the image's global context, the photographer's intent, and our honest reaction may differ substantially.

FASHIONABLE PERFECTION

Absent a caption to provide the story, we can misread, misunderstand, or just plain miss the content. A peaceful tropical beach makes us long for a cold beer on the sand. When told that the photo was taken minutes before a tsunami, horror breaks up the daydream. Our reaction changes yet again if we consider the photographer.

But deliberately hidden context can affect our response as well. If a photo looks "right" (no obvious strange elements or bad edits), we seldom look at it critically. Our tendency is to accept the story it tells as fact, not fiction.

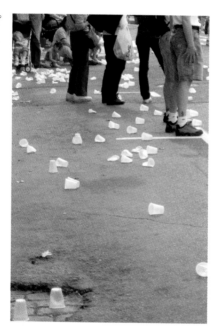

Figure 7-1 Is this photo about littering? Why are these people sitting on the street? Without knowing the story—the cups are discards from the Boston Marathon—the picture is easy to misread.

The Big Skinny Story

Yet fiction it is. Every new line of clothes, every fashion shoot or celebrity spread is all about the narrative—the fairy tale of promised perfection. If the actual captured image falls short, it can and will be edited. It is probably fair to say that not a single posed photo published in the media makes it into print without a visit to Photoshop.

Celebrities are frequently reworked. It's standard practice to repair hotspots and glare and to enhance lighting effects, and no one would begrudge these improvements. Next come the "self-esteem" edits. These turn the subject into the person he might be on his best day. Retouchers eliminate pimples or moles, brighten and straighten teeth, and smooth awkward wrinkles on clothing and a few equally awkward wrinkles on faces. Almost no one in the public eye wants these blemishes glaring back at them from a cover that millions of people might see.

Somewhat like eating potato chips, once a retoucher has embarked on improvement, it's hard to stop. Even if the celebrity isn't really super-thin or impressively muscled, he can be perfect by the time the retouching is complete (see the case file, "The Digital Diet"). In some cases, if the body edit isn't going very well, a new body can be used instead.

Edits are sometimes done so skillfully that, unless a different version of the photo is published so viewers can compare the two, the edited image becomes reality. This manufactured fact becomes a template for the young and unsophisticated. This is what success looks like. If they work hard at copying the template, they can get there, too.

Most celebrities either take this reworking in stride as part of the game or even actively encourage the changes. Only a few take a principled stand. In 2002, Jamie Lee Curtis, in an extremely brave move, volunteered to be photographed in *More Magazine*, a journal for women over the age of 40, with no makeup, no hair stylist, no special photographic lighting, and not a bit of retouching. (Pictures of before and after images can still be seen on lhj.com.) Kate Winslet complained publicly when GQ retouchers slimmed her down for a cover in 2005, explaining, "I do not look like that and more importantly I do not want to look like that." Unfortunately, few others would have the self-confidence and security to follow their lead.

The Case File: The Digital Diet

It's no secret that publicity photos are edited, but few people who aren't in the business know to what extent. A window on the practice opened in 2006, when *Watch* magazine, a CBS property, published a Katie Couric publicity still on the eve of her taking the anchor position at CBS News. An alert blog correspondent at mediabistro.com pointed out that what appeared to be the same photo had been released three months before. The original photo (Figure 7-2, left) shows a poised and friendly middle-aged professional. The second photo (Figure 7-2, right) displays a very different silhouette and face. Someone in marketing obviously thought that they had a makeover emergency.

Figure 7-2 On the right, Couric appears 20 pounds lighter, with additional work to make her face and neck thinner and younger.

It's difficult to know for certain how the artist approached this assignment. There are as many different ways to accomplish the work as there are retouchers. This sidebar proposes the most thorough and professional process, using a model of about the same age and dress size (Figure 7-3). These tools and techniques offer the easiest way for a celebrity to drop 20 years and 20 pounds.

Figure 7-3 This image was shot at 12 × 18 inches at a resolution of 240.

Anyone who's watched an *Extreme Makeover* episode knows that it's important to have a strategy. The first stage should hook you into staying through some of the messy details in the middle. That's true for a Photoshop extreme makeover as well. In this case, we don't need to motivate the faux celebrity, but the artist will want to move fast. The game plan will be to slim from the top down and then make the subject's face match the body's age rewind.

Most of our reshaping takes place in Photoshop's Liquify filter—surely the most versatile retouching tool in the imaging deck. It allows you to seamlessly bend, mutilate, and improve any image, leaving no visible traces of its work.

Liquify works by turning your image into a wire frame. As you click or press with a pen, the grid deforms. The amount of change is determined by a combination of pressure and brush size. These vary according to the resolution of your file. Larger resolution files can tolerate more pressure. You can set the amount of pressure in the dialog box or use a pressure-sensitive pen the way you would if you were drawing.

The tools allow you to apply pressure in various ways and to protect portions of the image from change (Figure 7-4).

Figure 7-4 The Liquify dialog box holds the toolbox on the left and the brush and view settings on the right.

Figure 7-5 Save Mesh lets you keep and reload a mesh.

As with all Photoshop tools, you can Step Backward several steps if you make a mistake. You can also use Liquify's Reconstruct options to return some portions of the image to their original state, as long as you still have the image mesh. A good retoucher knows that client needs can change, so most use Save Mesh to keep a running record of their changes (Figure 7-5).

Slenderizing

We start from the top: the shoulders. They're a little too chunky for the young, slender woman we have as our goal. If we push them down slightly, we'll make the neck look longer.

To move everything in one direction, select the Forward Warp tool at its largest diameter. The size of the brush determines how much of the image will be affected, with the most change taking place at the brush's center (Figure 7-6). With a large brush, the shoulder moves down in one smooth gesture.

Figure 7-6 The crosshairs on the brush tool identify the area that will be the focus of change. The force of the change decreases toward the brush's edge.

Our next goal is to maintain the subject's chest while decreasing her waist. The Freeze Mask tool can protect most of the body. Freeze is basically a quick mask that you paint onto areas you want to protect from change. Using a Brush Density of 100 ensures that covered areas aren't affected at all, but can make for an abrupt shift if you're not careful. A lower density protects, but not completely (Figure 7-7). In Liquify, how you freeze is almost as important as your warp settings.

Figure 7-7 The crosshairs on the Brush tool identify the area that will be the focus of change. The force of the change decreases toward the brush's edge.

The simplest way to cinch in the waist is to increase the visual space between arm and body by pushing the body inward. We decrease the brush size to 150 (Figure 7-8) because we are working with a much smaller part of the image and want to be able to judge the progress of our changes on the left and right sides. A quick time saver: Instead of constantly going to the tool settings, you can use the keyboard. Pressing the [key makes the brush size smaller, while the] key makes it larger.

Figure 7-8 Sometimes you need a thick brush to cover distance. Other times you need a thin brush for edge detail.

Now that the waist is svelte, the hips look larger than they did before. To start, protect the model's hands, the ruffles, and the piece of paper, and then zoom into the body and select a large brush diameter—in this case, 360. We use a density of 67 so we can move smoothly over a large area but not so quickly that it's hard to adjust as we go.

To hit the ideal, the female body should be a little top heavy, while the hips and thighs become very slim and boyish. Not only do we have to decrease the width overall, the skirt must taper to telegraph that these legs have no extra fat. These are radical changes. The best way to do them is in a couple of passes to prevent distortion and do-overs (Figure 7-9).

Figure 7-9 Move all the way down one side, evaluate the results, and do it again to slenderize and taper to hug the legs.

The process needs to be repeated on the other side. To make a symmetric change, or to verify that important parts of a picture are being protected, you can turn off Show Mask and turn on the Show Mesh view option. Using the grid view allows you to see exactly what is being changed and to adjust your brush size or stroke accordingly (Figure 7-10).

Figure 7-10 The sleeve ruffle is protected, so the grid compresses to show where the change ends.

The end result is a very slender, youthful-looking body (Figure 7-11).

Figure 7-11 Mission accomplished: body fat gone.

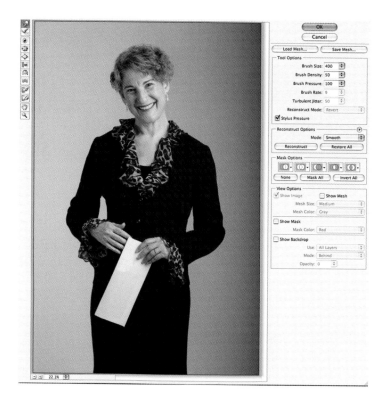

Face Lift

Now the most obvious problem is the face, particularly the neck and chin. As Nora Ephron famously pointed out, necks sag even when the rest of the face holds up. What she doesn't mention is that necks are attached to chins, and the entire structure gives way to gravity together. Liquify offers the Pucker tool, which carefully applied will lift and clean up the jaw line.

The first step is to protect the area from too much of a good thing with the Freeze tool. Select Pucker, and change the brush size to a fairly small diameter, in the range of 20 to 40 pixels (Figure 7-12), or the tool will create the world's most inappropriately placed dimple.

Figure 7-12 Pucker minimizes the size of anything at the center of the brush.

Starting with the places with the most sag just below the chin, we minimize the extra flesh down to a natural-looking shadow and carefully do the same on the jaw line to the right. Use Pucker again on the chin itself, and it's as if the flesh has tightened. The effect is a shorter, more youthful jaw line (Figure 7-13).

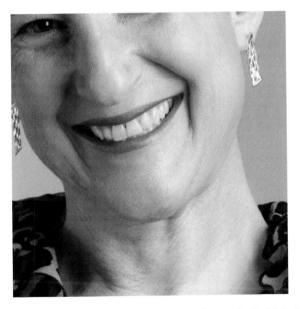

Figure 7-13 The neckline and chin on the right have been raised and minimized.

We need to balance the changes on the right with those on the left. The left is much easier because it's just a curved cheek. As with the waist, protect the area, use a very large brush to change the cheek all at once, and move the cheek line into the face (Figure 7-14).

Figure 7-14 Moving the cheek also compresses and softens some of the facial lines.

There's one last piece of flesh that feels the pull of gravity: the nose. The tip slowly droops and spreads with age. Pucker works nicely on this problem as well. Protect the lips and position the brush at the tip of the nose, and it will appear to move upward slightly (Figure 7-15).

Figure 7-15 The tip of the nose is minimized with a small application of Pucker.

To cure the middle-aged spread of the nose, position the brush just where the bone ends and the nose broadens (Figure 7-16, left). Increase the size of the brush so the nose is within the circle, and apply a very light touch to narrow the nose. The shorter, narrower nose makes the model look younger and subtly prettier (Figure 7-16, right).

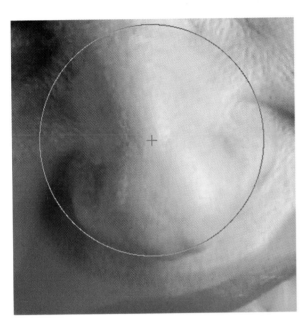

Figure 7-16 Pucker also slightly blurs the nose, making the skin smoother.

Figure 7-17 The left eye needs to be slightly opened to match the right eye.

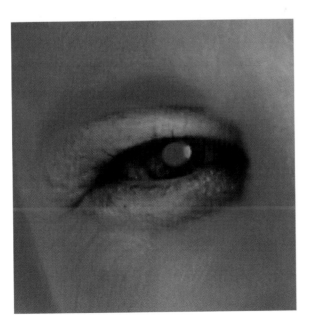

Eyes don't get fat, but lids do sag, and they don't do so evenly left and right. Opening up the narrower eye is a standard practice in retouching. Protect the area around the eye and also the pupil (Figure 7-17). Failure to do so will make the human eyes look out of proportion, like a lemur.

This time, the preferred tool is Bloat, which is Pucker's opposite. The point directly in the center of the brush will bulge. By protecting the pupil, the bulge will be subtle and mostly affect the eyelids (Figure 7-18).

Figure 7-18 The left eye appears larger after applying the Bloat tool.

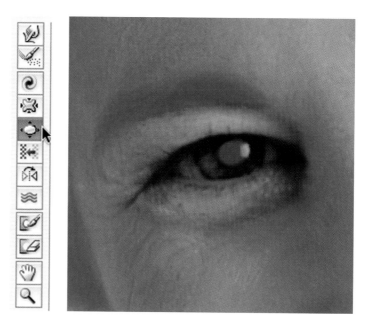

The last item is a standard retouch trick for fashion models, but it works here as well. The model's lips are a little thin, so we'll want to flesh them out a bit. Before we do, we paint around the mouth. In addition, carefully painting the teeth while zoomed up close to the image limits changes to a very small area.

Using one quick click of the Bloat tool with a small brush and moving along the lip line, the bottom lip expands into the tooth area, closing the mouth slightly and enlarging the lip (Figure 7-19).

Figure 7-19 *The top teeth will not be affected, and the small bit of bottom teeth will shorten and be replaced by the lower lip.*

Botox

The large changes are complete (Figure 7-20), so it's time for the finish work. There are still many wrinkles, large and small, to contend with before the skin looks age-appropriate.

Figure 7-20 *The Liquify plastic surgery is finished.*

There are many ways to retouch wrinkles. To retouch a normal subject, you'd just want to minimize deep wrinkles. But subtlety would be wasted here. Although celebrities are more likely to have undergone real plastic surgery and have fewer wrinkles than most subjects, any and all obvious problems need to be repaired.

If there are wrinkles that are deep and stand alone, the fastest way to eliminate them is with the Patch tool, an alternate of the Healing Brush (Figure 7-21).

Figure 7-21 When you select the Patch tool (left), change the settings to Source and uncheck Transparency (right). Doing this makes patched source pixels replace the original pixels.

With the Patch tool, draw a selection around the offending wrinkle. Drag inside the selection to another area on the face that looks like it might make a good replacement, and then release the mouse button (Figure 7-22).

Figure 7-22 Large wrinkles can be selected and replaced with the Patch tool.

For areas on the face where there are many wrinkles close together—like around the eyes—the Healing Brush works better than the Patch. Selection is key with this tool. Find a source point on the face that has similar shading to the area that needs work. With a narrow brush, paint over the wrinkles. It's best to lift your brush and stop between wrinkles to avoid an overly blurred look and to shift the source area occasionally to avoid obvious telltale repetitions (Figure 7-23).

Figure 7-23 Leaving a few wrinkles at the corner of the eye prevents the face from looking fake. Even young people have small wrinkles at the corners of their eyes.

The last major problems are the bags under the eyes. Again, using the Healing Brush and selecting small areas of the lid with the right color and texture removes the lines caused by the bags, making them appear flat (Figure 7-24).

Figure 7-24 Remember to not only erase the lines below the eyes, but to use the Patch tool or the Healing Brush to delete the light shadows they may have cast on the cheek below.

The work is done—far more quickly and cheaply than with cosmetic surgery and a strict diet. From here, a good retoucher would even out the lighting slightly on the face and send the image off to the graphic designer (Figure 7-25).

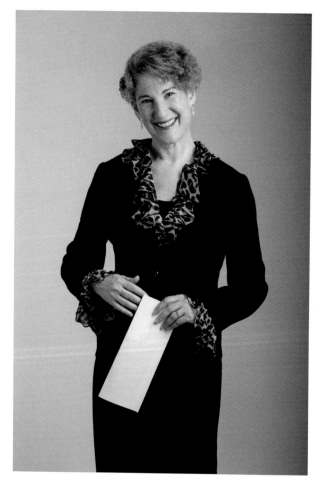

Figure 7-25 The result: a youthful face to match the body.

What, Me Honest?

Is this refashioning ethical? Apparently that isn't a worthwhile question for magazine covers and stories about pop culture icons. The editorial side of the media sees a difference between "hard news," where no enhancement is honest no matter how innocent and useful, and everything else, where no enhancement is forbidden no matter how deceitful and damaging.

This dichotomy may make sense to editors, but it has little traction with the public. Most readers see no difference among the print media—culture news can be found in *People* magazine, *Newsweek*, or the local newspaper. All the media outlets covered the death of Anna Nicole Smith or Martha Stewart's stint in jail.

The media blur the line themselves, particularly in magazine covers. Covers are considered advertising, not news. But for many people, the covers may be the only part of the magazine that they see, and they're certainly what readers and viewers remember. When 60-year-old Martha Stewart was blessed with a size six body on *Newsweek*, the incident simply proved that there is no bad publicity. Stewart's iconic status was confirmed, and the magazine gained sales and buzz.

SHRINKING BEAUTIES

Models have always been thinner than the average for their era, but the gap between the media standard for beauty and real people continues to increase. In the 50s and early 60s, the average female clothing model was about 5' 8" tall and weighed about 132 lbs. A model of the same height in the 80s weighed between 115 and 120 lbs. Today, the average model is closer to 5' 10" and weighs less than 110 lbs. Although this combination is possible for a healthy teen after a sudden growth spurt, it's close to impossible for a healthy adult.

The situation is not as extreme for males, but the discrepancy is increasing for them as well. The ideal male body based on ads in men's magazines is about 6' tall with a weight of about 145 lbs, all of it muscle. An average man of the same height is more likely to weigh 185 lbs and be considerably less toned.

Phat Times for Retouchers

The push for extreme body types has not resulted in less-extreme image manipulation. In fact, the level of fantastical improvement on professional models has only increased with Photoshop. How quickly things slide from documentary to science fiction! There is so much that can be done to the image after the photo is shot that no one worries about a few imperfections—in the shots or on the model.

The quality level of the work decreases as more work is done. Like any other industry, advertising has different levels of care at different price points. At the top rung are retouchers for TV ads and fashion magazines. Their production values must be high because the rates are astronomical. Newspaper ads represent comparatively low-budget placements, so the edits that appear on their pages are often the worst offenders.

Now that there are proportionally fewer supermodels and more who are young and anonymous, it's easier to make radical changes without people noticing. Fashion models often become flawless dolls, with skin so perfect it lacks pores. Their eyes are large and luminous, their hair sleek. A little strategic work with the Bloat tool and they can be both emaciated and a mammal. Since a fashion model is basically a mobile couture dummy, the most important thing is to avoid altering the clothes.

Some of the editing changes should be ludicrous, but they are accepted without comment. Photo retouchers with marching orders and no previous experience in figure drawing churn out hundreds of ads for everything from shoes to lingerie. A body can lose its internal organs to sell underwear (Figure 7-26).

Figure 7-26 *This ad appeared in* The New York Times. *The retoucher made the model thinner by cutting off her ribs and creating a ruler-sharp line from the bottom of her bra down to the undies.*

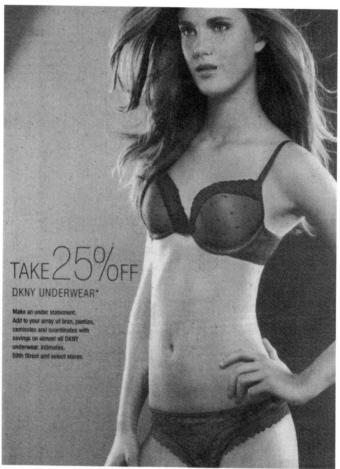

MEASURING UP...OR DOWN

This isn't the first era to set improbable beauty goals. Throughout history and in a variety of cultures, expectations (mostly, but not exclusively for women) have required self-denial and discomfort. In extreme cases, they've led to pain, illness, and death.

There is one important difference between today's followers of fashion and those of previous eras. This is the first time that the average, and even the disadvantaged, can be full participants in fashion extremes. Almost all prior aberrations required and in fact defined status and resources. Only an aristocracy with a developed servant infrastructure could survive and thrive in some of history's fashion contests.

Pretty Poison

Back in the 1990s, pundits were shocked by the "heroin chic" fashion rage. Skinny, pale bodies with heavy eyeliner and shadow seemed to make a fetish of sickness.

Equally shocking was the obvious youth of the models—these weren't supermodels playing at a look. They were emaciated unknowns.

But people who railed against the ads as a new low may not have realized that we don't have a corner on going too far. Sickness chic had been done before with an even more dangerous drug. Deadly in minutes if eaten in sufficient quantity, arsenic was a favorite cosmetic additive in the 1700s. To reach the ideal look of feverish delicacy—bright eyes, white skin, and rosy cheeks—women would take small doses, accustoming their bodies to the poison over time. Misjudge the dose, and the woman was a fashion victim in fact.

Bonsai Bodies

Dubious fashion aesthetics have a long cross-cultural history. Early frescos on the walls of the Minoan place at Knossos show men with extremely narrow waists encircled with belts (Figure 7-27). Although there's always room for style and artistry, the drawings otherwise look surprisingly modern and realistic. The bodies show wide, masculine shoulders and human proportions. Historians have come to the conclusion that some type of belt or corset was worn from an early age to artificially maintain an aristocratically constrained profile.

Figure 7-27 An aristocratic figure from the walls of Knossos, known as the Prince of Lillies. (Wikicommons license, courtesy Leonard G.)

Every imaginable body part has been singled out somewhere. The Kayan tribe in Burma has long been known for their curious fashion of wrapping the necks of some of their women with metal rings, which pushes their collarbones down, giving the impression of an extremely elongated neck. The rings are a sign of special favor, and women who wear them are exempt from most tribal labor.

Dandies of the Regency period in the early 1800s were similarly slaves to fashion's requirements. The style of the time required giraffe-like collars tied in place with cravats (Figure 7-28). Once wrapped and tied in place—a process that might take hours to reach perfection—the dandy could barely turn his head, let alone look downward. Although the middle classes could ape the look with a lower collar and cravat, only a person with no responsibilities and extensive resources could meet the ideal.

Figure 7-28 The profiles of both men and women were extremely cinched in and constricting in the early 1800s. (Library of Congress, Prints & Photographs Division, LC-USZC2-619.)

The Regency era was also the heyday of the corset. The ideal silhouette was similar to the look when a celebrity combines anorexia with breast implants. Add the Regency puffy skirt and sleeves to the tight-laced waist, and you get the effect of a much exaggerated hourglass. This look was as much an obsession in the 1800s as the size 0 look of today. Like teenagers who starve themselves into skin-wrapped skeletons, some women took the corset look to the point of danger. They laced so tightly that breathing was difficult and any form of exertion could lead to fainting.

Figure 7-29 The tight-laced waist was both fashionable and the source of humor. (Library of Congress, Prints & Photographs Division, LC-USZ62-52101.)

If there's a top 10 of fashion torture, Chinese foot-binding must rank number one. No other fashions have lasted so long—a thousand years. The practice went far beyond fad or fashion to become integral to the culture. Women who didn't have bound feet might never find a husband, and as they had no other reasonable alternatives in the society, foot binding became self-perpetuating. Although the practice began with the aristocracy, eventually everyone except the poorest classes took part. The process began with young girls below the age of six and involved breaking all the toes except the big toe (Figure 7-30). The result was a foot between three and four inches long, permanently wrapped and never seen without slippers. Women with bound feet were barely able to walk and were never pain free.

Figure 7-30 Chinese foot binding. On the right, an x-ray of a pair of bound feet. (Library of Congress, Prints & Photographs Division, LC-USZ62-104036 and LC-USZ62-80206.)

Thinking Thin

Compared with foot binding, our off-and-on obsession with thinness seems almost benign. Thin-as-beautiful began after World War I. The curved figure that had been the ideal for decades looked terrible in the new short, straight frocks of the mid-1920s (Figure 7-31). Only thin, young women could really carry off the new style. Everyone else required undergarments that flattened the bust and held in the hips. Although this sounds very like the early twenty-first century, the pressure to return to a longer, more rounded silhouette came from the fashion designers. Clothes were so skimpy and simple that not enough money was being made in the couture world.

Figure 7-31 The flapper look—very thin and long—has resurfaced in twenty-first–century styles. (Library of Congress, Prints & Photographs Division, LC-USZC2-1415.)

Looking at some of these excesses from the historical viewpoint, it's clear that the current obsession with extreme thinness is probably a moment in time like all the rest. Eventually, without legislation and campaigns, styles will change—and the popular ideal with them.

Although we aren't likely to see Photoshop employed for rounding and plumping up any time soon, the knee-jerk morphing of normal attractive women into waifs will eventually end. In part, that's because extreme body forms push the limits of proportions that seem to be irretrievably burned into our genome.

WHAT IS BEAUTY?

For centuries, artists have studied the human form. They discovered that, while the variations of the body's proportions were infinite, the average proportions conformed to mathematical ratios.

For example, if you were to use the length of the head from crown to chin as a unit of measurement, an average man measures 8 head-lengths tall. That is also the distance from right to left, finger to finger, of his outstretched arms, meaning that a man's longest dimensions would describe a square. Rotate the same well-proportioned man in spread-eagle position with his navel at the center, and his extended arms and legs would describe a circle.

The most famous visual expression of these proportions is Leonardo da Vinci's *Vitruvian Man*, which he based on measurements passed down by the Roman architect Vitruvius (Figure 7-32).

Most importantly for artists, photographers, plastic surgeons, and others charged with optimizing human beauty, we experience these averaged proportions as aesthetically pleasing. The closer a human form comes to the proportional average, the more likely it is that we will describe the person as attractive.

Figure 7-32 Vitruvian Man *is drawn to describe the circle and the square, the two perfect geometric shapes.*

The Fibonacci Series

This ratio of one body proportion to the next is more than a human curiosity. It turns out that this ratio, whether divided or multiplied, can be seen not only in the human body. It defines the growth pattern of nautilus shells, the number of petals on flowers, and possibly even the orbits of the planets of the solar system. It can be expressed mathematically by the number 1.618…, known as Phi, or the golden ratio.

The golden ratio is the result of dividing a line into two unequal segments. The ratio of the larger segment to the original line is the same as the ratio of the smaller segment to the larger segment. If you carry that division further, you can subdivide the smallest segment into two more segments, each of which maintains the golden ratio (Figure 7-33).

Figure 7-33 *The yellow and orange segments remain in proportion to the green line. Shrink the green line to the size of the orange segment, and the ratio holds.*

Or you can reverse the process to increase instead of decrease. Assuming you start with 1 (the smallest whole number), the next largest segment in the series would be the sum of that number and the one that precedes it. The first time you do that addition, the answer is also 1 (0 + 1, because there isn't a preceding number). But then you have two numbers to work with: 1 + 1 = 2. Add the 2 and its preceding number and you have 2 + 1 = 3. Continue, and you see a sequence of numbers, 1, 1, 2, 3, 5, 8, 13, 21, 34, 55, which extends infinitely. This is called the Fibonacci sequence, after the thirteenth century mathematician who first documented it in the West.

You can see elements of the Fibonacci proportions in the human face (Figure 7-34). The two green boxes are the same size. The lighter one is a square that describes the distance from the center of one pupil to the next and from the pupils to the corners of the mouth. The darker square is the distance from the top of the lip to the chin.

The pink boxes are a golden ratio one step down in the numerical sequence from the green ones. Together, vertically, they define the width of the nose. Horizontally, they are the distance from the center of the pupil to the tip of the nose.

The orange rectangle's width is a golden section one step down from the green boxes. It defines the width of the eye.

Figure 7-34 The face is a collection of golden proportions. Trace these boxes one step further and you can describe the proportion of the eye to its pupil.

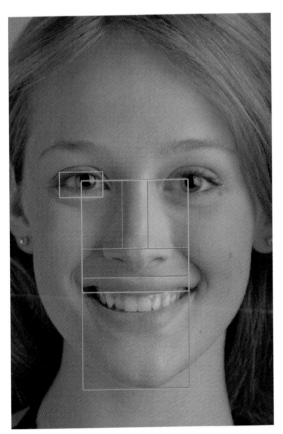

You may notice that the boxes are very close to perfect on the model's face, but not absolutely exact. It's important to remember that mathematics is a description of perfection. Human variation from perfection is what makes each of us recognizably different from the next person.

The Barbie Face

No real person could ever conform to the perfect average. If they did, they would look disturbingly artificial. That's one of the reasons why most people can immediately recognize that a human character in a movie is a CG construct.

A real human can only be generally symmetrical. Each of us is either left or right handed. As a result, one side of our bodies and faces gets more of a workout than the other. This translates into muscular asymmetry.

It's easy to test this principle. Take any person's face, divide it in the middle, and mirror one side to the other (Figure 7-35). One version will be wider, more muscular, the other thinner and weaker. The stronger will look a little more like the real person than the weaker side will. But both look fake.

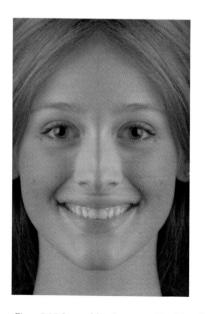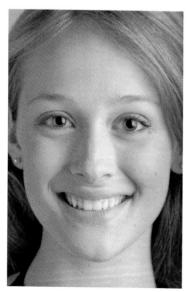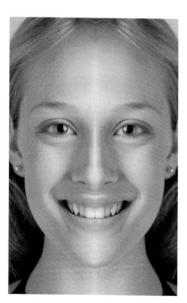

Figure 7-35 One model in the center and her left- and right-mirrored clones on either side of her.

THE BEAUTY FORMULA

As we've seen, an artist armed with a quality camera, studio lighting, and Photoshop can turn a plain woman into an attractive one and an attractive woman into a beauty. But successful retouching comes at a high price. It adds to the already high cost of advertising and printing. And such high-quality work is not available to the public.

But what if an actor or model's features could be optimized with the push of a button? Or what if the average person with a digital camera could take a decent snapshot, bring it into Photoshop, and through the magic of software, have the best MySpace photo ever? Suddenly we'd live in a world where everyone could look better than average, at least in their photos. That day may not be too far away.

In 2005, a team of researchers at Tel Aviv University in Israel surveyed 300 women and men about the relative attractiveness of hundreds of photos. They measured the facial features in each photo and calculated the ratios of nose to eyes to chin for each one. The result was a substantive collection of data that crossed sex and ethnic lines to document what people find attractive in another person's face…and what they don't.

Based on this research, Tommer Leyvand, then a graduate student in computer science, developed a computer program that created a "face space" in wireframe. If a full-front facial image is input into the software, the program maps it onto a grid similar to the one used in Photoshop in the Liquify filter. But instead of having a human being painstakingly adjust the image, the program automatically warps the picture to bring the features closer to the attractiveness ideal (Figure 7-36).

This subtle manipulation tends to bring the face closer to the ideal of the Golden Mean. Faces are made slightly more regular, noses enlarge or shrink to edge toward the perfect ratio. The results are compelling, as every subject looks identifiably the same, and yet somehow strikingly improved.

Figure 7-36 The changes the program makes are very subtle, particularly if the subject is already attractive and mostly symmetrical. As shown by the warp field, the major differences are the wider jaw line and position of the eyes.

The Case File: Making of a Model

Although it's possible through the magic of Photoshop to make enormous changes, turning plain people into beauties and hunks, one of the most common uses is to turn a good-looking young woman into a raving beauty. In many ways, it's a more challenging task, because it is so easy to err on the side of plastic. When you eliminate all of the slight quirks that make a face arresting, you can turn a natural beauty into someone pretty but unmemorable.

Usually, a model is photographed after claiming the attention of a makeup artist and a hair stylist. But many beautiful girls eager to strut in front of the camera don't have the professional résumé or the funds to pay for this work. Photoshop, and a careful eye, can fill the gap.

Our model is a beautiful young woman with a very natural look. We'll perform a model's retouching process that will change that impression. The first step is to fix the minor imperfections that the camera caught and that would ordinarily either be covered by makeup or eliminated in any post production. Step two is glamorization. Step three contains the lighting changes that make for a dramatic presentation.

The model has several small moles scattered on her face. As with the Katie Couric edits mentioned previously, these can be addressed easily by replacing them with perfect skin close to each mole with the Patch tool (Figure 7-37).

Figure 7-37 Each mole needs to be replaced with a patch from a different part of the skin, as close to the mole itself as possible.

Lips

The model's lips are naturally full and ripe, but they have a lot of glare and could use a more commanding look. To decrease the glare, select the hotspots on the lips and then use the Refine Edge dialog box to expand the selection and feather it (Figure 7-38).

Sample a color in the middle range of the lip colors, and then make a new layer from your selection. Lock the transparency of this layer—that will prevent you from painting outside the selection and will allow you to move quickly when you paint the color that you selected onto the new layer (Figure 7-39).

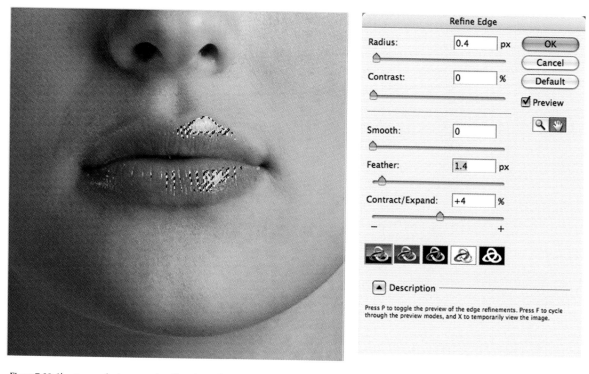

Figure 7-38 Almost every selection you make will need some feathering to merge well with other layers.

Figure 7-39 Command/Ctrl-J automatically puts any selection on its own layer.

Use the Linear Burn blend mode for this layer to allow the original lips to show through while darkening them, but also lower the layer opacity until the lips still glisten but no longer glare (Figure 7-40).

Figure 7-40 You increase the transparency so the lips will still glow slightly.

With the glare gone, we return to the original layer and make a selection of the entire lip. Copy this selection to a new layer and choose Image > Adjustments > Replace Color. The original lip color you selected earlier will appear as the starting color. Make sure that the Fuzziness slider is all the way to the right and that the Selection radio button is chosen. Click the color box in the Replacement section to bring up the Select Target Color dialog box and change the RGB numbers to your favorite lipstick color.

Figure 7-41 You'll have more alternatives later if you select a dark, saturated color.

Click OK, and you've applied the lipstick. If this color is a little too bright, you can decrease the layer opacity. If it isn't bold enough, change the layer's blend mode to Multiply or Hard Light. By combining changes in blend mode and opacity, you'll have a range of looks to choose from.

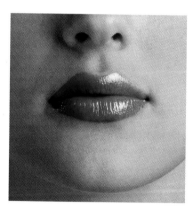
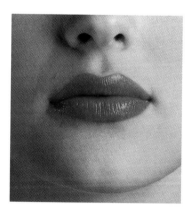

Figure 7-42 From left to right, layer blend modes set to Multiply, Hard Light, and Normal.

Eyes

The model's eyes droop at the outside corners and are not quite the same size. Before dramatizing them, we need to correct.

Fixing the uneven eyes is a job for Liquify. The right eye needs to have its lower lid closed up slightly. Masking most of the eye and the area around it allows you to push the lid upward. Because we are trying to make the two eyes even, this is a good use for the mesh. You can see very precisely when the bottom lids line up with each other (Figure 7-43).

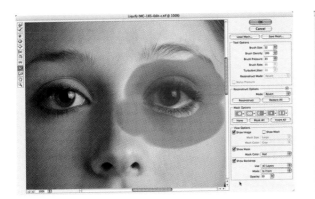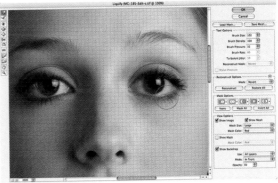

Figure 7-43 It's easier to see the mesh with the freeze mask view off.

Now that the eyes line up, we'll change that droop to a slight upward slant. Use the oval selection tool to select each eye, and copy each one to a new layer. Select Edit > Free Transform, and rotate the left eye clockwise. In this case, 3.4 degrees is the magic amount (Figure 7-44). Rotate the right eye counterclockwise the same amount.

The model has lovely brown eyes, but with her coloring, blue or green will be more striking. To change her eye color, select both irises and copy the selections to a new layer. Fill the selections with a medium green. Change the blend mode to Color and the Opacity to 60% (Figure 7-45). Color allows the texture and details of the eyes to show but changes the color of everything that isn't black.

Figure 7-44 The rotated eyes should look natural but slightly more alert.

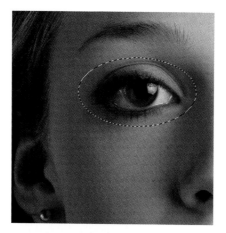
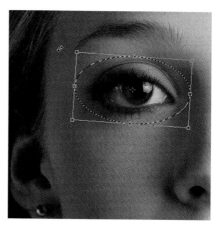

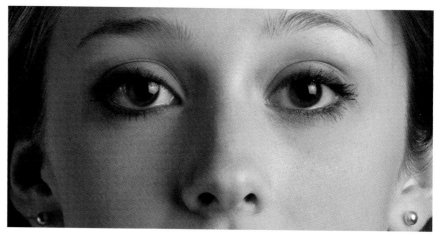

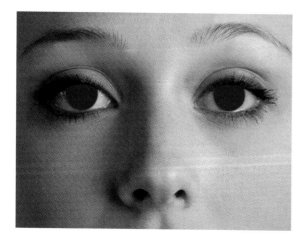
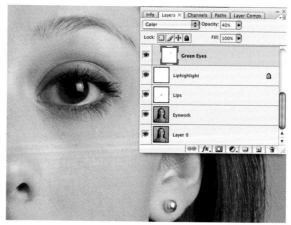

Figure 7-45 Reducing the opacity of the green mixes the yellow-brown and green together for a believable color.

These beautiful green eyes could use a whiter frame to make them sparkle. If one eye is more in shadow than the other, you'll have to adjust the whites, so you should work on each eye separately. Select the white of the left eye and then select Layer > New Adjustment Layer > Hue/Saturation. Move the Lightness slider to the right about +10–15. Repeat for the right eye (Figure 7-46).

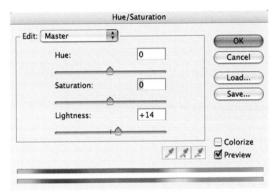

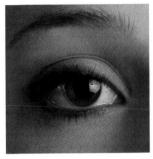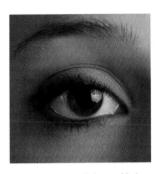

Figure 7-46 Be careful not to overdo this effect. It's dramatic in small doses and looks like the devil (literally) with too heavy a hand, as seen on the far right.

The model already has some eye shadow, but she could use a color glow. Add the effect of eye shadow by selecting a pastel color. Apply it above the eyes with a large, soft brush. When done, change the layer blend mode to Soft Light, which tones down the color and fades it naturally into the skin (Figure 7-47).

Figure 7-47 The brush has a setting of 100 px diameter and a hardness setting of 0 to keep the soft-focus edge.

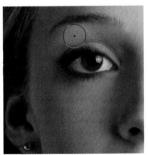

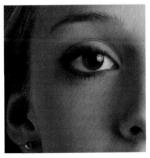

Eyebrows are one of the toughest facial elements to touch up. Usually, the model has brows that are too heavy and need pruning. But this model has light, uneven brows. The challenge is to add new ones while maintaining as much of her genuine line as possible.

The best and most natural way to add brows is to draw them on with a very thin, hard brush, using two shades of the same basic color. We use a 3-pixel brush directly on a new layer, following the model's natural brow line (Figure 7-48).

Figure 7-48 Laying individual hairs is the best but most time-consuming way to fill in brows.

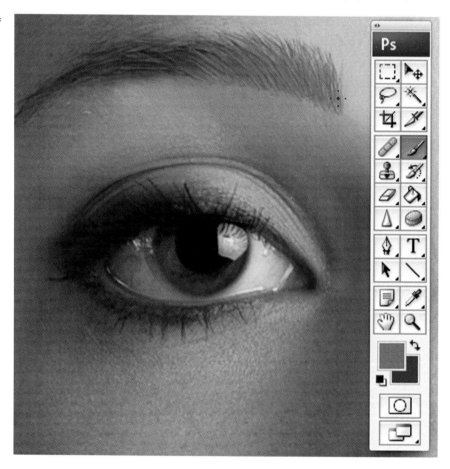

If laying the hairs on by hand makes you jittery, Photoshop artist David Nagel has created brushes for applying hair. They can be downloaded for free from his Web site, mediadesigner.digitalmedianet.com, with instructions on how to add them to the application (Figure 7-49).

Once the digital brows are in place, we go back to the original eyebrows and use the Clone Stamp tool to delete hairs that are outside the new line (Figure 7-50).

Figure 7-49 Nagel's brushes preview on the brush tool dialog display, so you can see the effect before you apply it.

Figure 7-50 To be safe, copy the original brows to a new layer and edit them there. If you make a mistake or don't like the effect, you can go back without having changed the layer with the intact image.

Hair and Skin

Hair in a professional studio has been processed and sprayed into a perfect confection. Our model's hair is soft and natural but has many small fly-away ends that distract more than they complement. Fixing her hair is a two-step process. First, use the Clone Stamp and Healing tools to replace the small loose ends with background (Figure 7-51, left). Second, use Liquify to smooth and shape the loose edges for a hair-stylist look (Figure 7-51, center).

Figure 7-51 After removing single loose hairs, large strands can be pushed in with Pucker and the outline of the hair is managed by pushing strands together.

A nice effect in fashion photography is when a soft focus blur is applied to the face to smooth out and perfect the model's skin. To get this effect, make a copy of your file and flatten it. In the Layers palette, select Duplicate Layer and select the original document as the destination (Figure 7-52).

Figure 7-52 Making a duplicate layer preserves all your changes and edits but gives you a composite of all your changes to date.

Select Layer > Layer Mask > Reveal All. Use the brush to protect the model's brows, hair, eyes, and mouth from change (Figure 7-53).

Figure 7-53 If you don't protect the features, the image will simply look out of focus when it is blurred.

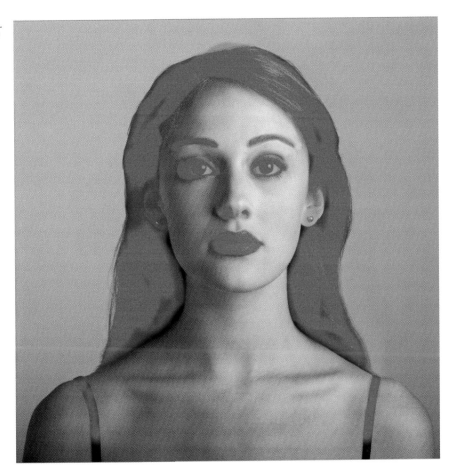

Select the layer image. Choose Filter > Blur > Gaussian Blur. In the dialog box, select the blur amount, which will vary according to the picture's resolution. The result is a softer, more matte-finished skin with any remaining minor imperfections minimized (Figure 7-54).

Figure 7-54 This image was created with a blur setting of 2.6, but your mileage will vary.

Expressive Lighting

The model was shot with neutral, fairly flat lighting. With Photoshop's Lighting Effects filter, the artist can add character and mood through lighting that used to require expensive and time-consuming setup in the studio. To set up the virtual lights, create a new layer. Select Edit > Fill and change the drop-down menu to 50% Gray.

With the filled layer selected, choose Filter > Render > Lighting Effects. In this dialog box, select Omni from the drop-down menu. Omni stands for "omni directional" and gives the same effect you'd get with reflected strobe lighting and a soft box. Click inside the color swatch box on the right, select a warm peach shade, and set Intensity to 88 (Figure 7-55).

Figure 7-55 The peach shade acts like a light filter to warm the color temperature.

Turn the opacity of this layer down to 50% so you can see the model. Select Layer > Layer Mask > Reveal All. In the Layer Mask, paint over the model's face, neck, body, the shadow areas of her hair below her ears. Change the layer blend mode to Overlay (Figure 7-56).

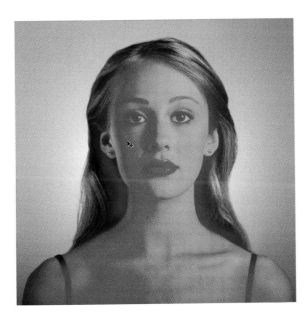

Figure 7-56 Overlay allows the light to warm the picture and add glowing highlights to the model's hair.

Mission accomplished (Figure 7-57)! Any subject, even one who isn't as perfect initially as this model, can be glamorized. It's a good lesson to remember when you look through a magazine, Web site, or TV ad. What you see may not be anything like what was originally in the camera.

Figure 7-57 From pretty to perfection, with no telltale signs.

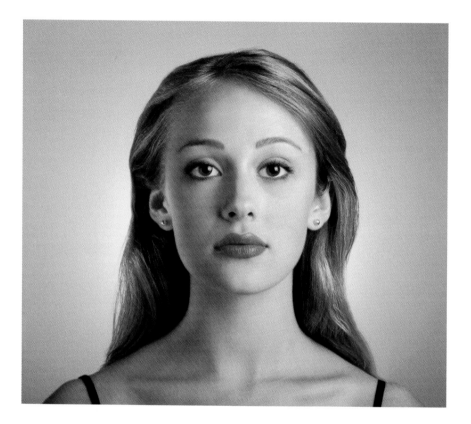

You would think that, with so many examples of faked images gaining publicity in the media, people would begin to mistrust what they see. And yet the opposite seems true. Even amateur photographers routinely scale down the width of photos five or ten percent before they give them to their friends. Our eye for proportion slowly erodes. It takes a fairly outrageous change for even the educated viewer to respond critically. The more common Photoshop editing of celebrity and fashion images becomes, the more the public accepts the fiction and grows accustomed to the look.

CHAPTER 8

PIMP MY PARTS

THERE'S BACON AND EGGS, heart and soul, ghosts and goblins, cheese and crackers—things that surface like reflex actions in our minds. These combinations are clichés that make game shows like *Family Feud* possible.

But what happens when you throw the pieces into a box and draw them out randomly? You could end up with eggs and goblins. That's a seemingly pointless pairing that can offer delicious results—Easter goblins, a pointy-eared Humpty Dumpty, or green eggs and ham. In fact, the more unlikely a combination, the more likely it is that we will remember it. That's what compositing is about—visualizing strange bedfellows just because we can.

MIX AND MATCH REALITY

This is certainly the era of the composite. We call it a mash-up when it involves two sets of data and fusion when it's used to create haute cuisine flavor mergers. The concept, however, is the same as when we merge two disparate photographs to suggest a more intriguing or exciting reality. And it is becoming a central theme in how our era views the world.

TRICKS AND TROMPES

The early history of Western art and architecture shows as many expressions of visual trickery as it does simple realism. Artful special effects were not merely a curiosity; they were a benchmark for mastery. In his book *The Natural History*, Pliny the Elder tells the story of two rival Greek painters, Zeuxis and Parrhasius, who held a contest to determine once and for all which of the two was the more accomplished. Each had to paint his most perfect illusion.

Zeuxis brought out his painting first—a still life of grapes. They were so realistic that birds flew down from the sky to try to eat them. Parrhasius brought out his painting of a scene from the Trojan wars, but it was covered with a cloth. When Zeuxis went to lift the cloth and view the entire painting, he was forced to admit defeat. The cloth was part of the painting itself.

Trompe l'oeil (literally, trick of the eye) is hyper realistic imagery that breaks the barrier between the flat picture and its frame. Its pleasure comes from recognition—that double-take moment when the viewer realizes the artist has created a successful optical illusion. It was a favorite decorative effect in ancient times—the walls of villas in Pompeii contain many examples.

With the rediscovery of perspective in the Renaissance, paintings to trick the eye became popular once more. The architectural *trompe l'oeil* was particularly popular. Palaces and churches were covered with vaulted naves and corridors to make their interior space feel more open and light (Figure 8-1). There are thousands of such frescos throughout Europe, particularly in France and Italy.

Trompe l'oeil has never lost its attraction in artistic expression, although it has gone in and out of mainstream art—sometimes just a novelty, other times a prevalent style. In the middle of the nineteenth century, William Harnett's rich and dark paintings of common household objects, from instruments and books to guns and money, fostered a new school of painting in the United States (Figure 8-2). Ironically, his work, which is quite popular with art collectors, is one of the most frequent targets of art forgery.

Figure 8-1 The oculus in the Camera degli Sposi (wedding chamber) in Mantua, Italy, painted by fifteenth-century artist Andrea Mantegna.

Figure 8-2 Harnett's backgrounds were always meticulously painted doors and walls. (Courtesy The Yorck Project.)

Architectural trompes came back into vogue in the 1970s. The practice continues with great enthusiasm today, although in modern times the murals are usually outside, not inside. Some, like the mural in Roussillon in Provence (Figure 8-3, left), bring life to what would otherwise be a dull wall or doorway. This mural feels like a surprise when you encounter it at the end of a long narrow street. Other *trompe l'oeil* murals are eye-grabbing expressions of both artistry and civic pride.. The extravagant wall painting in Lille, France (Figure 8-3, right), is a meta joke. It refers to the Roman amphitheater that faces the building and is used for performances in the summer.

Figure 8-3 Trompe l'oeil *ranges from the intimate to the monumental.*

Compositing

Like the trick image, compositing also has its roots in ancient art history. Many mythological creatures are compositing naturals—centaurs were half horse, half human; Medusa had snakes upon her head instead of hair. But the creation of the Frankenbody—defined as the deliberate compositing of body parts—was first recorded by the ancient Greeks.

Zeuxis, the same painter who ended up on the short end of the realism contest, was called upon to paint a portrait of Helen of Troy. Since Helen was considered the most beautiful woman who ever lived, finding a live model was somewhat challenging. Reportedly, the enterprising Zeuxis devised the first human composite by combining elements from several women to bring Helen to life.

Despite these roots, compositing as we know it needed a technological advance to be practical. If you draw on top of a painting, the original vanishes under the new colors. But superimpose one photographic image atop another, and both can be visible. Sometimes the combination is random and pointless, but other times the result is more arresting than either image alone (Figure 8-4).

Figure 8-4 *This image is one of a series of experiments. Lewis Wickes Hine, the photographer, composited multiple images of child workers in a cotton mill. (Print and Photographs Division, Library of Congress.)*

Trick Photography

Trick photography combines the falsity of the composite and the hyper-truth of *trompe l'oeil* and has always created controversy. From almost the beginning of the photographic era, practitioners could be divided into those who loved photography for its ability to document reality—or at least reality as they saw it—and those who most enjoyed its ability to create blatant unreality. The vogue of spirit photography (see Chapter 10) that swept through the Victorian era was mostly fed by a deliberate and cynical group of photographer fakers.

But not all trick photography was meant to fleece the gullible. At the turn of the twentieth century, William "Dad" Martin single-handedly invented the joke post card by using strategies familiar to anyone who surfs the Internet. Shoot some innocuous images, scale some images up, sandwich the two together with a great caption, and you're in business (Figure 8-5). The sales volume of these post cards was so large that, even a century later when old post cards have become hot collectibles, these are still eminently affordable treats on eBay. Dad Martin himself obviously maintained his sense of humor, even after leaving the lucrative post card photography market. He founded a national outdoor signage company as the market for billboards exploded with the automobile.

Figure 8-5 If Martin lived today, he'd probably be starting urban legends on the Internet.

COMPOSITING AND THE MEDIA

Dan Martin may have been puckish, but he was a clean-living Midwesterner. It's not clear that he would have approved of the darker turn photo compositing took when he left the field. Yet his post cards were a precursor for the tabloid press, which brought photo fakery to newsstands everywhere.

Contrary to common belief, neither the *Enquirer* nor its rival *The Daily News* invented the fake news composite. That prize goes to New York City's *Evening Graphic*, which slunk through journalism's basement from 1924–1932, when the sober atmosphere of the Great Depression and lack of advertising ultimately strangled it. Although it was nicknamed the "Evening Porno Graphic" (for good reason), it was also the starting gate for future stars Ed Sullivan (yes, of Beatles broadcast fame) and Walter Winchell.

But the paper had a problem. Covering sex and scandal left too much to the readers' imaginations, as it was very hard to get photographs of critical moments. The art department started combining pieces of existing photos of real people with photographs of staged scenes. The pieces were often surprisingly realistic expressions of the actual but unavailable events. In Figure 8-6, for example, the *Evening Graphic* created a stage set and then replaced the heads of the actors and actresses with photos of Rudolph Valentino and his doctors to illustrate his major operation. The paper started referring to these types of illustrations as "composographs"— a more honest label than today's "photo illustrations," which they eerily resemble.

Figure 8-6 Like today's celebrities, Rudolf Valentino was a boldface name in the 1920s press. (Print and Photographs Division, Library of Congress.)

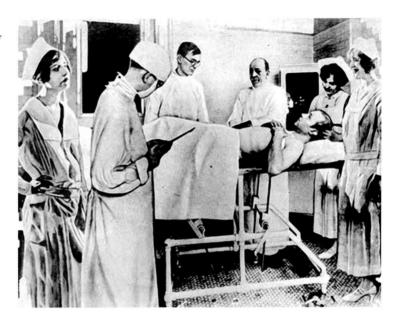

Because documentary photography was still in its infancy, there was no outcry on the editorial ethics of doctored images. And the paper was completely upfront about what it was doing—there was no nudge-and-wink attempt at passing off the pastiches as real photos, as there is on cover art today. Not surprisingly, people loved them, and the paper's circulation boomed.

FILM COMPOSITES AND EFFECTS

At the same time that print media were experimenting with composite illustrations, filmmakers were using trick photography and compositing to create the first movie special effects. Magicians, already well-versed in the world of illusion, were among the first to see the potential of using film as a way to expand their repertoire. Harry

Houdini starred in several silent movies at the turn of the century that focused on misdirection and his escape art. In 1902, Georges Méliès, a French magician and one of film's most innovative early directors, artfully merged live action, special effects, and animation into film's first science-fiction narrative, *A Trip to the Moon* (Figure 8-7).

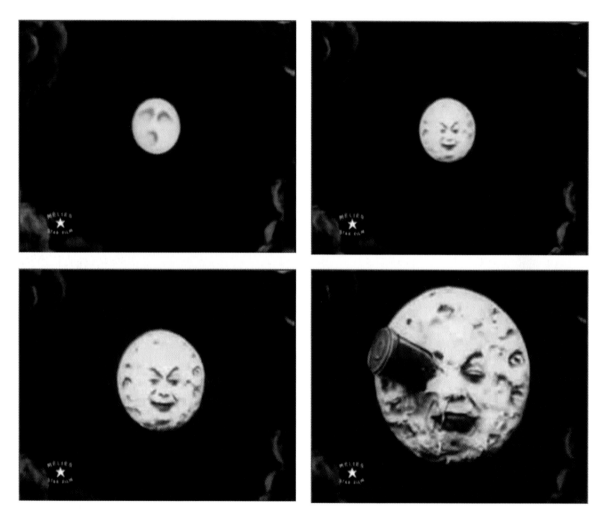

Figure 8-7 As the spaceship approaches the moon, the director smoothly substitutes a live-action sequence for an animation to give the impression that the spaceship has landed in the moon's eye. (Print and Photographs Division, Library of Congress.)

One year later, the first film composite, *The Great Train Robbery,* appeared through the invention of keying. Keying essentially creates a window in a portion of one scene, making it transparent. Another clip is matched up to the window and fills the missing space. In this case, the scene combined live actors inside the set of a train office with the footage of a train coming to a stop (Figure 8-8).

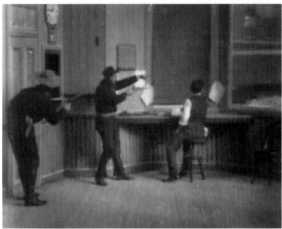
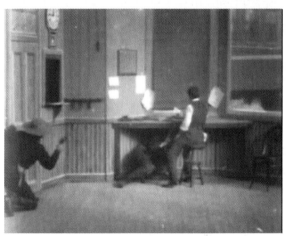

Figure 8-8 Although we take film compositing for granted today, a century ago, merging two separate film clips into one was groundbreaking. (Print and Photographs Division, Library of Congress.)

Today, this process takes place with color and is known as Chroma Key. To create the transparent window, a unique, non-natural color is used as a background placeholder behind live action. Essentially, the background is protected with an alpha channel, exactly as when a mask is used in Photoshop to protect portions of a still image.

Although in theory any color could be used for this purpose, practically speaking the color options are limited. The background color must be unlikely to appear in the real world. Otherwise, something in the foreground that was a similar color—like clothing or skin—would become transparent by mistake.

The film and video industries have settled on two very high-intensity shades—one blue, and one green. Generally, TV and film tend to use the blue screen, while video and animation composites are usually done with green. In either case, computer software for compositing recognizes them as default transparent colors.

COMPOSITING, COMPUTER STYLE

The spaces occupied by moving images and still images are no longer separated. It's possible to use a program like Adobe After Effects to composite several tracks of live video and animation on a computer. Portions of the output can be saved as a still image, which can then undergo even more changes, overlays, and composites in Photoshop. In a computer-based merry-go-round, these still images can end up composited again—as backgrounds for TV or video footage.

The fluidity of moving between digital images, scanned analog photographs, 3D animation programs, and a variety of film and video sources has brought compositing to a level never envisioned at photography's birth. It's still not clear whether we've reached the logical limit to the type of media that can be added to the image editing mix.

What is clear is that artists, designers, programmers, and casual users alike are still just scratching the skin of the options.

The Case File: Body by Fissure

Photoshop has given birth to a new hobby: the creation of the Frankenbody. Like the famous monster, the Frankenbody is cobbled together from bits and pieces of matter. Also like the legendary monster, the maker attempts to create a hybrid that will pass muster in the real world.

There are many reasons to make a monster. The most frequent explanation is that the head of a famous personality is no longer (or maybe never was) attached to a hyper-perfect body. Rather than artistically retouch, it's much easier to find a picture with the right body and stitch the two together. This solution is becoming standard practice for cover art. If the public were exposed to a celebrity's real figure, would they find the cover, and therefore the magazine it graces, less desirable?

No one is immune. The deed has been done to Martha Stewart, Oprah Winfrey, and Jennifer Aniston, to name a few. Occasionally the parts are "almost real"— the same person, but a combination of bits and pieces from different photos. More frequently, the famous head is grafted onto an anonymous body model.

Perhaps the most bizarre instance was one of the first computer-assisted celebrity composites. In 1989, *TV Guide* grafted Oprah's head to the neck of shapely Ann-Margaret's 1979 publicity photo. Since Ann-Margaret is a Swedish natural blonde and Oprah is not, a certain amount of adjustment must have been necessary. It's fun to extrapolate that a similar result could be done today, with a much more composite-friendly Photoshop application.

In Chapter 7, a Katie Couric stand-in underwent radical computer liposuction. The end result was elegant but time consuming. Imagine that a magazine such as *Newsweek* had wanted to show her tanned, rested, and psychologically ready for her new anchor position. They'd have combined her retouched face with a youthful model's body to create a cover illustration (Figure 8-9).

Figure 8-9 *The challenge: to combine the retouched celebrity face with the body of a young woman in a meditative pose.*

For a successful Frankenbody project, the source images must have similar resolution and image size so they won't have different textures when combined. They should also share similar lighting intensity, color, and direction. Direction is the most important of the three, because shadows and highlights must match.

Assuming your source images meet these criteria, you have two tasks: separating at least one piece from its background and matching skin tones.

Back in the day of the Oprah/Ann-Margaret splice, both of these tasks were extremely challenging. Although they still require patience and good process, current Photoshop tools make the work much easier. To start, you need the Extract filter, a tool that is capable of exact and realistic separation of background and image, even when dealing with seemingly impossible elements like hair or fur.

Extraction, with Less Pain

Since this filter makes irrevocable changes to the image, never enter it without first duplicating the original layer you're about to extract something from. Everyone who first uses Extract makes mistakes, and unlike most other Photoshop tools, this one actually dumps information when you click OK.

Basic instructions are simple. You use the Edge Highlighter (the top tool in the palette) to define where your object should disconnect from its background. Once you've completely enclosed that area, you use the Fill tool to indicate the extraction.

The actual process takes some practice. In fact, on first experience with Extract you might have dentistry-level nightmares. Despite the frustrations, dedicated retouch artists swear by this filter.

First, there's hair—the reason why Extract is better than just using Quick Mask or relying on selection tools. Unless you're extracting a sharp-edged 1960s beehive, hair and background are more closely entwined than lovesick teens. Extract pries them apart, as long as you carefully define the places where the two meet.

To get the best extraction, you need to vary brush size and strategy for different types of edges. For the hair, it's best to zoom up close and paint with a large brush everywhere that hair and background interact (Figure 8-10). Although you can paint on the background at will, don't paint at all into the part of the image that is hair only. If you do, Extract will confuse highlights with background and leave you with a straggly network of missing hair that you will have to clean up by hand—or give up on and start again from scratch.

The rest of head needs a clear, fine edge. The way to get it is to use a small, hard brush, carefully drawing just at the edge of the target area. Again, you don't want to paint more than a few pixels inside the area you want to extract. If you make a mistake, stop highlighting and use the Eraser tool to fix it as you go. Most of the time, erasing is a better choice than Undo when trying to draw carefully around an image, because it's faster and easier than redrawing.

If you have great visual definition between the background and foreground, as this image does where skin and background meet (Figure 8-11), you can check the Smart Highlighting box and Extract will authoritatively take over. It will increase or decrease the brush to the optimal size for the extraction and keep the line clean even if your hand isn't completely steady. Once you move to an area where foreground and background are similar—like where you need to separate the chin from the neck—turn this helper off and return to manual mode.

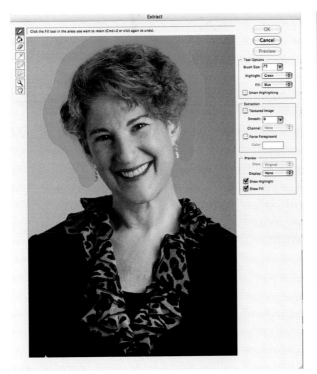

Figure 8-10 *The wide brush encircles the hair on the left. A close-up on the right reveals that the highlight only overlaps places where the background shows through the hair.*

Figure 8-11 *Even though the brush size is set to 20, Extract has chosen a much thinner stroke to capture the edge between skin and background.*

When you've encircled the head, click the Fill tool inside the highlighted area (Figure 8-12). You should get a blue center and a green outline. If there is any blue outside the green outline, erase it. If there is blue both inside the green outline and all around it, you haven't quite closed the circuit. Step backward, find the break in the highlighted "wall," paint it closed, and Fill again.

Figure 8-12 Fill is important, because without it Extract can't tell if you want to extract the head from the background or if you want to replace the head with a transparent window.

When you've enclosed the area, click Preview, and don't be disappointed if you see some problems. Perfect first-passes seldom happen even for retouch gurus, because you can't completely second-guess the filter. If your first attempt isn't perfect, determine what type of problem you have. Maybe you started with a more complicated background than the example. If so, check Textured Image, and then click Preview once more. Sometimes that's enough for the extraction filter to do a better job at distinguishing the background.

The worst problems will show up in hair. Either there are too many wisps of hair that weren't covered by the highlighter or you've painted too far into solid hair. In either case, breathe deeply and start again. In most cases, it's harder to touch up a bad hair extract than it is to redo it. If the hair looks basically good, move to the clean-up phase (Figure 8-13).

Figure 8-13 On the left, a successful extraction shows strands of hair are well defined. On the right, the hair was painted too far in, and highlights were made transparent along with the background.

Extract has clean-up tools for doing two very different things. The Edge Touchup tool is badly named; Smooth tool might be more descriptive. If you have accurate but overly sharp edges, this tool will soften them. Otherwise, you'll do all your work with the Cleanup tool. Paint with this tool to erase excess pixels. Hold the Option/Alt key down to bring pixels back. To help you figure out where to paint, you can use the Show > Preview drop-down menu to toggle between the original and the extracted views (Figure 8-14).

Cleanup responds to pressure, either with a tablet pen or by setting the level of pressure from the keyboard by pressing a key from 1–9. Heavy pressure quickly eliminates excess pixels from an edge. Brushing over jagged edges of hair with light pressure can often repair places where a strand of hair has broken during the extraction.

It's often a good idea to use the Cleanup tool with a wide brush to circle the area just outside your extraction. The filter has the nasty tendency to leave semi transparent ghost pixels, particularly around hair extractions (Figure 8-15). Ghost pixels don't show up on a quick glance in Extract, but when you bring the layer to another image, they'll hang on like little parasites and require extra deletion work.

Figure 8-14 Work back and forth between the preview and the original image to get the best results form the Cleanup tool.

When you're certain that you've finished your touchup, click the OK button. Extract will turn every pixel on the layer that was not extracted transparent, leaving you with a head waiting to be mated to a new body (Figure 8-16).

Figure 8-15 These pixels show up best if you change the Preview display to Black Matte.

Figure 8-16 The head sits on a transparent layer, making it easy to move to the file with the new body.

At this point, if you realize that you missed a spot, you can use the Background Eraser tool to delete ghost pixels or use the History brush to paint back in an edge where you've lost more than you planned. Bear in mind, though, that once you've closed the file, the memory of those pixels on that layer is gone forever.

Merge and Match

The worst is over, and now the Frankenfun begins. Copy or drag the layer with the head to the file with the body. Select Free Transform, position the head over the model's head, use the transform tools to scale the head to the right size if needed, and rotate it so it sits comfortably on the model's neck (Figure 8-17).

Figure 8-17 Clearly, these two skin tones are not even close, but a perfect match isn't far away.

You need to make sure that you'll only change the skin and not anything else on the layer that Photoshop may read as a similar hue. Using the selection tools you're most comfortable with, select the skin on the head layer. In this case, the Magic Wand might end up the easiest and fastest method, especially since it won't matter very much if a little hair ends up in the mix.

Use Select > Refine Edge to expand the selection about 5% and feather a small amount. Check your selection in Quick Mask (Figure 8-18), and then save it as a selection.

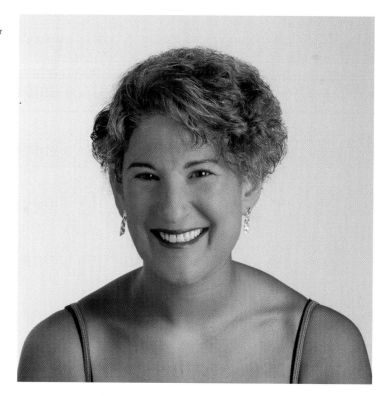

You can follow the same process for the model's skin, but since her skin color is distinctly different from her hair, we have a potential shortcut. Use the eyedropper to select a skin color in the middle range (not a shadow, not a highlight), and then choose Select > Color Range.

The dialog box gives several options for seeing the potential selection. You can adjust up or down by moving the Fuzziness slider. To add shades and increase the selection, click the + eyedropper, and then click in an unselected area (Figure 8-19).

In addition, you can view the color range with different types of Preview settings to see if you've captured enough of the skin. When the dialog box is set to Black Matte, it can be very easy to preview which parts of the image will be selected and which parts are missing (Figure 8-20). If you can't get a perfect selection, aim for a combination like the one on the right that gives you a selection that contains most of the edges without picking up clothes or background.

Figure 8-19 The selected color range is white in the Black Matte preview.

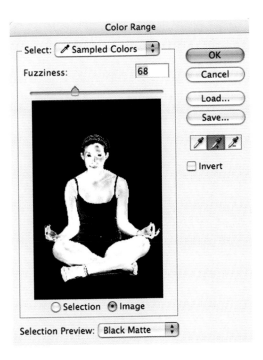

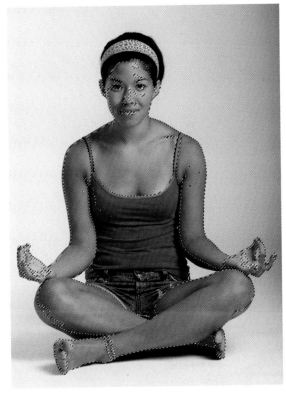

Figure 8-20 *You can always add to the selection with one of the other selection tools when you don't have to worry about finding or drawing the edge.*

To adjust the selected skin tone, you'll need two RGB numbers—one for the face, and another for the body. With the body layer active, select the Color Sampler tool (an alternate of the eyedropper) and click on a midtone on the model's face. Write this number down.

Now we need a midtone on the celebrity head. To do this, select the head layer instead of the body layer with the Info palette still open. The RGB settings for #1 in the bottom half of the Info palette have changed to sample the skin color in the same position on the head's layer. Write down this color combination as well—it will be our target skin tone for the body (Figure 8-21).

Figure 8-21 The two sets of RGB combinations remain a part of the file when you save it.

Select the body layer, load the selection if it isn't still there, and then choose Layer > New Adjustment Layer > Curves. Check the Use Previous Layer box, and Photoshop will make a Curve layer that will affect only the pixels in the selection (Figure 8-22).

Figure 8-22 Use Previous Layer refers to whatever layer was active when you selected New Adjustment Layer from the Photoshop Layer menu.

Press the Command/Ctrl key, and then click on the color sample while holding down the Shift key. This will mark a color value on each of the channels and make them editable.

Select a color channel in the Channel drop-down menu. For input, type in the original number that you wrote down for the channel. Our Red channel body number was 196, so that's what should appear in the Input. In the Output box, type in the Red channel number for the face, which was 226. Repeat for Green and Blue (Figure 8-23).

Figure 8-23 To change these numbers again if you aren't happy with the outcome, return to the channel and click on the point on the curve again.

Most of the time, you'll get remarkably close in the first pass. But in this case the model's body is very tanned, and the celebrity's skin is not, so their midtones don't match exactly. Rather than try to adjust the body, it's easier to add an adjustment channel for the head, just as we did for the body. In this case you don't have a specific color combination to match, but a little eyeball experimentation should do the trick. Decreasing the Blue channel just a little more than the Red and Green brings down the magenta tone in the skin and replaces it with a little healthy golden glow to match the body better (Figure 8-24).

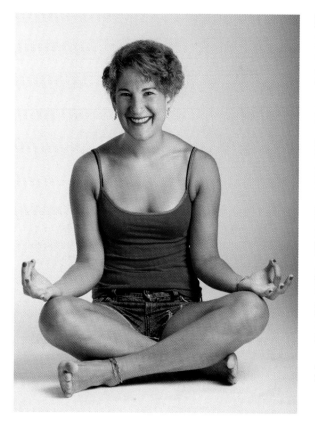

Figure 8-24 *The face and body are very close, but decreasing the blue will make them fit better.*

Figure 8-25 *The Frankenbody in its final form.*

The final image, just like the rest of today's faked covers, will convince everyone who doesn't read the tiny print that our celebrity, be it Oprah, Martha, or someone new, is a youthful hottie (Figure 8-25).

BAD COMPOSITING: TELLTALE SIGNS

Skillful Frankenbodies and other fantastic mergers are extremely hard to pick out—a fact that has led to numerous embarrassing moments for members of the media. Their startling reality has engendered the birth of a new specialization: the programmer-investigator. These latter-day Sherlock Holmes characters dig deep into the guts of digital images (see the sidebar, "Migrations"), mining the pixels for types of information that the image creators never suspect is there.

But most of the photographic composites that make their way into the general public via the Internet are just not that brilliant. For every visual delight, Worth1000.com, and other contest sites, there are dozens of composites that even a Watson should be able to spot, given some good pointers. Before splattering the wires with bulk e-mail or text messages, look for the hints that can help you see the truth.

■ **Halos.** Although perfect for angels, halos point immediately to badly executed Photoshop selections. If an element in an image has a light-colored border around all or part of it, chances are you're looking at the remains of the original background that once surrounded the person or object (Figure 8-26).

Figure 8-26 Not that there could be any doubt, but this joke image is a fake. There is a halo around the beard.

■ **Fuzzies.** Many photo composites are made up of bits and pieces from a grab bag of pictures. Some were originally scans; others are snagged from stock photo sites at low resolution and touched up. When grafted together, the difference in pixel quality and texture is often visible. A real image, no matter how many times it's been saved, will be consistently good or bad.

■ **Shadows.** If there are two faces, and one has shadows on the left side of the face and the other has shadows on the right, they started their photographic lives in different pictures. In Figure 8-27, most of the image is fairly fuzzy, but the face is very sharp. In addition, the highlights on the face are shining on the left, but all the other people have light on the front and right.

Figure 8-27 This is a faked image—the face is grafted onto the body.

■ **Shadows, part deux.** Although shadows indoors can be very complex, with light coming in from windows, bouncing off walls, and augmented with indoor bulbs, shadows on a brightly lit day outside, cast on similar terrain, ought to point in similar directions. If a shadow casts long to the left on one object and is short and leans right on another object, and these two objects happen to also contribute to the subject of the shot, think composite.

■ **Skintones.** Human beings are a rainbow, it's true. But when there's a photo with several people of the same general ethnic background, and one's skin tone is yellow-green and everyone else is rosy pink, you can bet that the unusual one isn't jaundiced. She was shot under different lighting than everyone else.

■ **Straight Lines.** They exist in vector graphics; they don't exist in real, unaltered photos. If something looks like a straight line in an image, you can zoom into the picture to examine it. A real straight line is actually made up of anti aliased pixels of several colors and is more likely to be slightly jagged than perfectly straight. The only exception would be a photo that was shot on perfectly level ground, with a camera attached to a leveled tripod, of the edge of a perfectly true building. Straight lines mean compositing has taken place, and you are looking at the edge of the merge.

■ **Scale.** Many fauxtography composites on the Internet play fast and loose with scale. There are monster cats, humungous alligators, Jaws-worthy great white sharks. Of course there are occasional situations when something is unusually large, like prize-winning vegetables at a county fair. But if you see something really monstrous, you should be looking for some of the other compositing tell-tales as well (Figure 8-28). Remember that newspapers and TV programs would be just as eager to show these photos, and, given their shrinking revenues, maybe even more eager—if they were real.

Figure 8-28 Nope, you really couldn't ride this dog. He's a fake…at least double the size he really must be. Very close examination of the pixels in the image (right) shows cloning duplications where the shadow had to be enlarged to fit the big dog shadow.

■ **Two different worlds.** When you see an image online where action is taking place but the people don't seem to be looking at each other or reacting appropriately, those people may be clueless for a reason (Figure 8-29). Is one in a summer skirt and another in a winter overcoat? Chances are they were captured at different times and merged.

Figure 8-29 You might think G.W. is heartless, but the complete disconnect between him on the left and the crying woman on the right wasn't real. The original Bush image was of him accepting a guitar at a very different event.

Migrations

Image editing's breakout year was 1994. This was the year of the O.J. Simpson arrest and its dueling Newsweek *and* Time *covers (see Chapter 5). People unfamiliar with toning and image adjustments were confronted with a radically altered image of an iconic and beloved celebrity. It was also the year that Art Wolfe, a giant in the world of nature photography, published his* Migrations *photo compilation.*

At the time, professional photographers still worked almost exclusively with analog cameras, although a growing number had discovered Photoshop. Using high-end slide scanners, they brought analog work to the computer and began to explore its possibilities. But the massive reprocessing that takes place almost automatically today was unthinkable then.

Like Wolfe's dozens of other books, Migrations *was breathtakingly beautiful, in keeping with his high production values. So the discovery by the* Denver Post *that he had augmented several images, including the cover of a herd of zebra (Figure 8-30) to create more artistic compositions raised to prominence a debate that has only increased with time. Is nature photography documentation or art?*

Figure 8-30 Several zebra were repeated in this image. The compositing was noticed because, like fingerprints, every zebra's coat pattern is unique.

This is the type of question that goes to the core of the composite controversy. It's very hard to determine culpability if everything turns on the photographer's intention. In the case of the Migrations *debate, there is no question that some people reacted with dismay because they had been deeply moved by the images. The shots seemed evidence that nature is inherently aesthetic.*

Awe at Wolfe's expertise as a photographer soon gave way to distress with his expertise as a compositor. The photographic community split into the two camps they inhabit today: those who believe that digitally edited photographs are not real photography, and those who believe that photography is an art now blessed with a new set of darkroom techniques.

PHOTOSHOP TRICKS
FOR FAKE SPOTTING

Photoshop provides some options for testing images you think might be fake. Although really adept alterations need industrial strength detection, handy adjustment layers and simple strategies can help you spot potential problem areas.

- ■ **Zoom.** The simplest tool, used by itself or in conjunction with other tests, is still worth trying. Things that might pass muster at 100% can be surprisingly blatant at 500%, like the telltale Photoshop halo around the monster cat (Figure 8-31).

Figure 8-31 The monster cat on the left is startling, but it has a monster Photoshop halo (right), particularly around the tail.

- ■ **Invert.** We see many colors the same that Photoshop sees as very different. In Figure 8-32 on the left, there appears to be a shadow behind the young man. When you invert, Photoshop looks for the mathematical opposite of the color, making these differences much more obvious to the naked eye (Figure 8-32, right).

- ■ **Channels.** Look at each channel separately. As when you invert an image, you can sometimes see things in a channel that are obscured by colors and blending. In Figure 8-33 on the left is a frightening image that purports to be Phuket just before the tsunami hit. A close-up (center), when examined channel by channel, reveals the obvious color shift of image-splicing.

Figure 8-32 Invert shows you that the dark line behind the hiker isn't a shadow. It's the line of a bad Photoshop cut.

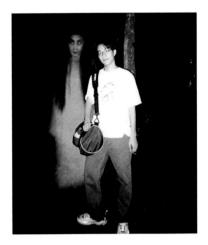

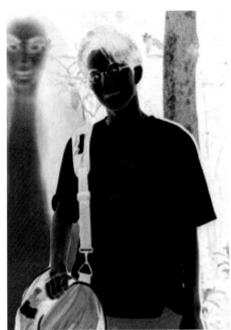

Figure 8-33 This grayscale image is a close-up of the Phuket image's Red channel. The cut and paste job is more obvious when you can't see the color blend.

■ **Sharpen.** A really extensive sharpen can suddenly show you the straight lines that escaped you before because the image had been deliberately blurred.

The Case File: Composite Detection Software

Wandering through photo blogs and photo sites like Flickr.com, one phrase will constantly occur: Is it real? Even visual experts who know every trick to pry out fakery eventually hit their limits. We run up against our physical limitations, even after using Photoshop to zoom, invert, and shift colors. We shrug our shoulders and give up.

But some people can't afford to move on. For a variety of professionals—police, security agents, media services, and human rights activists, to name a few—a found image can offer clues to real-world problems. Did this attack really occur, or was it staged and retouched? Was that video of tortured victims shot with real people in a real place, or is it a faked environment? Are those children real abuse victims, or are they 3D creations? Did these two terrorists really meet, or is the picture a composite?

When the answers really matter, investigators turn to the small but growing number of forensic programmers to pick apart computer images for clues. The most acclaimed go-to guy in the world of computer analysis of imagery is Dr. Hany Farid, professor of computer science and head of the Image Science Group at Dartmouth College in Massachusetts.

Farid and his group have become a major source for analysis programs that examine all aspects of digital images. Currently, there are more than a dozen individual tools, with more being added to the kit every few months. Each tool has its vulnerabilities, but collectively they form a powerful arsenal.

Although the first few tools were designed to examine only one aspect of an image, they formed a base of analysis that Farid now builds on, plugging holes as he discovers new ways of parsing digital imagery. The tools examine arcane bits and pieces of digital information. Some are designed to tell real from virtual imagery. Others look for duplicated regions in an image to see if cloning has taken place (Figure 8-34).

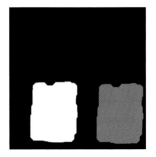

Figure 8-34 In this test, the garbage pail has been cloned out. Farid has developed a method of finding the duplicated area and determining what part of the picture was cloned to eliminate it. (Courtesy Hany Farid.)

original

tampered

Bright Eyes

Lighting is a major area of research. Although humans can see gross differences in lighting, the more complex the lighting environment, the less we can distinguish the differences. For us, light coming in from an angle of 30 degrees looks pretty much the same as light coming from a 35 or even 50 degree angle. But because light source direction is next to impossible to fake, programs that can identify these differences will become invaluable as digital composites become more sophisticated.

For example, when a person looks at the camera as a shot is taken, a bright spot of light reflects back from the eye. This is called a specular highlight. It has a useful property. Like a mirror, it reflects the light source back to the camera in a single direction. Follow the bouncing light, and you can determine exactly where the light source must have been.

Farid has leveraged this property with a tool that can estimate the placement of the original 3D light source from the 2D photograph. Stripping the math down to its essence, his program creates an elliptical outline of the limbus—the part of the eye that contains the iris and the lens (Figure 8-35).

Figure 8-35 The green dashed line is the ellipse. The red dots are the two specular highlights.

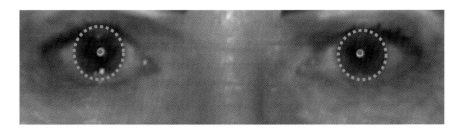

Figure 8-36 The eye is essentially a sphere. In this case, Farid determines the plane at a tangent to the point directly facing the camera, making it possible to determine the angle that the light enters and leaves the surface normal. (Courtesy Wikipedia Commons.)

Then, he uses the position of the specular highlights in this ellipse to mathematically determine the surface normal—the point on the eye where a plane would be perpendicular to the eye's curve (Figure 8-36).

Last, he estimates the direction of the camera/viewer. The result is rendered as a hemisphere that visually depicts the position of the light source (Figure 8-37).

Figure 8-37 By rendering the light source on a sphere, it's easy to visualize the light position and compare the specular highlights from different eyes. Two of these spheres represent two eyes shot with the same light source. The other one's specular highlight is dissimilar, indicating that it was shot with different lighting.

It might be possible for someone to beat this test by editing the specular highlights in the subject's eyes. But editing every bit of light on the rest of the face or body to be consistent with the tampered highlights is close to impossible, and that's what it would take to jump the hurdles of the related lighting detection programs that could be used as backup if the specular light test produces no definitive results.

For example, there are many photos where the subjects aren't facing the camera and whose lighting is much more complicated than the limited light sources found in many studio shots. Imagine light coming from several windows on more than one side of room, then add in photographer's fill-in lighting (Figure 8-38). Such a setting is a complex lighting environment and exactly the type of photograph that is hardest for a human to eyeball.

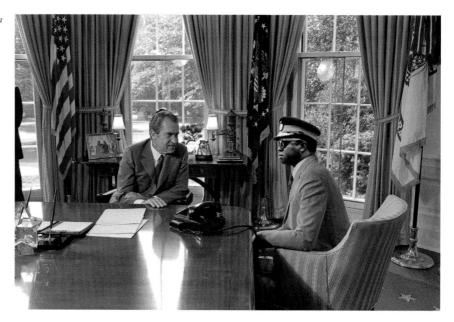

Figure 8-38 This photo appears to be a meeting between President Richard Nixon and the African dictator Idi Amin, circa 1972.

In this example, many of Farid's tools don't come into play. The image is grayscale, so tools that examine color shifts will retrieve nothing. In addition, given that the subjects are Richard Nixon and Idi Amin, it's obvious that the original picture was taken with an analog camera and scanned. That eliminates tools that can look at digital camera sensor artifacts.

Yet all is not lost. The same underlying concept used to examine specular reflections can be repurposed to build more complicated lighting models. In this case, however, instead of working with specular light, Farid assumes evenly diffuse light.

In this image, Farid selects convex contoured edges on areas of the primary subjects of the image: Nixon and Amin (Figure 8-39). His software breaks these areas into smaller bits and examines each one separately for its surface normal point. Because he is examining the edges of convex surfaces, any apparent shadows must have been created because the shadowed areas are facing away from the diffuse light, not because something is in the way and is obscuring them.

His conclusion is that Nixon and Amin's suits were photographed under the same lighting conditions. Amin's head, however, although consistent with the lighting when examined visually, must be a composite (Figure 8-40). The diffuse lighting is angled differently than the rest of the sampled parts of the image.

Figure 8-39 The red lines indicate the convex surfaces that Farid examined to determine their individual lighting directions.

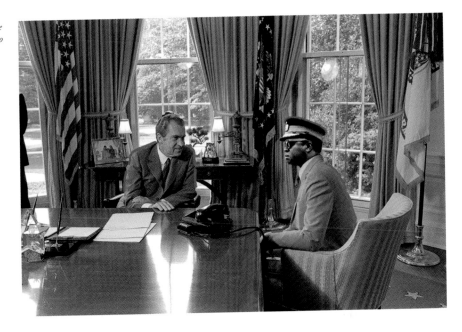

Figure 8-40 The purple spheres model the diffuse lighting space extrapolated for each surface. Amin's head is distinctly different mathematically, even though there is no radical difference visually.

Even Farid's tools sometimes run up against barriers. If a picture has too little resolution or is too small, the algorithms may not be able to see the kinds of details that will allow a good read. Other tools, like those from Neal Krawetz of Hacker Factor (see Chapter 9), might do the trick instead. That's the exciting thing about image forensics...there are so many different ways to examine the same data.

Of course, the question arises, once these tools are out in the real world, what's to prevent terrorists and fakers from testing their own work and using what they learn to create unbreakable fakes?

Farid and others like him do not view their tools as potential commercial plug-ins for this very reason. Some will end up licensed by organizations like the FBI for their exclusive use. Others may become part of a commercial suite that large organizations with the need to establish and maintain credibility of their images will subscribe to. The software would be server based, and images might be uploaded in batches for testing before being offered to news media. When that day comes, the constant question of "Is this real?" may not disappear, but it won't remain a quandary for those who most need to know.

COMPOSITING MARCHES ON

For every addition to the established version of Photoshop, there are dozens of new experiments created by independent computer programmers. Adobe has encouraged this creative flowering by making it easy for programmers working in MATLAB (an environment for program development usually provided free to developers in academic institutions) to plug their experiments into the extended version of Photoshop for testing and development.

Compositing is crossing a new threshold as programmers, using this tool, are developing methods to make it easier for everyone to composite high-quality, believable images. Some new algorithms make it painless and simple to insert objects (like people) into images without the usual arduous compositing work—and without the telltale signs experts now use to help spot a fake visually.

One release in 2007 indicates how far we've come already. Two researchers at Carnegie Mellon University, James Hays and Alexei Efros, are expanding on an algorithm for something they call "scene completion" that they developed in 2007. Without a single cloning tool, it can replace unwanted parked buses, house roofs, or groups of tourists with picture fragments that you wish had been there instead (Figure 8-41).

Figure 8-41 *This image is the perfect example of an "almost." Not a bad shot, but the photographer couldn't get up high enough to avoid blocking the harbor with the roofs.*

Their algorithm searches a massive image database like Flickr and scans the picture files for appropriate scene fragments. It does this not through imprecise keywords but by grouping color and texture elements under categories like "openness," "motion," or "ruggedness." This clever method of analyzing a scene eliminates all the tedious description techniques ("What do you call that? Ocean? Harbor? Seacoast?") that were a barrier to considering such software before.

With a bank of servers, the software can scan through thousands of images in a relatively short time. When it's done, it presents the photographer with a group of possible images to use as templates for its composite solutions (Figure 8-42, right). He picks the one that captures the hoped-for effect, and the software copies the needed areas into the waiting image (Figure 8-42, left).

Some of these solutions are startling in their appropriateness—tacky houses on a cliff are replaced by rock formations, or a European side street marred by cars becomes a peaceful empty row of charming doorways (Figure 8-43).

Like many of the works of image forensic and computer vision programmers, it could be years before this experiment finds its way to commercial release. One problem is finding enough people willing to allow portions of their intellectual property to be used in strangers' pictures for free. Instead, having shown that the work is theoretically possible, Hays will refine it. Ideally, the algorithm would "learn" from the images without actually copying pixels from them, creating totally new work.

Figure 8-42 All of the thumbnails have elements that might be useful to complete the missing foreground.

Figure 8-43 As a result of selecting the thumbnail in the second row, third image from the left, the image has been reconfigured with a beautiful and plausible alternative.

Explorations that will change how we look at compositing, as makers and viewers, will increase in number and ambition. It's almost a guarantee that every year at SIGGRAPH, the Association of Computer Machinery's computer graphics extravaganza, researchers will present new algorithms to provide great new tools for users…and new headaches for fellow researchers who develop analysis tools to show real from fake.

PART IV

OUTER LIMITS

Every man has a place

In his heart there's a space

And the world can't erase his fantasies

Take a ride in the sky

On our ship fantasize

All your dreams will come true right away

—Earth, Wind and Fire, "Fantasy"

CHAPTER 9

ABSOLUTELY FABULOUS

WE LIVE IN AN AGE of mysteries—an irony when you consider how much harder it is to keep a secret now than in the past. Between official and unofficial leaks, whistleblowers and bloggers, countless people feed their extracurricular energies on the bones of closet skeletons. Barely a week goes by without some revelation that makes the "I knew it!" reflex reaction kick in.

Yet all these surprises bear strange fruit. The more we know, the more we assume there is to know. Because we've become cynical about personal integrity, we assume that everyone in the public eye is lying. As a result, we don't merely question motivation; we dust off every mystery the world has ever entertained. Even puzzles with good explanations become "unsolved" once more. Each gets new life on a Web site, where it lives, seemingly forever, fed by faux imagery.

CONSPIRACY THEORY

There are rumors, mysteries, and full-bore conspiracy theories. Not long ago, there were big differences among these categories, but they are quickly eroding. Anyone can start a rumor with a well-placed post. Add a picture and the traffic increases. Images are the meat and potatoes of modern conspiracy themes. Readers will debate whether the image is real and what it means.

Ratchet up the stakes to include a big secret and a large organization and you have a conspiracy. No conspiracy coalesces around a fart joke. The secret must be something that if true would shake the world.

We know that conspiracies exist. But a thorough examination of history implies that plots are easier to dream up than they are to execute. Assassinations abound, but most that succeeded were planned and perpetrated by loners or a political cell with no personal relationship to their victim. Attempts on some of history's most hated rulers, including Nero and Hitler, were the product of conspiracies, and most of them failed miserably. Some member of the cabal broke ranks, either deliberately selling out the rest or being incapable of silence.

Judging from the successful conspiracies—those that weren't discovered until their goals were met—the criteria for success are high. A good conspiracy requires some combination of the following:

- A small core: the more people involved, the more likely the plot's failure.

- Absolute commitment by all the conspirators: An unconvinced or unmotivated plotter is a future whistleblower or mole.

- Secrecy from all who come into contact with the conspiracy: Loyalty or fear is required of all employees, family, peripheral players, and casual bystanders.

- A plausible story while the conspiracy is still pursuing its goals.

- Appropriate and seamless cover-up materials to convince researchers, debunkers, and enemies until the cover-up is no longer needed.

- Luck, and no stupid mistakes.

Government entities actually have a pretty spotty record in the conspiracy racket. They are most likely to be successful when the conspiracy has a clear target and a short time frame, like the CIA's adventures in regime change in South America and Iran. Domestic cover-ups, from the Dreyfus affair in France in 1894 to the Iran–Contra affair in the 1980s, have almost always been uncovered quickly.

Enigma

There is one example of governmental conspiracy and cover-up that proves they are not impossible. The Enigma conspiracy began in World War II and lasted a remarkable 30 years.

Nazi Germany relied on a cipher machine called Enigma to encode its secret communications (Figure 9-1). An aspiring code breaker would have to navigate variations in rotors and their scheduled changes, as well as frequent key changes, to break the encryption. In this pre-computer era, the common belief was that this would take so much time and effort that it was effectively impossible.

Figure 9-1 *One of several Enigma encoders once part of the German war effort. (National Security Agency, USA.)*

Thanks to the initial work of Polish code breakers, the Allies began decrypting Nazi transmissions in 1939. Nothing was more important to the war effort than keeping this knowledge secret. Elaborate disinformation, sacrifice of individual lives, and extraordinary commitment kept the knowledge under wraps, unquestionably shortening the war.

After the war ended, the discipline remained. For many reasons, including Cold War dynamics and the convenient sale of Enigma machines to other countries for covert purposes, no one talked. Not until 1973, when many of the principals were dead or retired and the Enigma machines themselves finally wore out, did the British government declassify the story, allowing F.W. Winterbotham to write the best-selling book that brought this well-kept secret into the light.

VISUAL LUNACY

The best perpetrators of conspiracies are the agencies with a mandate for covert action, like the FBI or the CIA. Schemes that require buy-in from members of the civilian bureaucracies are much less likely to stand up against serious investigation. The more people that are needed to work the plan, the shakier the security. Government is a leaky boat.

Although there are hundreds of active conspiracy theories that travel the Web, two in particular disagree with this opinion. Either case, if true, would require a massive investment in government silence, secrecy, and disinformation. And both depend for their continued existence on visual documentation and image analysis.

One Small Step

If you were beyond preschool age in 1969, chances are you remember a summer night in front of the TV, as Neil Armstrong and Buzz Aldrin walked on the surface of the moon. It was the culmination of several days of anticipation and excitement that began when Apollo 11 was launched from the Kennedy Space Center in Florida on July 16 (Figure 9-2).

Surprise! As much as 10 percent of the American public believes that the event never took place—that it was an elaborate hoax supported by falsifying everything from sound transmissions to rock samples. The argument: that the flight and landing were technologically beyond NASA's capabilities. Recognizing the impossibility, the government took the money earmarked for the moon flight and spent it on faking the event and bribing people into complicity. The motive: Cold War politics and national prestige.

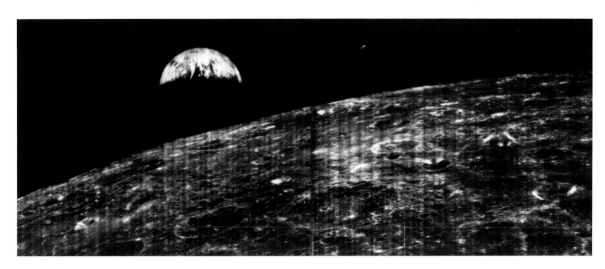

Figure 9-2 A panoramic view of Earth from the moon. (National Aeronautics and Space Administration, Apollo 11.)

There are several variations on the Apollo hoax theory. They range from the absolutist—everything about the event was faked—to the hybrid theory—the capsule was shot into space but didn't go all the way to the moon, and the astronauts taped the landing in Nevada before the flight. Although the theorists bring up everything from missing telemetry tapes to moon temperatures and radiation, the published pictures from the landing are the most frequently cited evidence.

Is there any support for these accusations? Well, not based on the photographs—the arguments lack a photographer's understanding of light. For example, most of the bullet points for a faked landing claim that there would be only one source of light on the moon. If so, an astronaut standing in a shadow should be totally dark. Since you can see the astronauts clearly when standing in the shadow of the lunar module, there must have been a second light source.

They're right—there is a second light source: reflected light from the first one. Think of being on the beach on a sizzling hot summer day, and how much brighter and harsher everything appears because of the reflection from the sand. The lunar surface would reflect light as well, with no atmosphere to dampen the effect. Note that reflected light is the only way to explain the secondary shadows on the backpack, inner arm, and lower legs of Buzz Aldrin in Figure 9-3.

Another claim is that NASA used a backdrop of mountains, and then they erred and took a picture without the lunar module in place (Figure 9-4). But two things stand in the way of this idea. The first is that there is no lunar atmosphere, so we don't have the same visual clues of distance that we do on Earth, where the atmosphere makes distant objects appear fuzzy and blue. The second is a standard of observation that anyone who has ever driven down a flat road in the desert has seen. You have to go quite some distance toward a far-away object before it feels like you've made any progress toward it.

Figure 9-3 Photographers use umbrellas to reflect single-source light and to punch up shadows. The bright moon surface reflected light the same way. (National Aeronautics and Space Administration, Apollo 11.)

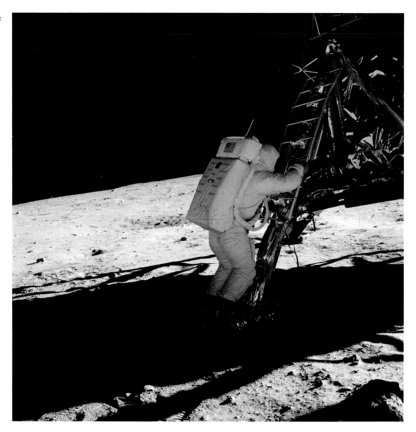

Figure 9-4 These shots show that the angle of view on Mt. Hadley does change with a slight change in the angle of the sun and a different vantage point—an impossible task for a backdrop.

After 30 years and many administrative and political changes, not to mention several follow-up landings tracked around the world, scientists of every political stripe agree that the landing, and all the moon visits, really did take place. But as long as the photographs exist and the element of mistrust remains, some people will disbelieve.

UFOlogy

UFOs have engendered more conspiracy theories than any other topic. Since the beginning of the flying saucer sightings in 1947, millions of people have become convinced that Earth has been or is still being visited by extraterrestrials. Almost as many are sure that the government has been keeping these aliens under wraps.

People who have made UFOs a major part of their life are extremely vehement in their stand. Even the term takes on different definitions, depending on who uses it. For a believer, UFO means "alien," so all UFO pictures or video clips are of extraterrestrials unless proven otherwise. Others emphasize the word "unidentified." If the flying object can be named or explained through deduction, it's no longer a UFO.

The question of extraterrestrial visitation is complicated. Even people who discredit conspiracy theories believe that there are other intelligent life forms in the universe. If you simply play the odds—hundreds of millions of stars and several planets circling them—it feels like a sure thing. If they exist, some of those alien nations may even know we are here; we've been working to get the word out (Figure 9-5).

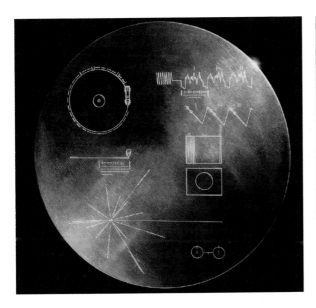
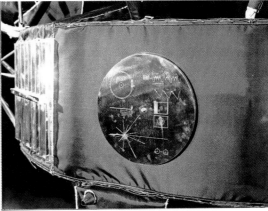

Figure 9-5 Both Voyager spacecraft contain a gold-plated copper disk with sounds and images of planet Earth. Symbols on the disk identify Earth's location. (National Aeronautics and Space Administration.)

In fact, the sheer volume of alien claims leads potential researchers to ignore even the genuinely puzzling incidents. Night airplanes, planets, stars, and weather balloons—the hallmarks of inexperienced witnesses—are frequently misidentified and then staunchly defended, no matter what the evidence. A recent study of cases tackled by the Innocence Project, which has proved the wrongful conviction of over 200 people through DNA evidence testing, reports that 79 percent of these convictions were the result of erroneous eyewitness identification.

Many of the shots that aren't traceable to known phenomena turn out to be pranks, made for YouTube mini-fame or recycled from endlessly inventive Photoshop artistry (Figure 9-6). Then there are the "professional" alien chasers who always find their game, scoring multiple shots even with inexpensive cameras. Their strategically fuzzy photos are accompanied by even fuzzier résumés.

Figure 9-6 Wouldn't it make sense for aliens to be interested in NASA's efforts? This startling sighting over the Cape Kennedy launch pad was a Photoshop composite of a real Florida setting and an artistically rendered saucer, scaled down small enough to hide its defects.

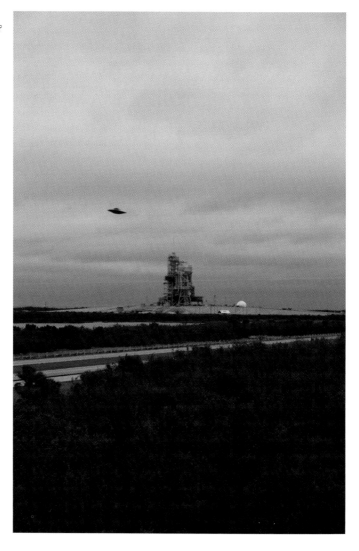

In real life, it's hard to be in the right place with a camera when momentous things happen, even when they are somewhat predictable. Every spring when the big thunderheads form in Tornado Alley, storm chasers use sophisticated devices that measure atmospheric conditions to help them predict the time and place when a funnel will form. Yet despite meteorologists' data, on-the-ground experience, and professional equipment, seasoned storm chasers can spend weeks without photographing a twister. The difference is that tornado pictures are really hard to fake without modeling and animation software. UFOs are relatively simple.

Faking a UFO

If you want to fake a UFO, there are many people who offer step-by-step guidance online. Some of them are scientists who do so because they think it will help to convince people that UFO pictures are fake. The effect can be quite the opposite—their solutions are often so elaborate that they are unconvincing. One great article recommends attaching a saucer to a painted mount and photographing it in perfect lighting against a green screen. That requires good equipment, a studio setting, and lots of planning.

Most people rightly realize that only a professional would go to such trouble, so they think that good UFOs must be very difficult to fake. Like reality shows, the images that have the most credibility online look like amateur shots—unplanned footage with the camera operators trying desperately to stay in focus and on target.

But you really can create a simple faked sighting. You need an inexpensive camcorder to begin. Then you need a place with a lot of open sky and an object that can look like a domed saucer or a boomerang/wing with some motion blur. A wide range of items can make effective stand-ins: a Frisbee wrapped in tin foil, a child's toy, or even a paper plate. Combine a windy day with an accomplice who has a good throwing arm, and you're ready for YouTube.

There is nothing wrong with these methods. But our photographic, video, and animation tools far outstrip them. It's easier to find or make a suitable saucer picture and composite it with your background. Or simply wait someplace that you know is in an airport's flight path, shoot a photo, and then open the file in Photoshop for some quick edits (Figure 9-7).

Unfortunately, it appears that you can get the same result whether you shoot real video, take elaborate pains to create visual authenticity, or just throw something together on a whim. People on both sides of the hunt are apparently so sure of their position that all posts are automatically either a hoax, mistaken identity, or proof positive that They are out there (see the sidebar, "Saving the Best").

Figure 9-7 This small UFO at sunset is actually an IFO. The beach is north of a major air route to Europe, and the blip is a scaled up and slightly edited airplane.

The Case File: Saving the Best...

In 2006, Australian filmmaker Christopher Kenworthy used a cultural grant from the Australian Film Association to fund an unusual art project. He anonymously posted a series of video clips of UFO sightings, eventually known as the Australian UFO Wave. The clips were presented as a collection of videos from multiple sources. They built a riveting narrative that conveyed the excitement of capturing a sighting on camera. Word spread quickly, and soon millions of viewers were watching the clips online.

The first clip was very convincing. For about 10 seconds, the camera tracks a bright, reflective sphere as it moves rapidly across the screen above wind-blown trees. Suddenly, the sphere changes its angle of direction, accelerates, and disappears.

Soon, the in-box was flooded with e-mails from believers who were convinced of the clips' authenticity. Although a few researchers were openly dubious (the words "too good to be true" were spoken), some UFOlogists jumped to repost the clips, rather than waiting to analyze the tapes themselves or even talk with the supposed eyewitnesses.

The number of clips grew, as did the response. People began to offer explanations. In the fifth sequence, a silver oval whizzes over clouds in broad daylight. The camera almost gets close enough to see the object before it disappears behind a tree (Figure 9-8). Many suggested that this clip had been faked by mounting a silver balloon on a wire and letting it slide between two trees—a standard "fake UFO" ploy.

Figure 9-8 The silver UFO moves swiftly and on a fairly straight path across the background.

One of the most discussed sequences was a clip of an airplane that is suddenly joined and then tracked by a small, indistinct object that eventually speeds up and passes the plane (Figure 9-9). According to Kenworthy, "hundreds upon hundreds of people commented on how the jet appears to be stationary. Many said this proved that the jet was bad CG. Others said it proved that the jet was held in the UFO's tractor beam."

Figure 9-9 The UFO comes from behind, crosses the plane's flight path, and eventually passes it.

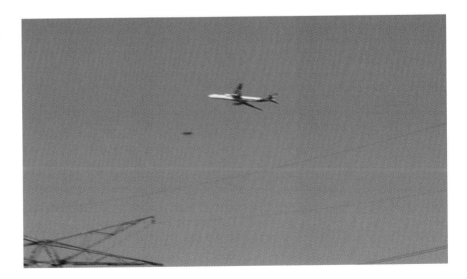

Little by little, the posted clips' production values decreased. They became progressively less plausible, as Kenworthy left visual breadcrumbs of his editing (Figure 9-10). Despite the deteriorating quality and more obvious editing, the later clips were greeted with the same mix of responses as the first.

Figure 9-10 This strangely shaped UFO appeared well into the series. It looks very much like an airplane of some sort rather than a UFO.

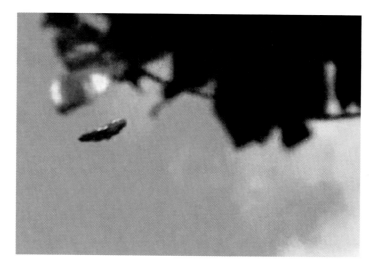

The last two clips crossed into melodrama, ending with an obviously CG-rendered alien contact clip (Figure 9-11). Only then did the majority of viewers begin to suspect the truth—that this had been an elaborate and very effective experiment.

Figure 9-11 This encounter involved a "Blair Witch" running camcorder scene and a badly rendered fence.

Even after the word was out, the analysts' scorecard was unimpressive. Two clips were genuine unedited videos. No one distinguished them from the rest, which were manufactured. Most of the skeptics identified the images as natural phenomena—from lens flares to weather balloons. In fact, the silver sphere from clip five was created in a 3D animation package. The background isn't video. It's a still background shot with a tripod. The camera moves were created in After Effects, as was the compositing.

The conclusion was that most of the experts on both sides were more attached to their preconceptions than interested in (or perhaps even technologically capable of) looking critically at the evidence. Only the most obvious hoax clips were correctly identified for what they were.

Kenworthy himself claims to have personally experienced a sighting. But he insists that his purpose was to upgrade the level of discourse. With so much awareness of desktop video and digital photography, why did so few viewers—UFO believers or their nemeses—analyze this work? And if there was so little observable difference between genuine and faked objects, how could they be sure about their positions on previous material?

True Lies?

Is it possible to examine one of Kenworthy's better images and determine objectively that the fake took place? We posed the question to Neal Krawetz, principal of Hacker Factor and developer of software that analyzes JPG files by examining their accumulated error history.

In the process of saving an image file as a JPG or MPG, some visual information is deleted to make the file smaller and more portable. Each time the image is altered and resaved, the mathematical fabric of the file, including its HSL (Hue, Saturation, Luminance) and RGB information, changes as well. These changes may be invisible to the naked eye, but they can be mined from the file.

In particular, Krawetz looks at two factors in a suspect JPG file: artifacts and resave errors. Both are an integral part of the file creation process, and neither can be reset or altered the way that camera EXIF data can. His forensic tools examine files and re-render them based on the results of the analysis. Since the results are visual, they are relatively easy to see and interpret.

Artifacts are introduced into a file each time it's saved in JPG form. The JPG process divides a file into 8 x 8 pixel chunks. For every chunk, it finds the average color. It then compares each pixel in the chunk to the average. If a pixel isn't exactly the average but is very close, it increases the similarity. That process eventually increases the difference between each 8 x 8 chunk, creating the blocky artifacts that become obvious as the image quality decreases.

But long before you can see the artifacts, they can be identified and tell tales about an image's history. If you map every pixel of a single image by its RGB value on a three-dimensional chart, it will form a cluster, because it contains a narrow range of colors. If you get two (or more) big clusters, that implies the file is the product of compositing. Similarly, when two pictures with different JPG qualities are combined, the difference in their artifacts can be charted as well. Render the image based on the artifacts, and you can see where the compositing took place.

Artifacts are the product of introducing error into an image. That error can be quantified as well. If you save a JPG at 90% quality, you've introduced 10% error. If you do that a second time, you no longer have a JPG at 90% quality, because you've got 10% error on the 90% image. That's the equivalent of one saved at 81%.

Obviously, each time the image is saved, the image quality decreases, but the quality drop doesn't go on forever. Eventually the JPG save runs out of pixels it can average, so the error level hits bottom and stays there. If the file is edited at that point, the new material starts at the top of the error pile. Chart the difference in quality as you save a suspect image, and you can figure out what parts of the image were added or altered, and in what order.

Just as there are many ways to create an illusion, there are many different ways to look for it. Digital images are rich with different elements: channels, RGB and HSL values, noise, and artifacts. Each element, properly examined, can provide clues about an image. When their results are seen as a whole, they can provide great insight into how the image was made and edited.

How do Krawetz's tools measure up against Kenworthy's artistry? For full disclosure, the image that Krawetz worked with was a full-resolution still from the clip. The final product was seen in a Web-based format, which masks errors and makes it harder to analyze.

The first readout is one that turns the image to grayscale and then looks for similarities to make it easier to find artifacts. If the image is untouched, all objects should exhibit about the same number of artifacts. When this enhanced image is examined, there are many artifacts around the airplane, but the UFO has more variation and is basically artifact free (Figure 9-12). This implies that the UFO may have been added after the image was shot.

Figure 9-12 Artifacts are larger blocky areas at the edges of objects. The airplane has a "halo" of darker artifacts, indicated in the inset with color; the UFO does not.

One tool examines consecutive colors. It tracks which pixels are next to pixels of the same color. Every yellow pixel is one that is not next to a pixel of the same color, implying randomness and natural image. A collection of pixels that aren't yellow could be foreign or simply enhanced in a software program. In this case, the tower, plane, and UFO all stand out by having less yellow but are similar (Figure 9-13). This information implies that the objects in the image were probably enhanced, but without a foreign file added.

Figure 9-13 The objects are distinctly different from the background, but they are consistent.

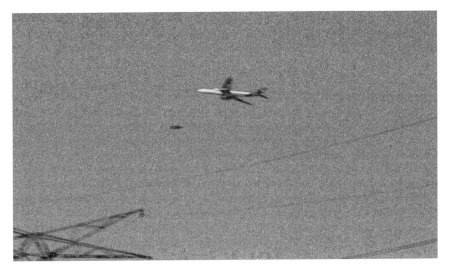

A key analysis looks for accumulated errors. An image with few errors is one that has been resaved very few times, if any. It will have mostly solid color areas, with some speckling. Areas with many errors will display as a rainbow of colors.

Adobe products tend to introduce this rainbowing—only visible in a forensic tool—when the file is edited. But no matter how many times the file is resaved, the entire image should be at the same error level. Further, that overall level should be consistent on objects with the same textures and colors. The image in Figure 9-14 shows rainbowing, but nothing stands out, implying a few resaves in Photoshop or another Adobe product.

Figure 9-14 This image has been edited and resaved in Photoshop or After Effects, but no material from another file shows up.

Light analysis looks at image noise, lighting patterns, and edges. In an unedited image from the real world, there is no such thing as a straight line or a smooth curve. Perfection happens only in CG-generated imagery or heavily enhanced images. Every line, when zoomed up, should display jagged edges. Yet there is something strange about the UFO. While part of the UFO does show jaggies and has the same texture as the plane, the UFO has a smooth, almost straight line where light and dark transition (Figure 9-15). This is very suspicious.

Figure 9-15 The transition between dark and light (green and red) on the airplane is a jagged line made up of black, green, and red. The transition line is a smooth and straight combination of red and black on the UFO.

The final conclusion: A skillful job, but this image has been edited. The UFO was very likely added to the image from someplace else on it, since there is no indication of a composite from a different file.

Of course, the only way to verify the accuracy of this analysis is to ask the artist himself how the clip was created. Kenworthy describes his process: "…we were close to the airport, driving around the plane as it took off at a relatively slow speed, and it creates the illusion of stillness. Tracking this footage would have been close to impossible due to camera shake, so the UFO was created by cloning one of the jet's engines and animating it by offsetting the cloned layer over time."

It's good to know that forensic researchers are finding ways to glean information that can help us distinguish true images from false. But it is also disturbing to realize that the low-resolution Web is practically tailor-made for disguise. Computer scientists who are exploring the secrets of digital images all agree that, currently, direct observation by a sharp-eyed analyst is still the best first response. But it should be followed by investigation, both with software and with more traditional forensic procedures. As Aristotle's problems with horse's teeth show, pure logic without investigation is not much better than blind belief.

URBAN LEGENDS

Urban legends are to conspiracy theories what sprinting for the bus is to a 10k marathon. They are small practice sessions for major disinformation. Somewhat like conspiracy theories, they have a rhythm. They start small, become viral, and then flag. The major difference is the longevity of the viral effect. After a few moments of intensity, they subside below the waves until discovered by a new constituency.

An urban legend usually has as its source a deliberate attempt to mislead. It preys on the current tendency to mistrust mainstream authority of all sorts. Blogs are more honest than traditional media. eBay sellers are more trustworthy than the average retailer. And an "authentic" first-person appeal in your e-mail from someone who got that e-mail from their best friend who got it from their cousin is more affecting than the yearly call from some large charity.

Urban legends used to show up only as chain e-mail. Now that it's so easy to post pictures, which are far more economical ways to get people excited, they can be found on personal blogs and Web sites as well. Amazingly, many of the pictures used to bolster the fantastic story behind the urban legend were originally created and posted openly online. The extremely popular worth1000.com site, which holds contests for the best faux creations, is a diamond mine for people with an image agenda.

IMAGE REINTERPRETATION

It's easy to make an image disappear from one site and resurrect it, with a new context, as something completely different. Unlike text, which can easily be found with a Google search, it is much more difficult to track multiple copies of an image on the Internet unless they still carry the same name. Change the title and recast the description, and the image disappears until serendipity brings both images together again.

Eye in the Sky

The chain letter reads: "This photo is a very rare one, taken by NASA. This kind of event occurs once in 3000 years. They're calling it 'The Eye of God.' This photo has done miracles in many lives. Make a wish, for you have looked at the eye of God. Whether you believe it or not, don't keep this mail with you. Pass this on." Included was this startlingly beautiful image (Figure 9-16).

Figure 9-16 The Helix Nebula, a photographic composite based on data captured by the Hubble telescope. (Courtesy National Aeronautics and Space Administration and the Space Telescope Science Institute.)

Here is a lovely example of how a real image takes on a hint of the faux, without the edit of a single glorious pixel. For years, NASA has posted an Astronomy Picture of the Day on its Web site, http://antwrp.gsfc.nasa.gov/apod/. On May 9, 2003, they posted this one of the Helix Nebula. The Helix is one of the closest nebulae to Earth. Since it's also very large, it has frequently been the subject of astronomical photos. In fact, it was imaged by the GALEX telescope in 2005 and again by the Spitzer telescope in infrared in January 2006 (Figure 9-17). Not exactly a rare 3,000-year event.

But could it still be a picture of the eye of God? Perhaps the artist was divinely inspired. Although it looks like a human eye, Hubble was actually looking down the long end of a gaseous cylinder.

The image is a computer composite of nine individual grayscale pictures, each shot with a different filter. Because the nebula is so large, Hubble could capture only a portion of the whole, so the composite was augmented with additional images shot from an observatory in Tucson.

Figure 9-17 The Helix Nebula is a favorite subject because it is extremely photogenic. (Courtesy National Aeronautics and Space Administration and JPL-Caltech.)

When all the pieces were in place, scientists took two images shot with different filters and one image from another telescope that contained more detail in the center of the eye (Figure 9-18) to create a combined image.

Figure 9-18 The original images captured different wavelengths of light from the nebula.

They combined the first and third images to create a Red channel, combined the Red channel with the second image to create green, and used the second image alone to create the blue. To do this, they used Calculations, a feature in Photoshop found in the Image menu, which allows you to merge different images or layers into one image. If the images are already exactly the same size and are aligned identically in their canvas, they can be combined from two different files. If they need to be aligned, it's easier to do the combination by putting the files into one file as different layers and aligning them before the combination (Figure 9-19).

Figure 9-19 Because these images were not perfectly aligned, it made sense to adjust them in one file.

In this case, the scientists combined one Hubble image and the image from the other telescope in Calculations to create a file that would become the Red channel. Calculations combines the pieces equally, but you can exercise more control by merging only one channel from each image and using blend modes to determine whether the combination will result in a darker or lighter image, and how the pixels will merge.

In addition, you can use any image or channel as a mask to prevent or decrease the amount of merge in different parts of the image (Figure 9-20, left). The same process with different proportions took place to combine the result of this first calculation (Figure 9-20, middle) with the OIII channel to make the green channel (Figure 9-20, right).

Next, the three images (two made through calculation, and one an inverted version of the OIII image) are saved in grayscale mode. Select Merge Channels from the Channels menu and select RGB (Figure 9-21). Since each calculated file was saved with the name of the channel it will become, Photoshop recognizes and matches up each one.

Figure 9-20 This complicated calculation to create the Red channel adds the H-alpha layer to the NII layer, but not at full strength. The NII layer will dominate. The original files were negatives, so they need to be inverted.

Figure 9-21 To combine three images, you combine them into a new document with the name of the channel color you want each image to represent.

The merged image has full color content but isn't necessarily as visually pleasing as you might want. Since all the color effects come from aesthetic interpretations, there's no reason not to tweak the result with a Curve adjustment layer (Figure 9-22).

Figure 9-22 Full color doesn't mean artistic. In the final image, human decisions are critical.

So far, so good, and the result is a beautiful illustration that's a tribute to the marriage of art and science. But it's not a factual representation of the Nebula, nor is it unique. There are many objects in the sky that look like a human eye under certain circumstances, including other nebulae photographed through Hubble.

You're in Good Hands

In the Eye of God, the effect is real. Only the interpretation turns it into a miraculous mystery. But once you've accepted the eye as a supernatural vision, it's easier to accept other images as real and to fail to recognize the image editing in an image like God's Hands (Figure 9-23).

Figure 9-23 God's Hands, photographed and edited by an anonymous author.

In 2007, many spiritual blogs posted this image, claiming that a woman named Cara Winship had shot it while traveling by car to London, Kentucky. Fortunately, the posters never knew the entire truth. The image had been sent in another e-mail blast more than three years earlier, with claims that it was taken in the aftermath of Hurricane Charley in Florida. The original was eventually posted online, minus the hands, as proof of the editing for those who still doubted.

But why was it faked? Not to show infinite love and care. It was originally posted on the infamous goatse.cx pornographic parody site. The site was an homage to the graphic close-up of two hands opening an anatomical part. People would add the hands to otherwise innocent images. God's Hands was one of those parodies and can still be found whenever a goatse tribute site is posted.

Accidental Tourist

There were many 9/11-related images in the aftermath of the World Trade Center attack, but none made the rounds faster than the image that came to be known as "Tourist Guy." It combines that "Watch out!" moment that everyone has at a horror movie with the double-take fascination of a moment frozen in time (Figure 9-24). But like most other such images, it's a fake.

Figure 9-24 The famous, but completely faked, "Tourist Guy."

There are several clues that lead to this conclusion, but three are all we need. The most obvious is that 9/11 is more than our name for a terrible event. It's also a date. On September 11, 2001, New York City experienced a beautiful late summer day in the upper 70s. Even in the early morning, anyone wrapped in a winter coat and wool hat would have been very inappropriately dressed. No sane tourist would have even brought those clothes for a September visit, let alone worn them that day.

Next is the photographic impossibility. The camera was obviously focused on the tourist. The airplane, had it really been in the shot, would have been moving so fast that it would have been nothing but a silver blur. No camera, and certainly not any digital camera available in 2001, could have captured the plane hanging in the air. But the crisp look is entirely consistent with an image composited on a Photoshop layer.

The last requires a little fact checking. The outdoor observation deck for the Twin Towers was at the top of Two World Trade Center, the South Tower, which was the second tower to be hit. Had there been a tourist on the observation deck, that's what he would have been shooting. And even if he hadn't, his crisp view to the north would have been obscured by smoke coming from the tower just outside the frame of this photo on the left (Figure 9-25).

As for the camera date, nothing is easier than faking a digital time stamp, as the quick switch of numbers in Chapter 2 of this book shows.

Figure 9-25 *Just outside the frame of the Tourist Guy photo, on the left, is the edge of the South Tower.*

Celebrity Heaven

People invest their favorite celebrities with special powers and infinite resources. Some fans develop an almost religious fervor that can generate a "saint reflex"—the belief that there is more to a celebrity's death, especially if it is tragic and unexpected, than meets the eye.

The first celebrity saint was Elvis Presley (Figure 9-26). Within a short time after his death, small and fuzzy pictures purporting to be Elvis sightings found their way into the tabloid newspapers. Rather than being reincarnated in heaven, he was resurrected on Earth…living in happy obscurity among normal people.

As Elvis fans have aged, their idol has been sighted less frequently, but he has aged with them. Image editing has been a boon for the tabloids, which have creatively reinterpreted him through his 50s and 60s and into his golden years. Nowadays, there are so many Elvis impersonators that, even if the original really did visit his local supermarket, no one would blink twice.

Paul McCartney of The Beatles had the dubious distinction of celebrity sainthood when in 1969 the rumors started that he was dead and had been replaced with a look-alike rather than break up The Beatles. Thousands of fans gathered around turntables to play their Abbey Road records backwards for purportedly hidden clues. Every element of the record cover was examined and interpreted—why was he the only Beatle barefoot? Unfortunately, at least one fan, named Charles Manson, believed it all. Convinced that The Beatles were supernatural beings, he interpreted their writings as a call for him to help them begin the apocalyptic end of days, starting with "helter-skelter"—murder.

Figure 9-26 Elvis Presley, in one of his many incarnations. (Library of Congress, Print and Photographs Division.)

Looking for hints in dead writers' lyrics has been a constant theme. Fans searched for the truth behind Kurt Cobain's suicide in the 90s. But the most recent ascent to celebrity sainthood has been gangsta rapper Tupac Shakur. Gunned down in 1996 by persons still unknown, his fans believed that he was biding his time until the statute of limitations on prosecution for faking his death had passed. As the seven years has long passed, hope of his return diminishes but has not ended the sightings.

CLARIFY AND OBSCURE

Image forensics is a mutable field. For every investigative advance that makes it harder to hide information, there are others that balance the sheet by making it easier. What's most amazing is the flexibility inherent in a digital image and how very different it is from its analog predecessors. Images carry within them their history and sometimes offer a free ride to piggybacking information.

Anti-Blur

After you've shot your alien encounter, is everything a blur? Some video and still camera shots of strange sky objects end up blurred through the application of deliberate computer effects. But a blurry real shot gets that way because the person holding the camera moves.

Digital cameras and camcorders are particularly prone to this problem because they are so lightweight. They don't provide enough heft and resistance to balance small movements. Even the optically stabilized lenses included in some digital cameras have limitations, and they are specific to a single camera.

Rob Fergus and collaborators at MIT's Computer Science and Artificial Intelligence Laboratory (CSAIL) have developed a technique for removing the effects of camera motion blur. Like many tools that will eventually be used to analyze or repair our images, it builds on concepts inside Photoshop's existing tool set but finds news ways to approach them.

Dull Sharpening

As anyone who has worked with Photoshop's suit of Sharpen filters knows, even Smart Sharpen and Unsharp Mask are extremely limited. They can improve images that are in focus but are too soft, but they are not particularly good at distinguishing between good blur and bad blur. It's easy to over-sharpen without actually gaining clarity (Figure 9-27). That's because the software doesn't, and can't, know enough about each image to optimize it.

Relying on general rules doesn't work. Although all blurs look the same, in fact each one is unique. Fergus approached the problem in a new way. Rather than try to intuit what the image was supposed to look like (the approach to this point), he concentrated on the shake itself. If he could determine the blur kernel—the path of the image shake—he could apply a mathematical formula to reconstruct the image as it should have been. That means a three-part process: find a place on the image that might contain a blur kernel, refine the blur kernel in stages, and then run an algorithm that uses the blur kernel to repair the image.

Figure 9-27 An out-of-focus image sharpened with Unsharp Mask still looks blurry and has strange textures and artifacts.

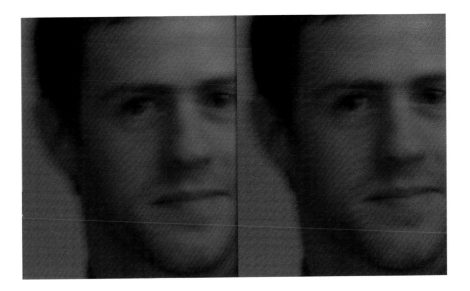

Determining the algorithm for repairing the image might seem an insurmountable task, but it's made easier by knowing that most natural (not computer-generated) images follow some predictable rules. One of them is that, although each image has its own color distribution, the way that color and value are distributed is not random. A small number of value ranges will take up large areas of an image, while a large number of values will appear only infrequently—to define edges between the large areas. So any change in a blurred image that tends to decrease the large areas in favor of the small areas will probably increase the blur, and vice versa.

Clarifying the Kernel

The current version of the algorithm requires some human input to initiate the process, but future versions will probably find good starting points automatically. The user selects a small rectangular area that is most likely to contain a blur kernel. The best places are those where there are variations in color and brightness rather than those that are very saturated or very uniform (Figure 9-28).

The user also has to create a starting point to speed the process by figuring out how big the blur kernel is and whether it started moving horizontally or vertically. That's not so hard when you know what to look for. Zooming into a blurred image at the pixel level, you can sometimes readily identify a blur kernel from a bright point light source (Figure 9-29).

The program starts with a very crude blur kernel, 3 × 3 pixels in dimension, and then refines it until it matches the resolution of the image itself. The number of steps and the amount of time that the process takes are determined by the maximum size of the blur (Figure 9-30).

Figure 9-28 This area on the image of a decorative ceiling has a good range of color and brightness.

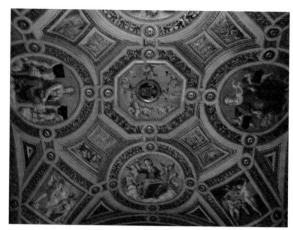

Figure 9-29 When the image is zoomed up, you can even see how the bright areas have all followed a pattern from left to right, then down. This corresponds to the blur kernel.

What the program cannot do is improve the quality of the image itself. It works better on RAW camera images than on JPG files, because some JPG artifacts often look like edges. Even so, the results, particularly compared with other deblur methods, are remarkably effective (Figure 9-31).

Figure 9-31 The final image reveals itself to be the center of the ceiling in the Stanza della Segnatura in Rome.

One major plus is that the program can tell the difference between the blur kernel and real motion. That means an object in motion will tend to stay that way, while everything else that was not really moving will sharpen. This factor alone will make the anti-blur algorithm a very attractive option for video applications when Fergus adapts it for moving images.

Steganography

In the 1960s, there was a half-joking phrase, "Just because you're paranoid doesn't mean they aren't really out to get you." Sometimes, there really are conspiracies, or at least messages hidden in plain view. The world of steganography develops ways to hide, misdirect, and communicate through hidden imagery.

Steganography's purpose is covert, and it works best by misdirection. The actual message is hidden behind or within a cover image. Many elementary-schoolers are delighted to discover the concept of invisible ink. Using an acidic liquid, like lemon juice or white vinegar, you can lay down a secret message on a blank piece of paper. When the "ink" dries, you take a standard ballpoint pen and write a different message right on top of the first one. Anyone who opens the letter will read the ballpoint message without knowing about the second text. The person in the know just needs to heat the page—putting it near an incandescent bulb is usually enough—to make the hidden message appear.

Many Photoshop users are familiar with one use for steganography: watermarking. A demo version of the Digimarc filter is included with Photoshop, and the reader portion of the filter is free (Figure 9-32). If you become a registered user, you can embed information to identify an image as yours. The watermark can withstand digital editing and allow you to maintain your copyright.

Figure 9-32 The Digimarc reader is free, but the embedding portion is only a demo.

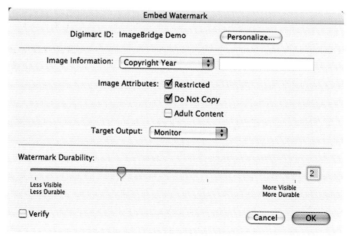

But this filter, although very useful, has only one application. Through the use of readily downloadable free and shareware steganography programs, you can customize a logo for your watermark, embed secret text, or even install another image invisibly in innocent-looking image files. Windows users can find a plethora of choices at http://home.earthlink.net/~emilbrandt/stego/softwarewindows.html. Mac users can find a smaller collection of options at http://www.pure-mac.com/security.html.

As with watermarking, these programs take advantage of the massive amount of image redundancy in a standard image file. We know from creating JPG files that you can lose a lot of image data and still end up with a good-quality image onscreen. With a steganography program, instead of just throwing data away to create a more compressed image, the extra pixel data is shifted to carry different information. Text, image, and even application files can be comfortably hidden in this invisible space.

CryptoBola, a shareware program for Windows, is a good example of a program that can stuff any type of file into a JPG. The limitations are in the size of the JPG and the amount of redundancy in the image. The best images are complicated organic landscapes (Figure 9-33). They can hide a surprising amount of visual information without obvious degradation.

Figure 9-33 The bucolic image on the left has this 600k JPG file inside it. There is no visual difference between it and the original file before the steganographic embedding.

Images with lots of redundancy, like blue sky and snow fields, are not good candidates. The steganographic program will give you a readout on how much the image will degrade, but the same percentage in two different types of images will express itself in different ways (Figure 9-34).

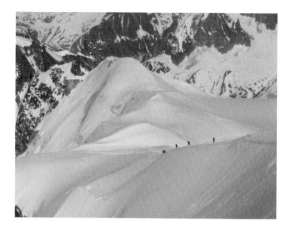

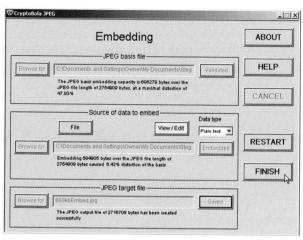

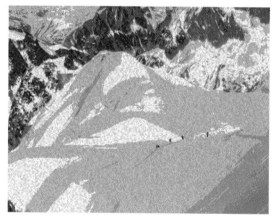

Figure 9-34 The original image has strong redundancy in the glacier. The program has embedded a fairly small file with less than 7% degradation, but the image is clearly deformed.

Once the extra document is stashed, it can be posted innocently on a photo site like Flickr or attached to an innocuous e-mail message. The intended recipient applies a deciphering program and receives the camouflaged information. If the correspondents are sufficiently obsessed with privacy, they can encrypt the message before embedding it, practically guaranteeing its security.

The potential applications of this technology for the sharing of secrets are almost unlimited. They range from the innocuous—like sending credit card numbers or passwords securely from home to work—to immoral, illegal, and infamous. Not surprisingly, steganography has become a major topic in law enforcement and counterterrorism circles. Look for a conspiracy involving hidden images in our collective future.

Believers in conspiracies and even urban legends usually stay within the bounds of the possible, even though they may cross the line on the probable. That's part of their appeal. The lines between paranoia, politics, and science may cross into science fiction and religion, but they still have some grounding in rational, documented realities. It's only when you hit the supernatural that all bets are off in the image-editing world.

CHAPTER 10

THE MEDIUM IS THE MESS

IT'S POSSIBLE THAT ghosts, fairies, or other supernatural beings exist. At least there's no definitive proof that they do not. They certainly are a universal part of the myth and culture of most human societies. Sometimes they are benevolent spirits that offer us the promise of a life beyond the grave. Even when they aren't nice at all, they still fascinate.

Unfortunately for photographers, if supernatural beings do exist, they're either very rare or pathologically camera shy. We've had the ability to capture and keep a still image for almost 200 years. In that time, we've shot pictures of creatures 4 miles below the surface of the ocean, of cells and the tangled proteins of DNA, of waves of energy outside the visible spectrum. In the same time, we've captured few ghost images that can't be easily explained with prosaic causes.

On the other hand, images of the unexplained are great fun to make and to deconstruct. In this chapter, our forensic eye concentrates on analyzing existing images and explaining how Photoshop can help us make our supernatural dreams come true.

SPIRITUALISM MEETS PHOTOGRAPHY—VICTORIAN ERA

We are so visually sophisticated that we are blasé about special effects. Even though most of us don't know how the magic is done, we do know that Johnny Depp isn't really doing battle with a sea monster, or that Spiderman isn't swinging from New York's skyscrapers.

Looking back on older movies, we laugh at the cheesy special effects. The Internet Movie Database cites obvious tech bloopers from movies of the 50s, 60s, and even 80s that viewers were thrilled by when they first saw them.

In the nineteenth and early twentieth century, the human ability to recognize fake reality was even less developed. Photography was a mysterious technology. Very few people understood how it worked—even fewer than those who truly understand our computer technology. This stage of photography coincided with the heyday of spiritualism.

Spirit Photographs

Spiritualists believed they could prove the existence of life after death by communicating with dead spirits, usually with the help of a specially attuned helper called a medium. When photographs began to appear with a ghostly image of a second person superimposed on the picture of the sitting subject, they were hailed as "spirit photographs"—images of the dead attempting to communicate with the living (Figure 10-1). The favorite spirit photograph showed the sitter surrounded by small faces of departed family, friends, or even pets.

There were many ways to make a spirit photograph. At the time, images were exposed on sensitized plates, not on film. Plates were washed between shots and reused. If the washing was not done carefully, parts of prior images would appear. Alternatively, the spirit image could be created by double exposure. Either before or after the main subject was photographed, an accomplice would be photographed in the same setting, but with a shorter exposure time. The result was a semi-transparent image, blurred and indistinct if the person moved into or out of the frame during exposure.

The photos look enormously contrived to the modern eye but were a source of great wonder at the time (Figure 10-2). Many mediums would provide them for their clients as proof of their success. In all cases, the mediums were able to control the photographic process at all or some stages, making fraud extremely simple.

Figure 10-1 This photograph was created in 1920 by Hereward Carrington, a noted psychic researcher of the time, to prove how easy it was to fake spirit photographs.

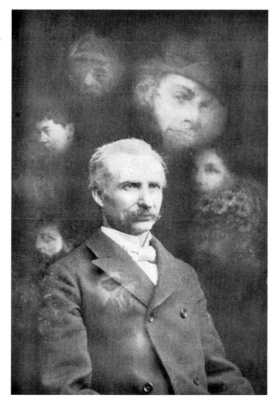

Figure 10-2 This faked photo is a double exposure that has also seen some work in the darkroom on the "ghost's" left hand and the subject's nose.

Cottingley Fairies

Nothing is more likely to get a Shakespearean historian more exercised than the question, "Who really wrote Shakespeare's plays?" We know so little about the author of some of the most important literary works in the English language that a cottage industry has grown up around the question. It's hard to believe that such transcendent work could have been the product of so humble a beginning.

On the other hand, we know a lot about Sir Arthur Conan Doyle. Yet anyone familiar with the Cottingley fairies story has to wonder how so gullible a Watson could have created the devilishly logical Holmes. Did his wife ghostwrite for him?

In 1917, two young cousins in Cottingley told their parents that they had played with fairies in the backyard, and they had two pictures to prove it. The older girl's mother was a believer in spirits and magical beings and told everyone she knew about these magical proofs.

Eventually, word traveled to Conan Doyle. He deeply and uncritically believed in fairies, spiritualism, and magic. He wrote to the girls, telling them that he planned to write an article about them and eventually persuaded them to repeat their success. Less than a month later, a new series of fairy pictures gave the already convinced Conan Doyle the confirmation he wanted.

The photos were examined by photographic experts of the time, who certified that neither the images nor the negatives were altered and that no photographic trickery had been used. There was no way that they could certify, of course, that the photos hadn't been staged. To the twenty-first century eye, the pictures are charming examples of Victoriana, and the fairies are obviously unreal (Figure 10-3).

It wasn't until the 1980s that the children (now senior citizens) admitted that they'd copied the fairies from a World War I Christmas book, *Princess Mary's Gift Book*, pasted them on cardboard, and held them in place with pins while they took their photos.

Figure 10-3 The fairies are clearly paper cutouts, unmoving and two-dimensional.

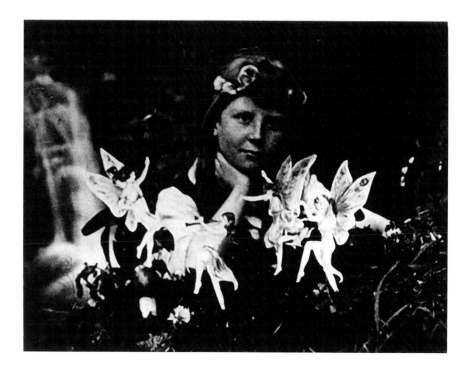

Ghosts from the Machine

We've come a long way from spirit photographs. If the skeptics from the Victorian era were ever confronted with the effortless concatenation and creative composition of our image-editing era, they might all have become Sir Arthur Conan Doyle clones.

Sadly, there is an inverse aesthetic in ghost picture believers today. Since the advent of the digital era, there have been few really good ghost images—just a plethora of smoke, glows, blurs, and abstract shapes. What ever happened to ghosts that look the way we expect ghosts to look? Perhaps special effects and movies have ruined us for goosebumps.

If we were to have the pleasure of a real ghost picture sighting in the digital era, what would it be like? Perhaps like the grunge ghost.

The Case File: Grunge Ghost

People continue to die in sad, violent, or romantic ways. Yet all human-looking ghosts who make their appearances on the modern stage seem to date from the 1600s, and most of those inhabit Great Britain. If we had a modern ghost, he'd probably haunt lofts, warehouses, and offices after hours, constantly looking for a way out. Until he surfaces, Photoshop will have to help us see him.

The most effective way to plan a Photoshop ghost is to set the stage initially with photography. To do that, you need a good setting, some atmospheric lighting, and a tripod. That ensures that the actor will have light and shadows in keeping with the lighting of the setting (Figure 10-4). To make the compositing of two images even easier, we'll turn them into grayscale first.

Figure 10-4 The two images, shot at the same time from the same angle and lighting, will be relatively easy to composite without telltale problems of shadow or scale.

 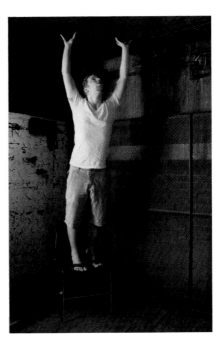

The objective is to make the model float transparently in space. Because the two images are exactly the same size, if you subtract image information from the person image on the second layer, the first layer will take its place. To fade the body into nothingness without a sharp dividing line, select Layer Mask > Hide All. Draw a vertical gradient from the top of the image (Figure 10-5).

Figure 10-5 *The top part of the image is unaffected; the bottom fades slowly away.*

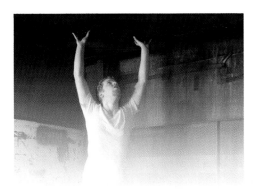

Now we have a very solid person whose bottom half has disappeared. Turning him into a ghost requires transparency, which is very simple. By changing the layer opacity setting to 33%, the top part of the body loses its solidity (Figure 10-6).

Figure 10-6 *The layer with the model is transparent.*

By solving one issue, another becomes apparent. Although many ghosts are face-less, this one should have character. The solution is to treat the face differently than the rest of the body by interfering with the Body Fade layer mask in this critical area.

Duplicate the Body Fade layer and make sure the duplicate layer is positioned above it. Click in the layer mask on the new layer so any changes you make will be in the layer mask rather than in the image. Select all and delete the blend, and then use the Paint Bucket tool to fill the layer mask with black. With the Eraser tool set to a large, soft brush, erase the layer mask over the face (Figure 10-7). To prevent the face from looking too solid, set the layer transparency to 86%.

Figure 10-7 Erasing the layer mask over the face gives the ghost character.

At this point, we've accomplished our task. If we want to liven up the space, which now feels a little too gray and dim even for a ghost, we can finesse the image with the strategy outlined in depth in the creation of the atmospheric alleyway in the following case study—by applying a Curves adjustment layer.

As seen in Figure 10-8, grabbing the curve and moving it up and to the left adds light to the image in the layer. Painting strategically with a semi-transparent brush adds light only where we want to see it. Making the layer transparency about 40% ensures a soft transition between the light and dark areas.

The final result in Figure 10-9 is our soulful modern ghost, waiting for discovery and a way out.

Figure 10-8 A layer mask protects the areas we don't want to be affected by the brightness added by using Curves.

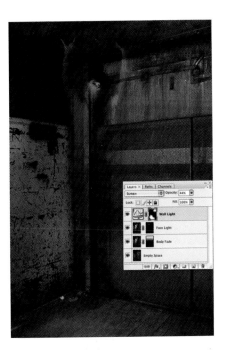

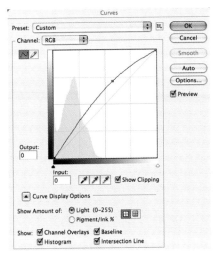

Figure 10-9
The final modern ghost image.

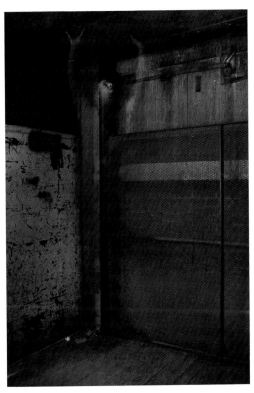

It Must Have Been Moonglow

Many people take photographs that they believe have been touched by the supernatural. They didn't Photoshop these images. In fact, some of the images were produced with traditional cameras and with commercially processed film. Witnesses who were present when the shots were taken are willing to swear that the pictures are genuine and that no strange effects were visible to the naked eye. So where did these objects come from, if not the beyond?

Floating Orbs

Consider the classic movie *The Wizard of Oz*. When Glinda, the Good Witch of the North, arrives, she's traveling in a lovely glowing bubble. Orbs in photos look much like that, except they're usually more numerous and typically white. Could they be fairy dust?

Well, maybe dust. Orbs are such a frequently reported ghost-photo phenomenon because they're very easy to create. Walk into a room that's been closed up for months, kick up some dust, and shoot into the light. Orbs may appear until the dust settles back down.

Humidity of all types can bring them. On a really hot, sticky day, water can condense inside a camera lens and cause orbs and other distortions. Walk onto the porch in the rain at night and shoot with a flash, or turn on a sprinkler in late afternoon. A whole army of mini-Glindas might arrive. Or use an aerosol spray bottle in front of the lens if you want a guaranteed visitation (Figure 10-10).

There are two technical terms for these mysterious forms: lens flare and flash artifact. Instead of the well-behaved reflection of light from your intended subject to the film or image sensors, the light comes into the camera at an angle. When it gets there, it bounces around inside the lens, finally joining the image in the picture. With a lens flare, the source of the light is probably the sun. With a flash artifact, it's the camera's flash bouncing off something reflective nearby.

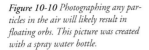

Figure 10-10 Photographing any particles in the air will likely result in floating orbs. This picture was created with a spray water bottle.

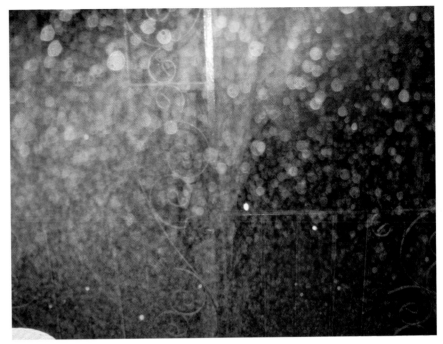

Lightning Bolts and Vortices

Orbs are cute and friendly manifestations. Glowing lines on a picture are dramatic and disconcerting. They look like bolts of energy, and sometimes they seem to be sending a message, especially when they seem to connect people or objects. Sometimes instead of a line or angle, it looks like a glowing funnel. Could these white flashes be psychic energy?

Probably not. Like orbs, they have their source in reflected light but are usually caused by the camera flashing on something very close to the lens. You don't see the offending object because you're focusing beyond it. And since your camera is also focusing at a distance, the closer object is very out of focus. Add the light of a flash to the mix, and the object becomes a glowing blur. For example, the very successful lightning bolts in Figure 10-11 were created by reflections from flashing party favors.

The classic cause of a bright vortex in a picture is, amazingly, the camera's strap. Some digital cameras are particularly prone to this problem. When the photographer looks through the viewfinder instead of the display, it may not accurately display the dimensions of the final image. The strap swings in mid-air and reflects back the flash to the camera lens. Other likely causes of thin bolts of light are strands of hair or pet fur.

Figure 10-11 The fiery glow that appears to hold a demonic face was a lucky reflection from a fire torch.

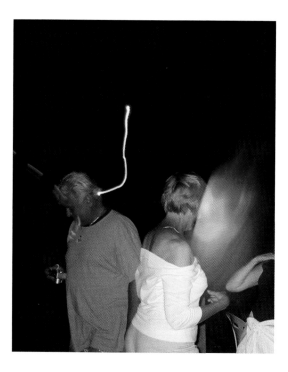

Eerie Glows

Glows and foggy mists in a shot can be puzzling. They look like classic ectoplasmic spirits. They're transparent and ill defined and can't always be seen with the naked eye. Sometimes only the camera seems to capture them.

Glows fall into two groups: soft white mist and streaks of transparent color. Many mists are caused by something that people bring with them everywhere: their breath. In the cooler months, especially at night or in dank, damp cellars, the warmth of a person's breath interacts with the cooler surrounding air. The result is mist, which often hangs in the air waiting for a flash of light to give it substance. Exhaled cigarette smoke particles blown into the air last even longer than mist and are even better reflectors of light (Figure 10-12).

Streaks of transparent color were more common before digital cameras, although they occur in digital photos when people shoot through a pane of glass or through a smudge on the lens. Such streaks can also be the result of a reflection of light bouncing off a mirror or other highly polished surface. They were mainly the fault of damaged and out-of-date film. In particular, heat breaks down emulsion, which is why professional photographers who still use film store it in refrigerators.

Figure 10-12 *Shooting a photo while smoking may add a mist to the picture.*

The Case File: Atmospheric Alley

Mists and orbs may be bargain-basement wonders, but they do provide moments of fun and mystery. However, as we saw in the vortex party photo, they often show up in pretty mundane shots. It seems a shame to throw away such an atmospheric effect on a quick snapshot. But with Photoshop, any relatively prosaic image can become a horror setting. Here, one of the crime scene alley shots from Chapter 2 gets recycled into the kind of photo that would never be admitted in court, even if the perpetrator were being grilled from beyond the grave (Figure 10-13).

Many images of supernatural events are in black and white, not color, even when color film was available. There are many reasons for that, ranging from the age of the picture to the type of film in the camera. But one explanation is obvious to a traditional photographer or good Photoshop artist. Grayscale images allow much more leeway for fakery. Problems of shading and image compositing that are embarrassingly obvious in a color collage may not be apparent when the image color is eliminated. Our first step in creating a moody setting is to eliminate the color information.

Now, what we really need is a warped point of view. Photoshop has several tools for seamlessly distorting image content. Many people know about the Liquefy filter, which is great for detailed adjustments. Transform offers similar possibilities but can be used to make global changes that can look very real. It also has the advantage of being grid based, so it's possible to affect specific areas very precisely.

Figure 10-13 *The color photo of the alley is duplicated and saved as a grayscale image.*

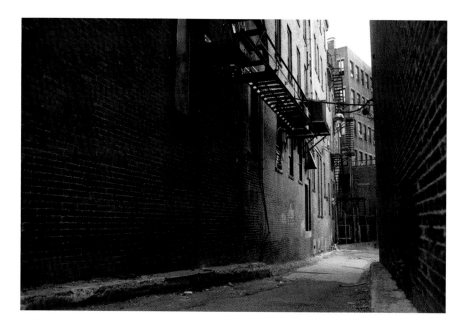

We select the grayscale layer and go to Transform > Warp. To use Warp effectively, we enlarge the image window so the warp grid can extend outside the borders of the image (Figure 10-14). Our adjustments curve back the left side of the image. We curve the right side inward and then out again at the top to make the walls look as if they are moving and breathing.

Figure 10-14 *Using Warp, it's possible to turn a typical alleyway into one gripped by a supernatural horror.*

If the walls are breathing, they need to exhale. Since mist not only gives a sense of mystery but also provides a visual clue that the scene is dank and chill, we need to add a little to the mix. The Difference Clouds filter helps us do this with ease (Figure 10-15).

Figure 10-15 Fill a new layer with a medium shade of gray, and then select Render > Difference Clouds. You'll end up with a layer of two-tone smoke.

Smoke is nice, but it doesn't give the sense of movement and breathing that would really make this scene live. Warp can help here as well (Figure 10-16).

Figure 10-16 Warping the result of the Difference Cloud filter adds movement to the clouds and make them more the texture of lightly blowing mist.

If we tried to combine the mist and the alley layer as is, we'd have a very unsatisfying effect. Everything is too dark. There are easy ways to solve that with settings on the Layers palette. Changing the transparency of the mist layer to 40% makes the mist translucent and much lighter (Figure 10-17). When you look at the alley after the changes in the mist layer (Figure 10-18), the effect is subtle and realistic.

Figure 10-17 The clouds now look like mist, not smoke.

Figure 10-18 The alley after adding the warped mist layer.

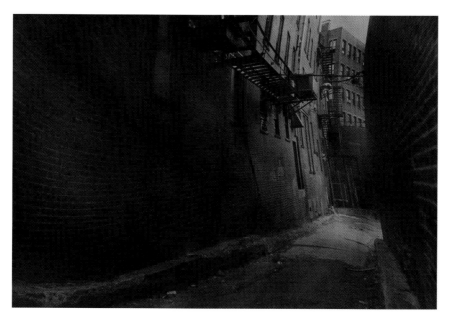

Last, it would be great to give the impression of a tunnel of darkness leading to the sickly light at the end of the alley, and to make the walls feel darker and less obviously like familiar brick. The easiest way to make an image darker is by using a Curve adjustment layer. Using Curves is more effective than Levels because you have more delicate control of light and color. But if we just change the overall image brightness, all of the image will be darker, not just the edges.

Create a new layer on top of the others and select Adjustment Layer > Curves. Click about two-thirds toward the lower end of the curve line and drag it to the lower right to make the medium-dark pixels darker (Figure 10-19). Click the box that says Show Clipping to create an empty layer mask on the adjustment layer.

Figure 10-19 Curves is the only *Photoshop tool that allows you to finely alter the amount of brightness in different areas.*

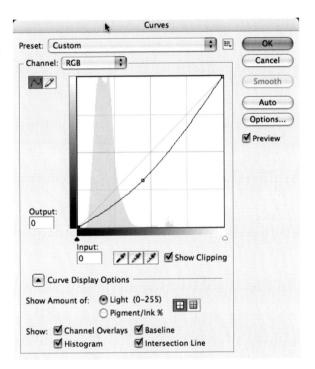

When you paint on a layer mask, you can have enormous control over exactly what part of the image will be visible. Any painting tool—Brush, Pencil, Fill, Gradient—can create a mask to reveal or protect portions on a layer. In this case, we'll get the creepiest effect if we select the Gradient tool. If you draw a mask that's black in the center and white at the edges (Figure 10-20), the black will protect the center area from change. The Curves adjustment will affect only the areas on the edge of the picture.

With the walls darkened and warped, the alley seems to go on forever and gives the feeling that you won't like what waits around the corner (Figure 10-21).

Figure 10-20 *The soft edge of a gradient creates a gradual transition from the darkened area to the untouched center.*

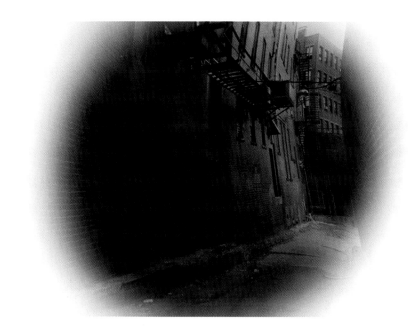

Figure 10-21 *The final effect has turned a quiet city alley into a setting worthy of ghosts, goblins, and their friends.*

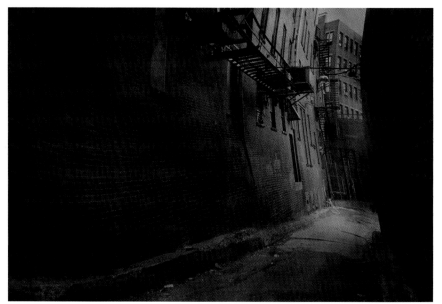

GLOW BY CHOICE

As you can see from the explanation of effects that can happen by chance, it's not hard to inadvertently make an angelic or demonic extra appear in a photograph. It's even easier to make them happen deliberately. Photographers have been making magic in

the darkroom for almost as long as chemical photography has been in existence (see the sidebar "Spiritualism Meets Photography," later in this chapter). Needless to say, the process is different for digital photos, but the results can be equally astonishing for people who haven't had much experience with the craft.

As a quick example, consider how a little bit of Photoshop can give you some of the camera and atmospheric features that sometimes randomly occur on demand. Take one ambiguous setting and add some night experiments, and the result looks suspiciously like some of the glow pictures on the Internet.

In Figure 10-22, the image on the left of gnarled branches is combined with a blurred detail from another image. The blur is placed on a second layer, whose blend mode is changed to Lighten. Lighten turns transparent any pixels that are darker than the image below. The black background in the blurred image disappears, leaving the glow behind.

Figure 10-22 *The source for this startling glow is an out-of-focus set of headlights from a large truck.*

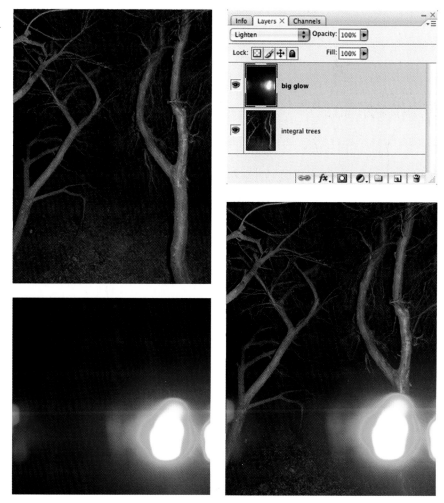

Bodies and Souls

Once you've eliminated the obvious camera-related faults and misinterpretations, a smaller group of images remains. These are the most startling pictures. There are faces in the backgrounds of snapshots, floating distortions, and vaguely human forms. Some send shivers down the spine. But the fact that they scare us doesn't necessarily mean that they are any more real than *Saw II*. When you bring the CSI aesthetic to an examination of ghost photographs, it's disappointing that so many of the most exquisite ones don't hold up.

PATTERNS, PEOPLE, AND PERSUASION

Our brains are excellent at recognizing patterns, particularly visual ones. Almost from the moment we open our eyes on the world for the first time, we make sense of what we see. As we get older, we can spot Waldos in a complex illustration. We can look at a chessboard and see the moves ahead that lead to a checkmate.

So it's not surprising that we sometimes see patterns when they aren't there. Psychologists have a word for this tendency: apophenia. We impose connections on random events and create narratives out of meaningless collections of objects and pictures.

The visual pattern that we find more than any other is the face. Studies of infants indicate that they can recognize the difference between a human face and other objects almost immediately and recognize individual faces within a month or two. Evolutionary biologists and psychologists have theories to explain why this is so important. The most common sense of the theories is that it's a highly useful trait. A responsive infant is more likely to receive attention and affection and to thrive because of it. In studies of brain-damaged adults who lose the ability to recognize faces, we can see how important this specific type of pattern recognition is. To remain connected to society, the sufferers must make a special effort to find other ways to recognize and respond appropriately to other people.

The Face on Mars

A famous example of our ability to find a human face in the most unlikely of places took place in 1976, with the first Viking Mars Orbiter mission. The landscape of Mars was methodically documented in a grid comprising thousands of photographs. Each photograph came back as raw data that needed to be reconstituted, cleaned up, and adjusted for contrast.

Scientists were most interested in areas that had distinctive features or that might provide clues about Martian geological history. Did Mars have flowing water? Did it ever harbor life? It was a monumental task, made only a little easier by our keen ability to recognize patterns.

So it made perfect sense, when they examined images of the Martian area known as the Cydonia Mensae, that one rock formation would catapult to center stage.

Figure 10-23 shows the original file of the Cydonia area (left) as transmitted to Earth. The white specs are static or missed bits of data. Two filters used together, Dust and Scratches and Despeckle, have wiped away most of the static.

Figure 10-23 *The original NASA image of the Cydonia area. The interesting area is marked.*

Although the original picture reveals very little, bring it in to Photoshop and apply a Curves adjustment layer to improve contrast, and you can understand the scientists' excitement (Figure 10-24). There, recognizably and startlingly, are two eyes, a mouth, and a nose, framed in a way that suggests an Egyptian god. The imagination of the world was captured.

Figure 10-24 Cropping into the area eliminates the brightest parts of the Cydonia landscape and allows finer adjustments in tonal value using Curves.

Needless to say, when NASA planned their second Viking launch, Cydonia was definitely on the menu. In 1998, the Mars Orbiter Camera passed over the region again, but this time with much improved image technology. At 10 times the resolution of the 1976 images, the face no longer looked human at all (Figure 10-25).

Figure 10-25 The 1998 images of the same Martian landscape shot with better technology reveal the disappointing truth: If there's a human face on Mars, this isn't it.

What's most interesting about the face on Mars from a forensic point of view is how much like the face the ghost faces are. It takes very little detail for us to form high-contrast shadows and reflections into features.

Five Hints of a Phosphorescent Fake

How can you easily tell the fakes from the genuine puzzles? Although there are always some images that defy easy explanation, if you apply some general forensic observations to a ghost image, you'll be able to narrow the field.

1. The original is missing.

If you shot a photo with a film camera that showed a strange ghost-like image, what would you do with the negative? Or for that matter, with a digital camera's CF card? You'd want to be able to prove the existence of the supernatural, so you'd ensure its preservation by putting the negative or card someplace safe. Yet for the vast majority of photos of unexplained phenomena, from all eras, there are no negatives or digital originals.

Why does it matter? A traditional photographer can do amazing things in the darkroom that can only be discovered if the print can be compared with the negative. As for a digital image, once it's out of the CF card and on the computer, the sky's the limit.

2. It's black and white, but it was shot post-1960.

In 1935, Kodak introduced Kodachrome, and the modern commercial use of color photography began. By 1960, most consumers were shooting with color film. Yet a significant number of "unexplained" ghost photographs in the color era are not in color.

3. It's out of focus or badly over or under exposed.

It's pretty easy to get a decent photograph with a point-and-shoot camera. But pictures with ghosts are often out of focus. It's very easy to read into a fuzzy form, like finding animal shapes in clouds. Images shot in low light with a medium or low-resolution digital camera will develop a range of new features when they are brought into Photoshop for fixing. The colors posterize and deform the image, sometimes making forms out of things that began as noise. A badly over-exposed image probably means that the image was shot with the lens open wide for a long time. Any movement, from the camera or an object in front of it, becomes a mysterious trail of light.

4. **It's been "authenticated by an expert."**

Saying something has been authenticated is very easy. Actually producing the expert who vouched for the photo is not. Most experts are willing to stand behind their expertise. In fact, they insist on being given credit when their decision is quoted in the media. Anonymous expertise is the same as no expertise.

5. **The shot is pointless without the ghost.**

People often claim that the supernatural entity in their pictures wasn't visible when they shot the photo, but appeared when the picture was printed. One way to test this concept is to inhabit the role of the photographer. If the eerie phenomenon wasn't there, was there something else that made this photo worth taking? In the realm of ghost pictures there are many empty staircases, interiors of churches lacking an object of interest, or uninspired graveyards. Insert the entity, and suddenly the photo has a focus—and a purpose.

ANIMAL STORIES

There is one other category of being that rears its head in the digital imaging swamp: the fabulous creature. Unlike supernatural spirits whose existence has never been proven, bizarre animals have certainly existed on Earth—they left their evidence everywhere. Locked in stones or excavated from fields, bones from long-lost animals were the source of many myths and legends. In ancient times, fossils were identified as beings turned to stone. In Asia, they may have been the source for the legend of the dragon. In Judeo-Christian countries, people who found them assumed that they were animals that failed to find a place on Noah's ark.

Eventually, we gave them names—dinosaurs, mammoths, Neanderthals—and accepted that they were extinct. But extinction is such a harsh and final concept. People continue to hope that some escaped to the deep ocean or to untrammeled wilderness.

This hope certainly burns at the heart of cryptozoology, the study of hidden or legendary animals. Not exactly an established discipline but with many devotees from the traditional sciences, cryptozoology examines connections between real animals and myths. For example, stories of mermaids can be found in ancient seafaring countries dating back to the ancient Greeks. So prevalent was the belief in mermaids as real animals that hundreds were manufactured by grafting shaved monkeys to fish tails and sold as curios (Figure 10-26). Historians among cryptozoologists speculate that sailors actually mistook dugongs (seal-like mammals) for mermaids.

Cryptozoologists also follow up reports of unusual animal sightings, correctly noting that many animals once thought to be fantasy, like giant squids, have actually turned out to exist. The coelacanth stands out as the most famous example of scientific hubris and supports the belief that cryptoids (hidden animals) are still waiting to be found. A vestige of the Cretaceous Era, 80 million years ago, it appeared in the fossil record and was assumed extinct. Not only did it survive, it proved to be a common, familiar animal to Indian Ocean fishermen (Figure 10-27).

Although examples of faulty assumptions exist and lend credibility to some researchers' efforts, cryptozoology is most known for the people at its fringes—the hunters for Bigfoot and Yeti. Even without digital assistance, they have collected untold numbers of indistinct, blurry, or ambiguous imagery. With some digital editing, the number of fantastic images has grown.

In particular, the urge for a real dinosaur, sparked by the Loch Ness monster, animates photo retouchers. Everyone seems to want a plesiosaur. That easily identified long neck is a favorite, and examples of retouched images of Nessie cousins can be found easily online.

Figure 10-26 *This drawing from* The Book of Days *portrays a typical curio "mermaid" from the pre-Hans Christian Anderson era.*

Figure 10-27 *The coelacanth proves that many sea creatures may still be unknown or unidentified by scientists. (Drawing by former FishBase artist Robbie Cada.)*

The irony of the images in Figure 10-28 is that the animal pictured in the original photo on the left—a megamouth shark—is a cryptoid in its own right. This harmless krill eater can reach about 15 feet long, with a mouth large enough to envelope a small child whole. Reports of this distinctive beast were ignored until one was reeled in with a ship's anchor in 1976. This one was found in South Africa in 2002 and was only the seventeenth member of its kind found dead or alive to that date. Eliminating its most distinctive feature to create a badly retouched plesiosaur seems a shame. The amateurish editing skills displayed in erasing the little boy and cropping the megamouth's tail are shameful as well, but made this fake easy to spot.

Figure 10-28 The megamouth on the left is so rare that they average around one sighting a year worldwide. Fake plesiosaurs, however, abound. (Courtesy Beefy Mance, Nature's Valley Trading Store.)

The Case File: Manmade Mermaid

One of the most persistent of all cryptoid creatures is the mermaid. Every few years, hoax pictures of mer-creatures, usually looking like refugees from *Creature of the Black Lagoon*, recycle as e-mail attachments. But the Hans Christian Andersen version of a beautiful half-human being still predominates. So, like the enterprising craftspeople of yore, why not use today's best tools to make one for collection (Figure 10-29)?

Fauxtography, when all is said and done, has three requirements for success: good sources for sampling, flexible tools, and an active imagination. Given the great variety of stock images, creative borrowing is frequently about being able to imagine prosaic materials in new forms. To illustrate this principle, Figure 10-30 keys our manmade mermaid to her photographic raw material. The sources are these:

Figure 10-29 The completed mer-
maid—a composite of many sources.
(Courtesy Mitch Weiss.)

1. Underwater environment: stockxpertcom
2. Rocks and gravel
3. Model, isolated from original background and toned
4. Porpoise: stockxpertcom
5. Shell
6. Hair brushes: www.gorjuss.co.uk/
7. Grass brushes: iws-stock.deviantart.com/
8. Bubbles: created with filters, below

Figure 10-30 *Each of the sources for the mermaid elements is keyed to the finished composite.*

The underwater image needed turbulence and water motion. These were added in several stages with the same strategy as the haunted alley: Filter > Render > Clouds on several layers, each with its own layer mask to isolate the different turbulence effects in different parts of the water (Figure 10-31).

Figure 10-31 *Each layer adds to the sense of water activity in the background.*

The rocks were chunks from the gravel image, grabbed from the source and edited to create cliff-like edges (Figure 10-32). There was no need to change their color, because they, like all other environment pieces, were placed below Hue/Saturation adjustment layers that colorized everything below them with blue and green washes of color.

Figure 10-32 The gravel chunk (left) was placed in the water environment and colorized with the Hue/Saturation layer (right).

Enter the top half of the mermaid. Most of the top of her bathing suit is cloned away (Figure 10-33), and a layer mask (shown in red) fades her legs into the background. That leaves a nice place to attach the porpoise tail, scaled down and transformed to fit the model's proportions.

Once the two major pieces are in place, portions of the tail are picked up with the Patch tool and painted onto the rest of the model's bathing suit and up to her waist with different amounts of transparency to create a smooth transition from tail to skin (Figure 10-34). Additional shadows are painted onto the model's arm and chest to make the flesh lighting consistent with the tail. Lastly, highlights and shadows are added with a Layers adjustment layer.

That pesky remainder of the bathing suit is next. The original shell is duplicated, scaled, and rotated into the correct position. While still in the Transform tool, the shells are carefully warped to conform to the model's curves (Figure 10-35).

The model's hair does not look like it's under water. Hair is particularly difficult and time consuming to draw, so being able to use an existing shortcut is particularly handy. There are several sites with excellent collections of brush tools.

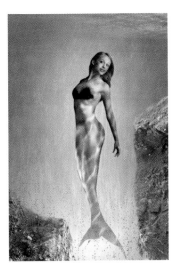

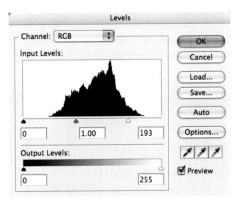

Figure 10-34 *The model's skin and tail are seamlessly joined by combining the pattern of the tail with highlighting.*

Figure 10-35 The shell takes the place of the top of the bathing suit.

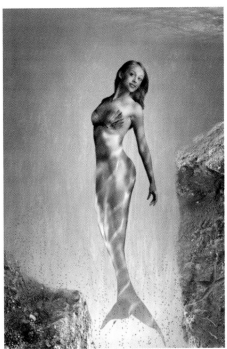

You can see a preview of the brush outline before you click on your artwork to paint with it, just as you can with Photoshop's own brushes (Figure 10-36, left). Varying the type of brush, we start with shorter, thicker strokes to blend the brushes with the model's own hair (Figure 10-36, center). The second stage creates long, extravagantly dramatic strands (Figure 10-36, right).

Figure 10-36 Each brush click adds many strands of hair in a pattern.

Figure 10-37 The original brush tip (left) is good for a dramatic, tall seaweed effect.

The ocean environment looks very bare and empty. Brushes can help here as well. With the second group of downloaded brushes, we have a collection of different types of grass. Although we can certainly use them in some places in their original form (Figure 10-37), we probably need more variety.

Photoshop makes it easy to adapt an existing brush in the Brushes window (Figure 10-38, left). Select a brush tip, and click Brush Tip Shape to access all the options. We've increased the spacing so that each click is a distinct plant, and we changed the angle to make the brush shorter and wider (Figure 10-38, right). By combining several variations of this brush at different transparencies, we produce a variety of vegetation in the foreground and background (Figure 10-39).

Figure 10-38 The edited brush tip can be saved and added to the brush options.

With so much activity in the water, there ought to be bubbles. There are many ways to make them, but there is already a perfect brush for applying them in the group called Wet Media brushes. It lays down circles in a variety of sizes. The first image on the left in Figure 10-40 shows the effect of varying the brush size of this style.

Figure 10-39 With several types of sea-weed, the environment is much richer.

To turn these black circles into bubbles, select Layer > Layer Style. You want to do several things. First, you want a subtle shadow to give the bubbles dimension. Next, you want an outer glow on the bubbles and an inner glow as well to make them feel like glowing spheres. Last, you emboss the spheres, which will give them thickness. From left to right, Figure 10-41 shows the visual progression of these changes. To get these effects, you'll need the settings in Figure 10-42.

Figure 10-40 These black circles will soon be replaced with multitudes of bubbles.

Figure 10-41 The bubble effect takes shape from left to right.

Figure 10-42 *Layer effects are a surprisingly powerful way to bring a 3D feel to an image.*

The final step is to make these bubbles transparent. Change the layer blend mode to Screen, and set the transparency to 50% (Figure 10-43).

Figure 10-43 The Screen mode has the effect of inverting the black parts of the circles without changing the inner or outer glows.

A few sets of additional bubbles, and your mermaid's environment comes alive. Time consuming? Certainly. But much nicer than a hairy Yeti. You've ended up with a sailor's ultimate fantasy and an extraordinarily rich and realistic composite image.

If you began this book wondering what you had to learn about the image editing world and found that this book kicked your skills up a notch, that was certainly part of the plan. The fun of creating a total flight of fantasy can be addictive. But so can the analytical side. The next time someone sends you a too-bad-to-be-true JPG via e-mail, you might not have to post it on a site and ask a group of strangers "Do you think this is real?" Perhaps you'll have the inclination and some of the tools and background to answer the question for yourself—and even better, to be the person who answers that question for others.

APPENDIX

THE
INVESTIGATORS

A **GROWING NUMBER** of very smart and persistent scientists, researchers, and law enforcement officers are looking at the common electronic image in exciting new ways. As the field of image forensics continues to grow exponentially, this book has little more than highlighted some of the more visible and accessible fruits of their labor. No doubt it has missed many intriguing findings in image analysis and several important software tools. The book's author can only plead time constraints and deadlines.

The admirable people who have been highlighted in this book will be the first, but hopefully not the last, to lament that their work has been compressed in these pages. If you've been intrigued and want to learn more about their explorations and the applications of their research, this appendix provides URL contact points for papers, discussions, and commercial software discussed in this book.

Charles E. H. Berger
Document Group, Chemistry Department, Netherlands Forensic Institute
4N6site.com
mail@4N6site.com
Color Deconvolution Photoshop plug-in

Hany Farid
Professor, Department of Computer Science, Dartmouth College
www.cs.dartmouth.edu/farid/
farid@cs.dartmouth.edu
Several research papers on exposing digital forgeries. In particular, "Exposing Digital Forgeries in Complex Lighting Environments," "Exposing Digital Forgeries Through Specular Highlights on the Eye," and "Exposing Digital Forgeries Through Chromatic Aberration."

Rob Fergus
Assistant Professor, Computer Science, Courant Institute of Mathematical Sciences, New York University
cs.nyu.edu/~fergus/
Fergus@cs.nyu.edu
"Removing Camera Shake from a Single Photograph"

James Hayes
Doctoral candidate, Computer Science Department, Carnegie Mellon University
www.cs.cmu.edu/~jhhays/
jhhays@cs.smu.edu
"Scene Completion Using Millions of Photographs"

Dr. Constantine (Gus) Karazulas
Forensic Odontologist
c/o Connecticut Forensic Science Laboratory
www.ct.gov/dps/cwp/
ct.scientificservices@po.state.ct.us
and
Lucis Pro Scientific Software
www.imagecontent.com/
sales@imagecontent.com

Christopher Kenworthy
www.christopherkenworthy.com/
chris@skyviewfilms.com
Artist, author, videographer: Australian UFO Wave

Dr. Neal Krawetz
Hacker Factor
www.hackerfactor.com
web@hackerfactor.com
"A Picture's Worth: Digital Image Analysis and Forensics"

Tommer Leyvand
Senior Development Lead, Microsoft
www.cs.tau.ac.il/~tommer/
tommer@tau.ac.il
Digital Face Beautification

Christopher Russ
c/o Ocean Systems
www.oceansystems.com/
ClearID Image Analysis Software

Dennis Van Gerven
Professor, Anthropology Department, University of Colorado at Boulder
dennis.vangerven@colorado.edu

Marianne Wesson
Professor, School of Law, University of Colorado at Boulder
www.wessonbooks.com
Wesson@Colorado.EDU

SELECTED BIBLIOGRAPHY

Chapter 1

Adams, Mike. Consumer Alert: Hoodia Gordonii weight loss pills scam exposed by independent investigation, March 26, 2005, Truth Publishing, Inc. http://www.new-starget.com/006016.html.

BBC News. "Counterfeit money gang is jailed," BBC News, June 13, 2005.

Flegal KM, Carroll MD, Kuczmarski RJ, Johnson CL. "Overweight and obesity in the United States: prevalence and trends, 1960–1994," *Int J Obes Relat Metab Disord.* 1998 Jan;22(1):39-47.

Murdoch, Steven. Software Detection of Currency, www.cl.cam.ac.uk/~sjm217/projects/currency/.

Murdoch, Steven, Ben Laurie. The Convergence of Anti-Counterfeiting and Computer Security, Proceedings, 21st Chaos Communication Congress, December 27–29, 2004, Berliner Congress Center, Berlin, Germany.

Tomlinson, Heather, Prickly solution to obesity? *Guardian Weekly, Guardian Unlimited.* http://www.guardian.co.uk/guardianweekly/outlook/story/0,1383777,00.html.

United States Secret Service. http://www.secretservice.gov/money_history.shtml.

Chapter 2

BBC News. Traffic Warden "fitted up" driver, bbc.co.uk, January 25, 2005.

Bloom, Murray Teigh. "The man who stole Portugal," Secker & Warburg, 1967.

Douglas, K.S., Lyon, D.R. & Ogloff, J.R.P. "The Impact of Graphic Photographic Evidence on Mock Jurors' Decisions in a Murder Trial: Probative or Prejudicial?" *Law and Human Behavior*, Vol. 21, No. 5, 1997.

Garcia, Crystal A., Kennedy, Sheila Suess, and Lawrence, Barbara. "Picturing powerlessness: digital photography, domestic violence, and the fight over victim autonomy." *Hamline Journal of Public Law and Policy* 25.1 (Fall 2003): 1–19. Academic OneFile. Thomson Gale. Northeastern University. 6 May, 2007.

Karazulas, C.P. New Forensic Odontology Tools, Connecticut State Police Forensic Science Lab, March 2001.

Levy-Sachs, Rebecca, Sullivan, Melissa. "Using Digital Photographs in the Courtroom – Considerations for Admissability," ABA, August 2004.

Lyons, Troy. "The digital roadmap," *Law Enforcement Technology*, October 2006.

Perlmutter, Emanuel. "Death Ends Hunt for Check Forger," *New York Times*, July 30, 1959.

Royal Pharmaceutical Society of Great Britain. Counterfeit medicines, guidance for pharmacists.

Smith, Beverly, "Crook That Everyone Liked," *Saturday Evening Post*, December 12, 1959.

St. John, Warren, "In the ID Wars, the Fakes Gain," *New York Times*, March 6, 2005.

State of Connecticut v. Alfred Swinton (SC 16548), *Connecticut Law Journal*, May 2004.

Topp, Michael Miller, *The Sacco and Vanzetti Case: A Brief History with Documents*, Bedford/St. Martin's, 2005.

Weiss, Sandy, "Fair and Accurate, Applying the principals of vision, photography, and perspective," *Evidence Technology Magazine*, Vol 4, No. 3, May/June 2006.

Wigan, Henry. "The Effects of the 1925 Portuguese Bank Note Crisis," London School of Economics Working Paper, February 2004.

Witkowski, Jill. "Can Juries Really Believe What They See? New Foundational Requirements for the Authentication of Digital Images," 10 WASH. U. I. L. & POL'Y 267, 273 (2002).

Chapter 3

Bredius, Abraham. A New Vermeer, *The Burlington Magazine for Connoisseurs*, Vol, 71, No. 416, p. 210–211, Nov. 1937.

Brunker, Mike. Is eBay stamp racket the Net's stickiest scam?, MSNBC, February 26, 2007.

Hamlin, Gladys E. "European Art Collections and the War, Part 2," *College Art Journal*, Vol. 4, No. 4, pp. 209–212, May 1945.

Jeppson, Lawrence. The Fabulous Frauds: Fascinating tales of great art forgeries, 1970.

Nickell, Joe. *Camera Clues: A Handbook for Photographic Investigation*, University Press of Kentucky, 1994.

Prisant, Barden. In the World of Forgery, No Work Is Sacred, *Art Business News*, October 2000.

Roberts, Chris. Group saddles up to ride against forgeries of equine art, Associated Press State & Local Wire, September 30, 2006.

Walton, Kenneth. *Fake: Forgery, Lies & Ebay*, Simon & Schuster, 2006.

Werness, Hope B. and Denis Dutton. *The Forger's Art: Forgery and the Philosophy of Art*, University of California Press, 1983.

Chapter 4

Baron, Cynthia. Propaganda!, *Critique Magazine*, Depth, Volume 11, Spring 1999.

Campbell, W. Joseph. 1897 American journalism's exceptional year, Journalism History 29, Winter 2004.

Delwiche, Aaron. Demons, Atrocities and Lies, www.propagandacritic.com/articles/ww1.postwar.html, 2002.

Jowett, Garth and O'Donnell, Victoria, *Propaganda and Persuasion*, Sage Publications, 2005.

Lienhard, John. The FAX Newspaper, Engines of Our Ingenuity, Episode 1433, University of Houston, 1999.

Taft, Robert. Photography and the American Scene: A Social History, 1839–1889, Dover Publications, 1964.

Totten, Michael. Busted, *Middle East Journal* (www.michaeltotten.com), January 29, 2007. Copyright in part Bruno Stevens.

Chapter 5

BBC/Reuters/Media Center Poll: Trust in the Media, May 3, 2006.

Brower, Kenneth. Photography in the Age of Falsification, *Atlantic Monthly*, May, 1998.

Cozens, Claire. Editors 'clean up' bomb photo, MediaGuardian.co.uk, March 12, 2004.

Fulton, Marianne, ed. *Eyes of Time: Photojournalism in America*, Little, Brown and Co., 1988.

Hughes, Jim, W. *Eugene Smith: Shadow and Substance: The Life and Work of an American Photographer*, Jim Hughes, 1989.

Jowett, Garth and O'Donnell, Victoria. *Propaganda and Persuasion*, Sage Publications, 2005.

North, Richard. The Corruption of the Media, EUReferendum.blogspot.com, August 23, 2006.

Project for Excellence in Journalism. The State of the News Media 2007, stateofthemedia.org.

Roth, Daniel Shoer. Una aclaracion necesaria para el lector, *El Nuevo Herald*, July 27, 2006.

Strouse, Chuck. Listen Up, McClatchy, *Miami New Times*, July 27, 2006.

Winslow, Donald. Photojournalism Ethics: "The Problem Seems To Be A Lot Deeper", *News Photographer*, June 1, 2007.

Chapter 6

Bell, Robert. *Impure Science: Fraud, Compromise and Political Influence in Scientific Research*, John Wiley & Sons, Inc., 1992.

Hao Xin. Online sleuths challenge Cell paper, *Science* 314.5806 (Dec 15, 2006): p1669(1).

Lafollette, Marcel C. *Stealing into Print, Fraud, Plagiarism, and Misconduct in Scientific Publishing*, University of California Press, 1992.

Pearson, Helen. CSI: Cell Biology: *Nature* 434.7036 (April 21, 2005): p952(2).

Walsh, John E. *Unraveling Piltdown, The Science Fraud of the Century and Its Solution*, Random House, 1996.

Chapter 7

Hesse-Biber, Sharlene. *Am I Thin Enough Yet?*, Oxford University Press, 1996.

Laver, James. *The Concise History of Costume and Fashion*, Harry N. Abrams, 1969.

Owen, P. R., & Laurel-Seller, E. (2000). Weight and shape ideals: Thin is dangerously in. *Journal of Applied Social Psychology*, 30, 979–990.

Ruark, Jennifer K. A Second Look at the Big Squeeze, *Chronicle of Higher Education*, 48.13, November 23, 2001.

Sypeck, Mia Foley, Gray, James J, Ahrens, Anthony H. No Longer Just a Pretty Face: Fashion Magazines' Depictions of Ideal Female Beauty from 1959 to 1999, Wiley Periodicals, 2004.

Chapter 8

Berger, John. Ways of Seeing, British Broadcasting Corporation and Penguin Books, 1972.

Brower, Kenneth. Photography in the Age of Falsification, *Atlantic Monthly*, May, 1998.

Gregory, R.L., ed. *Illusion in Nature and Art*, Scribner, 1973.

Hattam, Jennifer. The Watched Photographer, *Sierra Magazine*, January/February 2007.

Pierson, Michele. *Special Effects—Still in Search of Wonder*, Columbia University Press, 2002.

Stepno, Bob. The Evening Graphic's Tabloid Reality, University of North Carolina-Chapel Hill, School of Journalism, 1997.

Chapter 9

Fenster, Mark. *Conspiracy Theories, Secrecy and Power in American Culture*, University of Minnesota Press, 1999.

Fergus, Rob, Singh, B., Hertzmann, A, Roewis, S.T, Freeman, W. Removing Camera Shake from a Single Photograph, 2006.

Friedman, Stanton. *The Case for the Extraterrestrial Origin of Flying Saucers*, 1995.

Garrett, Brandon L. Judging Innocence, 108 Colum. L. Rev, forthcoming 2008.

Hamilton, Denise. Spies Like Us: Understanding Information-Hiding Technology, *Searcher, The Magazine for Database Professionals*, October, 2003.

Krawetz, Neal. A Picture's Worth…Digital Image Analysis and Forensics, Black Hat Briefings USA, 2007.

Moltenbrey, Karen. CSI: Dallas, *Computer Graphics World,* January 2004.

Polidoro, Massimo. The Walrus Was Paul!, *Skeptical Inquirer,* January/February 2006.

Sagan, Carl. *The Demon-Haunted World—Science as a Candle in the Dark.* New York: Random House, 1995.

Scotti, James V. Fox Special Questions Moon Landing But Not Its Own Credulities, *Skeptical Inquirer* 25.3, May 2001, p. 9.

Steiger, Brad and Steiger, Sherry. Conspiracies and Secret Societies: The Complete Dossier, Omnigraphics, 2006.

Chapter 10

Carrington, Hereward. *The Physical Phenomena of Spiritualism, Fraudulent and Genuine,* Dodd, Mead & Company, 1920.

Doyle, Arthur Conan. *The Coming of the Fairies,* George H. Doran Company, 1921.

Hopkins, Albert. Magic: stage illusions and scientific diversions, including trick photography by Albert Hopkins, 1898.

Sagan, Carl. *The Demon-Haunted World—Science as a Candle in the Dark.* New York: Random House, 1995.

INDEX

9 Aug '08 Aragon 23.0° (34.92) 105400